STREET CULTURE

50 YEARS OF SUBCULTURE STYLE

Gavin Baddeley

Plexus, London

All rights reserved including the right of
reproduction in whole or in part in any form
Copyright © 2015 by Gavin Baddeley
Published by Plexus Publishing Limited
The Studio
Hillgate Place
18-20 Balham Hill
London SW12 9ER
www.plexusbooks.com

British Library Cataloguing in Publication Data

Baddeley, Gavin.
 Street culture : fifty years of subculture style.
 1. Subculture. 2. Adolescent psychology.
 I. Title
 306.1-dc23

 ISBN-13: 978-0-85965-475-3

Cover photo by Dimitri Otis/Getty Images
Cover and book design by Coco Balderrama
Printed in Great Britain by Bell & Bain Ltd, Glasgow

CONTENTS

INTRODUCTION

Belonging to a countercultural tribe is as absurdly foolish to many outsiders as it is passionately important to many devotees. Lots of the movements in this book have at one point or another been described as 'cults', most often in a spirit of condemnation, yet the term isn't wholly inappropriate.

While many – both within and outside the realms of these street tribes – would be uncomfortable with the comparison, subcultures fulfil a lot of the same functions as religion. They provide distinct rituals, value systems and peer group support, their own heretics and martyrs, sacred sites and creation myths. Yet the idols and prophets of subcultural legend are of modern, fallible flesh and blood, their dogma rooted in the world around us. To sceptics, this makes them trivial, even laughable. But from another perspective, at the very least it makes subcultural devotion somewhat more rational and relevant than conventional creeds that worship intangible entities, revealed to us by distant historical figures whose recorded words we are asked to take on trust.

Being willing to risk violence on the streets, the disapproval of your family and peers, and your future career prospects by adopting the trappings of a subculture implies a level of true devotion seldom given credit by outsiders. Truth be told, it's not often analysed by the devotees themselves – it just seems like the right thing to do, a natural act of self-expression or self-discovery. True countercultures command fervent loyalty among the faithful, but the nature of that faith can be maddeningly fluid.

To give an example of the confusion surrounding our subject, for many years the devotees of heavy metal weren't regarded as an 'authentic' counterculture at all – too macho and apolitical to fit the unwritten blueprint concocted by liberal media commentators. Yet, as your author can attest, long hair and a black leather jacket certainly put you beyond the pale in many eyes in the eighties, attracting unwelcome attention from both the police and belligerent conformists, and making numerous bars and jobs off limits. And, while there were clearly countless thousands of us in the UK alone, nobody seemed quite sure what we were called. I remember reading the back of a 1982 Iron Maiden album in my teens, which described the band's fans as 'Headbangers, Earthdogs, Rivet Heads, Hell Rats and Metal Maniacs'. I was fascinated by who these diverse tribes might be, though upon more mature reflection, they were fanciful inventions, only 'headbanger' enduring with any credibility.

I later discovered numerous localised contemporary variants. For example, in the West Country, kids in black leather jackets were mysteriously known as 'jitters', while in parts of South Wales they went under the singularly unaffectionate moniker of 'sweaties'. One unifying factor was that most of the terms weren't exactly complimentary, yet many sanguine headbangers reluctantly accepted the pejorative label as the mark of the outsider (even 'reclaiming' the word, in a sense, in the same way that the homosexual community reclaimed the insult 'queer' in the nineties). The solidarity of this – and each of the tribes featured in this tome – points to a single conclusion.

While during the 20th century, British power was declining in almost every other field, the influence of the UK's counterculture was only rivalled by that of political and entertainment

superpower the USA. In his book *The English: A Portrait of a People*, the respected political journalist Jeremy Paxman pays tribute to what he describes as 'the most effervescent youth culture in the world'.

'The old hierarchies are finished,' he opines. 'And as they crumbled, we have seen energy unleashed in fashion and music.' Perhaps, as Paxman implies, the UK proved fertile ground for the growth of subcultural style in part as a response to Britain's plummeting status on the international stage?

Paul Rambali, ex-editor of eighties style bible *The Face* – which, along with *i-D* magazine, played a pivotal role in defining 'street style' in the UK – reflected that, 'On the streets of Britain, you can still be whoever you want to be. You can masquerade as whatever you like, be as outlandish as you please, and only tourists will stare. It's an aspect of the liberal tradition in Britain that's much admired abroad – our apparent tolerance of eccentrics – where it is seen as part of the British character.'

Indeed, when Jeremy Paxman extols the vibrancy of British fashion, he is specifically referring to 'street fashion' rather than haute couture. While London certainly has its vaunted designers, mention high fashion and you're more likely to think of Paris or Milan. An important idea to appreciate while reading this book is the distinction between fashion and style. Fashion and style are not just different, but the direct opposite of each other. Style is a celebration of self-expression; fashion the art of wearing what you are told by 'experts'. These different attitudes to dress are emblematic of the gulf of understanding between countercultural devotees and conformist consumers. While 'normal' folk cannot appreciate why anyone would deliberately dress 'weirdly', the 'weirdos' themselves cannot comprehend why people spend huge amounts of money on a seasonal basis in the hope of looking like everybody else. In case you haven't guessed, this book takes the side of the weirdos. There's more to this difference of opinion than first meets the eye.

At the core of the concept of fashion is the idea that style – like everything else – can be bought. Subcultures value authenticity, and most, having little time for poseurs, express contempt for those who have tried to purchase a look off the rack.

If counterculture style has no other value, then it is at bare minimum a reminder that some things can't be bought for money, which is a valuable notion in a world where almost everything seems to come with a price tag and cash conquers all. It's this idea that lies behind the definition of subculture in this book – movements that erupt outside the mainstream to create value systems of their own, bewildering the business world by disdaining consumerism, and infuriating insecure conformists by rejecting the herd defence of anonymity. It also defines the point at which some movements stop becoming countercultures, and simply become another flavour on the mainstream menu.

This book – like all history books in a sense – has evolved into a series of stories. Within each entry I have tried to capture the central mythologies that went into transforming a series of different ideas into a coherent culture that attracted devoted followers. While music is inevitably prominent, other oft-overlooked factors – from movies and books, to politics and sexuality – also play a vital role.

Counterculture is a vast area that is at once so subjective and passionately felt. I have done my best to get beneath the skin of each subculture covered, while retaining enough distance to remain objective. If I have failed to truly capture the essence of the subculture you love to your satisfaction, it is perhaps inevitable – nobody really gets it unless they wholly embrace it, and there are a million stories to tell. I respect and salute that. With those humble provisos, I hope you will find this trip through fifty years of doing things the wrong way for all the right reasons enlightening.

TEDDY BOYS
Rock Around the Clock

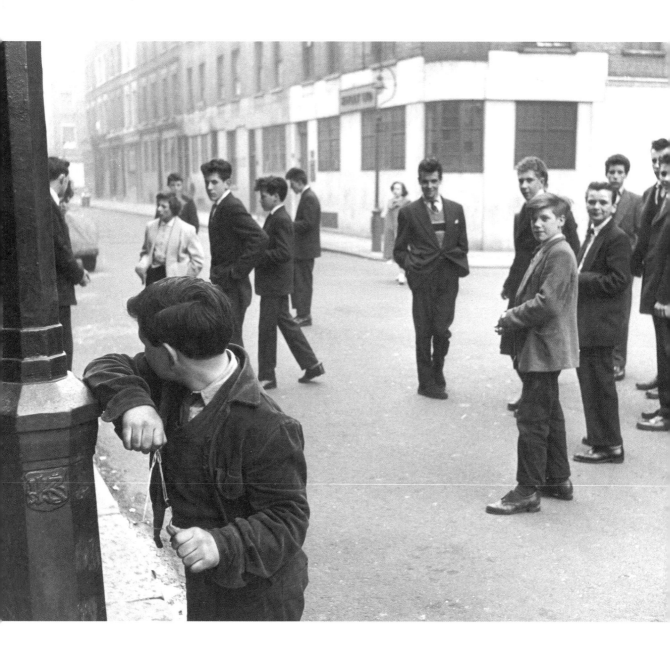

When the subculture first emerged, over half a century ago, teds were regarded with fear and loathing by many of their contemporaries.

In many eyes, the image of the teddy boy is now swathed in a warm nostalgic glow. He cuts an almost cuddly figure in his distinctive drape jacket and quiff, a reminder of safer, simpler times. Yet when the subculture first emerged, over half a century ago, teds were regarded with fear and loathing by many of their contemporaries. If nothing else, the teddy boys offer a fine example of how nostalgia distorts our vision of the past.

The component most associated with the teds today – American rock'n'roll – was perhaps the least significant, and certainly among the last of the factors that helped shape what is often described as Britain's first home-grown youth culture. 'Everybody now associates teddy boys with rock'n'roll – rightly so – but the teds came out way before rock'n'roll,' observed original teddy boy Brian Rushgrove, interviewed for the 2008 BBC show *British Style Genius*. Significantly, at the time of the interview Brian was still a ted, confounding the enduring myth that such subcultures are merely youthful indiscretions, teen fads abandoned once the adherent 'grows up'.

Judy Westacott became a teddy girl in 1978, at age thirteen. 'It married two things I really liked – the 1950s music and the style of dress,' she told the *Times* in 2003. 'It was exciting going out in tight skirts, looking elegant – it was very stylish compared to flares. My parents hoped it might be a passing phase but it lasted twenty-five years.' Westacott was

Opposite: Teddy boys became a familiar fixture on the streets of fifties Britain.

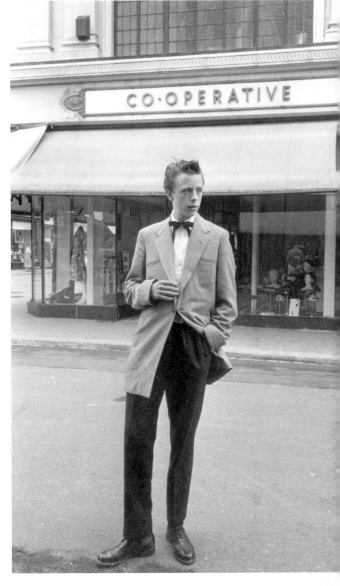

Above: *Ted style was a streetwise blend of Savile Row fashion and styles borrowed from Hollywood Westerns.*

being interviewed because she'd discovered the original prints of photos taken by the esteemed maverick film director Ken Russell in 1955. Russell was then working as a photographer for *Picture Post* magazine; the photos were of teddy girls. 'The public perception is that teddy girls all wore circle skirts and bobby socks and listened to "Rock Around the Clock", and that kind of stuff,' said Westacott. 'But these

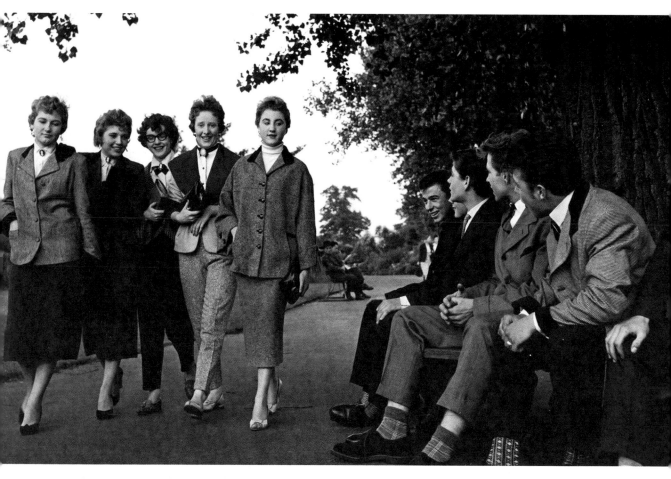

Above: Ted flamboyance could turn girls' heads, as in this 1955 scene from a London park (note the early Teddy girl garb).

pictures predate it, and it proves that the cult wasn't really music-based at the start, that was something that came later. What the teddy boys and girls were listening to was big-band stuff like Ted Heath and Ken Mackintosh.'

The teds were a product of Britain's post-war period, before American rock'n'roll took the nation's teens by storm in the late fifties. The only obvious element of ted style borrowed from the US was the bootlace tie, influenced by the bad guys in Hollywood Westerns. The immediate predecessor to the teddy boy was the spiv, the flashily-dressed petty criminal who dodged conscription, preferring to take advantage of wartime shortages in order to make quick profits on the black market, rather than fight Hitler on the frontline. While affectionately spoofed in the form of such fictional anti-heroes as Private

Walker in the BBC sitcom *Dad's Army* (1968-77) or Flash Harry in the *St Trinian's* films of the fifties and sixties, spivs are an uncomfortable reminder that the idea that everybody pulled together when Britain was menaced by Nazi invasion is at least partially a myth.

When the Allies finally triumphed, one unexpected consequence was the rise of the teenager. While other factors played their part, the war's terrible toll of lives lost facilitated social mobility, as mass mortality made prestigious jobs more freely available.

Many working-class youngsters south of the Thames – the traditional symbolic barrier between rich and poor in London – decided to use their newfound spending power to make

sartorial gestures. Meanwhile, north of the river in 1948, tailors on Savile Row, who'd dressed the Empire's elite for generations, launched a new fashion based on the styles of the Edwardian age. The first decade of the 20th century was the last time that the British Empire had really meant anything, so the logic applied by these exclusive tailors was that flamboyant styles – harking back to less troubled, more confident times – would appeal to young gents and off-duty army officers who wished to cut a conservative dash in the dour, uncertain years after the Second World War, wearing clothes that celebrated stability and the status quo. Once this style crossed the Thames, however, cultural piracy instantly inverted such symbolism.

This new look consisted of long jackets with ornamental lapels, fancy waistcoats and tight trousers. 'Oxford graduates wore them, gentlemen from London wore them,' observed Brian Rushgrove of this forties neo-Edwardian fashion. However, the style was swiftly being copied by the flash dandies selling black-market goods in London markets, and Rushgrove recalls, 'Once the spivs got hold of it the gentleman's whole wardrobe became unwearable – the Oxford graduate couldn't wear it, the gentleman couldn't wear it, because he would be classed as a hooligan.' A modern parallel might be chavs – Britain's current underclass – who have embraced modern designer labels like Burberry (much to the dismay of the company itself) and ostentatious gold jewellery in order to try to project a defiant, if unconvincing, image of affluence. Yet the significance of such a style statement in the fifties was more profound. At a time when the identity of Britain was in flux, these rough working-class peacocks struck a nerve.

Before they were called teddy boys, many

> The teddy boys offer a fine example of how nostalgia distorts our vision of the past.

suggest that the teenagers who adopted this Edwardian style were called 'cosh boys' and belonged to 'razor gangs' – the volatile young malcontents who haunted Britain's most deprived neighbourhoods after the war. According to writer Harry Hopkins, 'Most significant, perhaps, was the teddy outfit's function as the badge of a half-formed, inarticulate radicalism (upon which the political left had failed to capitalise). A sort of half-conscious thumbing-of-the nose, it was designed to establish that the lower orders could be as arrogant and as to-the-manor-born as the toffee-nosed ones across the river.' Juvenile delinquency was nothing new, yet the impertinence of these strutting street toughs in their flash gear was something else.

The teddy boys took the neo-Edwardian style and exaggerated it. The drape jackets were typically in dark shades, trimmed in a contrasting colour with velvet at the lapels and cuffs. The size of the coats provided ample space to conceal weapons or bottles of beer. Trousers were tapered and tight, deliberately cut short to show off the archetypal ted footwear, the crepe-soled brothel creeper. Reputedly based on the suede boots worn by British soldiers in the North African desert campaigns, the disreputable name undoubtedly appealed to teds, as did the extra height the thick soles provided. At a time when fashion was highly regimented, anyone wearing shoes that couldn't be shined was seen as a potential cad. The crowning glory of any true teddy boy was his quiff, formed by combing long hair forward into a crest held in place with grease, the rear of the style completed in a DA – or 'duck's arse' – at the nape of the neck. Accessories included pocket watches and flick knives, though the extent to which these were for show rather than actual use has been debated.

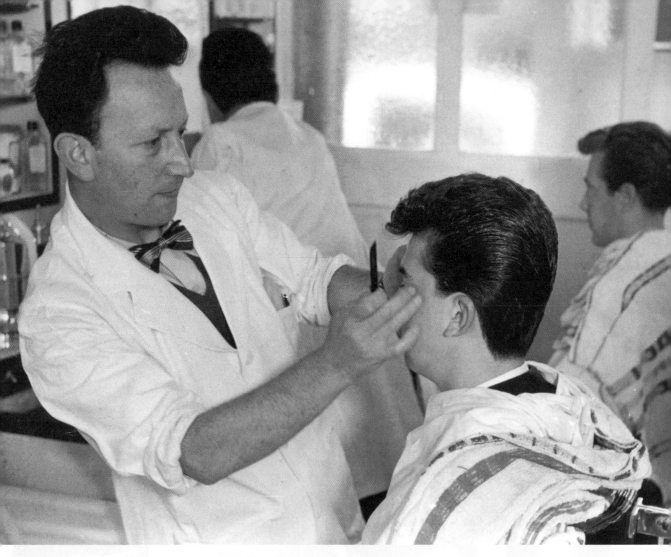

Above: Angel Rose – the West End barber who claimed to have introduced the quiff to the UK – in action in 1954.

Certainly they were sometimes used in deadly earnest. In July of 1953 a gang of teddy boys stabbed a teenager named John Beckley to death near Clapham Common in London. The *Daily Mirror* reported the murder under the headline 'Flick Knives, Dance Music and Edwardian Suits'. The term 'teddy boy' was coined in an article by UK daily newspaper the *Daily Express* in September of 1953. It's a classic early example of the way in which the conservative media seeks at once to mock a burgeoning youth culture as foolish – the term 'teddy boy' clearly intended to belittle its subject ('Teddy' from 'Edward', as in 'Edwardian') – while simultaneously branding it an ominous threat. Venues were soon posting up notices requesting 'No Edwardian clothes, crepe or rubber-soled footwear please!', while teddy boys became the subject of prurient fascination in the press, villains to be exploited for cheap copy on slow news days.

Inevitably, this bad reputation lent teds glamour in some young eyes. 'We got dressed up because it was always the teddy boys who got the look-in. We weren't being noticed by them,' recalled Rose Shine of what inspired her and her friends to become teddy girls. 'We weren't bad girls,' she adds. 'We were all right. We got slung out of the picture house for jiving up the aisles once, but we never broke the law. We weren't drinkers. We'd go to milk bars, have a peach melba and nod to the music, but you weren't allowed to dance. It was just showing off: "Look at us!"'

'Cinemas, dance halls and other places of entertainment in South-East London are closing their doors to youths in "Edwardian" suits because of gang hooliganism,' reported the *Daily Mail* in an April 1954 article. 'The ban, which week by week is becoming more generally applied, is believed by the police to be one of the main reasons for the extension of the area in which fights with knuckle dusters, coshes, and similar weapons between bands of teenagers can now be anticipated. In cinemas, seats have been slashed with razors and had dozens of meat skewers stuck into them.' The most notorious

The cinematic release of *Blackboard Jungle* cemented the subculture's love affair with rock'n'roll. Teddy boys were largely ignorant of the music's black roots, while visiting American rock'n'roll artists were often bemused when they saw the sea of drape jackets and brothel creepers among British audiences, as they looked nothing like US crowds. The darkest days in ted history came in the late summer of 1958, when Notting Hill witnessed what became known as the Teddy Boy Riots. They were the culmination of building racial tension between Caribbean immigrants in the London

Juvenile delinquency was nothing new, yet the impertinence of these strutting street toughs in their flash gear was something else.

example of such movie-theatre vandalism occurred in 1955, when *Blackboard Jungle*, a film about juvenile delinquency, played at a cinema in the teds' South London heartlands, and the teenage audience rioted. The primary trigger was the opening song 'Rock Around the Clock' by Bill Haley and the Comets, which led to frenzied dancing in the aisles, a reaction subsequently recreated across the country.

In predictably sensational terms, the press blamed teddy boys for the worst of the vandalism. A South London social worker of the time perceptively observed that this piously breathless reportage may have actually acted as a catalyst, or even recruiting tool for the teds, as the 'excitement and sense of destruction were fed by publicity. The gangs felt that such behaviour was almost expected of them . . . they began to behave more defiantly, to show off, to be "big heads", to become what they thought the public wanted them to be – cosh boys, teddy boys. It was as if they were being sucked into violence by something bigger than themselves. In other words, press publicity itself sharpened the lines of conflict between society and teddy boys.'

borough and gangs of racist white youths, many of them teds. For almost a week, groups of as many as 400 white youths ran amok, targeting black people and their homes. When the authorities finally re-established control, there had been 140 arrests, predominantly of white troublemakers; four of those convicted being handed weighty four-year prison sentences.

The teddy boys faded into the background in the sixties. Some abandoned their drape jackets in favour of bike leathers, becoming rockers, and while many remained true to the original look, the press had largely lost interest. One business that catered to the hardcore of ted traditionalists was Let It Rock on London's fashionable King's Road, which opened its doors in 1971. It sold fifties clothes, records and magazines, by then generally regarded as retro. Its co-proprietor, Malcolm McLaren, was fascinated by the history of youth rebellion, but his teddy boy clientele often proved something of a handful. Politically conservative, authentic street toughs, they were nothing like the longhaired student radicals of his art college days.

'We became very disillusioned with the

teddy boys because they never changed,' said McLaren's then partner, Vivienne Westwood. 'They were very static, reactionary people. Not what we thought they were.' In 1972 McLaren and Westwood rebranded the business Too Fast To Live Too Young To Die, dealing in rocker gear, before finally entering the style history books two years later when the shop assumed its third identity, as SEX, arguably the world's first punk fashion boutique. The punk image McLaren and his co-conspirators were pioneering borrowed heavily from teddy-boy style, something the teds themselves seldom appreciated.

that the media deliberately sensationalised the situation – even largely concocted some of the early reports – but once things got going they developed a momentum of their own.

The friction, at least in part, derived from punks appropriating and then defacing teddy boy styles. 'Punks bastardised drapes with safety pins and wore paint-splashed brothel creepers to annoy the teds,' recalled Boy George, a seventies punk before he became a gender-bending eighties pop star. 'I was punched in the face and booted several times for wearing brothel creepers.' Many teds were also no doubt intoxicated at having high-profile media

The crowning glory of any true teddy boy was his quiff, formed by combing long hair forward into a crest held in place with grease.

In April 1976, the influential UK music paper *NME* put teddy boys on their cover, suggesting a revival might be on the cards. Rock journalists are not noted for their accuracy as oracles, and magazines are inclined to be a bit overenthusiastic when identifying burgeoning trends, but there was clearly something in the air.

In 1977 the teddy boys would be in the papers again, but now in the sort of negative light they'd been portrayed in twenty years previously. That August, the *West London Observer* printed a story headlined 'A Day of Violence': 'Vicious street fighting broke out for the third weekend running in the King's Road area on Saturday afternoon. The clashes were between rival gangs of teddy boys and punk rockers . . . The main trouble erupted when police moved in to try and arrest some of the crowd of over 100 punks assembled in Sloane Square . . . the whole road was blocked by fighting . . . At about 3:30pm, the mob moved off, but the fighting went on till early evening.' Many compared it to the clashes between mods and rockers that had dominated British headlines over a decade before. It's probable

notoriety for the first time in two decades. 'The younger teds have got more feeling about it than we have because they are out to build the image up again,' opined 'Big John', a ted interviewed by *Melody Maker* in a 1977 feature on the violent rivalry between punks and teds. 'It's due to the younger ones we're hearing more about the teds these days.'

Differences were also ideological. Teddy boys remained essentially conservative, and didn't take kindly to the punks declaring 'Anarchy in the UK' and disrespecting the Royal Family. 'To me they look effeminate,' explained one ted interviewed in a TV item on the clashes. 'They don't look like they'll even be men when they grow up. They look like some sort of third sex. It's weird. Strange. They look like invaders from another planet or something. Very odd . . . They copy bits of our music and try and say it's new. It just sounds like rock'n'roll played very badly to me.'

While the teds won most of the battles – they were typically older and bigger than the archetypal skinny, teenaged punk – in many respects they appeared to lose the war. 'In this

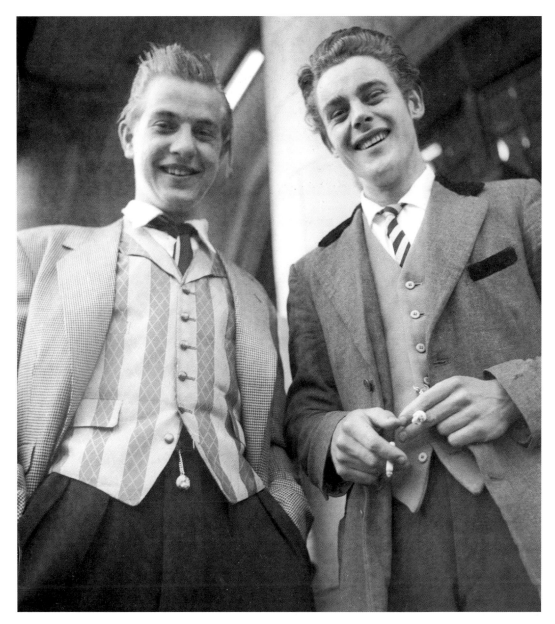

country it's gone right down,' Sunglasses Ron, who had once proclaimed himself to be 'King of the Teds', reflected glumly in 1981. 'Very few of the old clubs are left. What there are, they're getting over-run by these youngsters out there – punkabillies or whatever they are, you know. A lot of people like myself who are still about just don't bother anymore, it's just not worth the effort. You can go there and mix, but when you get up and jive with your wife, and you get a

Above: For many teddy boys the subculture was a celebration of style in the face of fifties austerity, of refusing to bow to their 'elders and betters'.

dozen kids who are pogo dancing around you, you think, what's going on?' Yet such defeatist talk was unduly pessimistic. As we shall see later, the 'punkabillies' Ron describes would bring new blood to the scene, while the fifties rebel style doggedly adhered to by the teds has now been widely recognised as the essence of timeless cool in the 21st century.

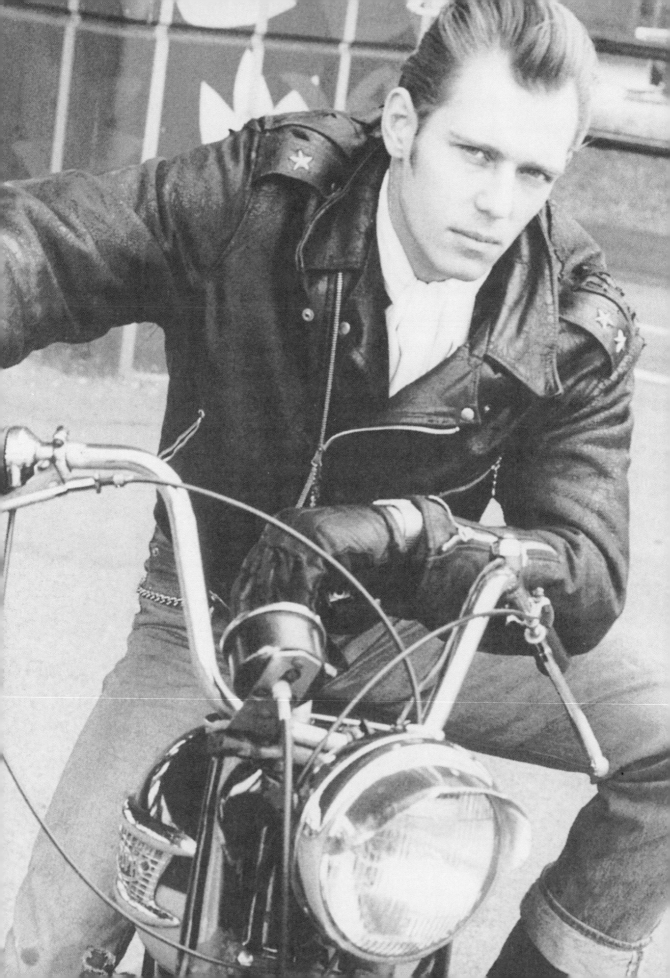

ROCKERS
All Shook Up

Three symbols are indelibly associated with modern youth rebellion – the motorcycle, the black leather jacket and the electric guitar. Depending on how you define it, the origins of the black leather jacket can pretty much take you as far into the past as you like; prototype motorcycles were emerging in the late 19th century, while the history of the electric guitar doesn't really begin until the 1930s. Yet, for our purposes, the story starts in the years following the end of the Second World War in 1945. It was an event that changed everything, not just altering national boundaries and setting the stage for future ideological conflict, but creating the backdrop against which the first modern subcultures tentatively began to strut their stuff.

The first relevant date on the calendar is 1947, when a motorcycle rally held in the quiet Californian town of Hollister over the first weekend in June got out of hand. The subsequent cultural fallout has been echoing ever since. It was the weekend when motorcycling transformed from a healthy outdoor pursuit into something dark and subversive, turning

Opposite and right: Black leather and biker boots have proven a timeless style statement – one with its roots in practicality for the motorcycle enthusiast.

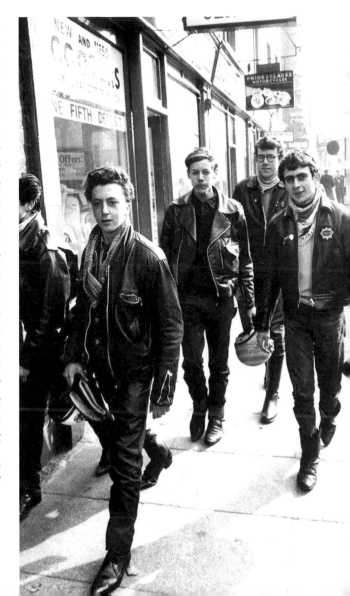

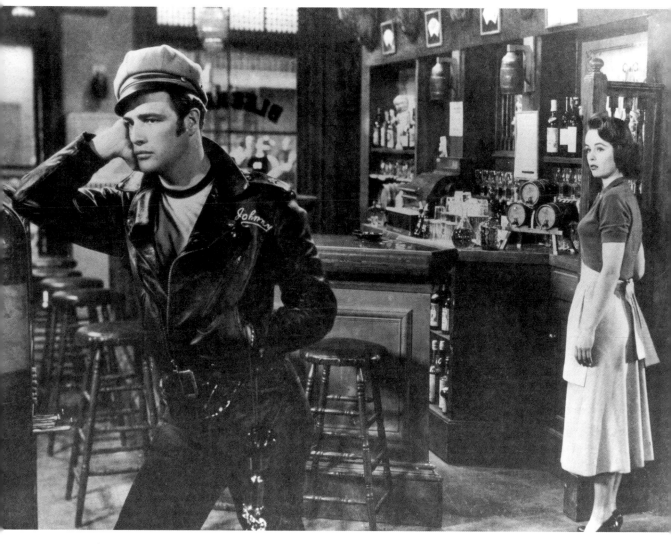

Above: Marlon Brando as Johnny in The Wild One – one of the most iconic performances in the history of Hollywood cool.

an innocent means of transport into an iconic symbol of anarchic rebellion. The process by which this happened is a textbook example of how sensationalist reporting can turn a minor local incident into a mythic event. Of how overreaction by sensationalists in the news media, out to start a paranoid witch-hunt against supposed deviants, inadvertently raises a standard that attracts rebellious youngsters. Stir in the efforts of a few opportunistic authors and filmmakers, and you have the basic recipe for many of the subcultures to be found in the pages of this book.

The 1947 bike meet at Hollister was part of a national series of events co-ordinated by the American Motorcycle Association. It drew a crowd of some 4,000 motorcyclists, many more than anticipated, and the town and its police force of only seven officers were ill equipped when drink and over-exuberance led to riotous disorder among a section of the visitors. The lawbreaking consisted of misdemeanours – thrown bottles, vandalism and drag racing down the main street – and by Sunday, reinforced by forty highway patrolmen, Hollister's lawmen re-established order. There

Hollywood's most obvious shorthand for youthful villainy remained the motorcycle and accompanying black leather jacket.

were some fifty hospital admissions – all bikers injured during misadventures – and around the same number of arrests for drink-related offences, such as indecent exposure, disturbing the peace and traffic violations. The weekend was clearly a deeply unpleasant experience for many of Hollister's citizens, though several local businesses made a killing, reportedly earning some $50,000 in revenue generated by the bikers.

It qualified for a brief report in the local San Francisco press, and that would have been it, were it not for the fact that among the visitors to Hollister that weekend was a press photographer named Barney Peterson. He arrived too late to witness the worst of the unrest and so, by all accounts, improvised a shot, coaxing a clearly intoxicated passing reveller into perching atop a bike brandishing two beer bottles, with further empties scattered artfully around him. *Life* magazine, then America's leading weekly, bought the shot and ran it on 21 July. A legend was born. It was syndicated across the nation, alongside the accompanying caption that implied all 4,000 motorcyclists had practically ransacked Hollister like some medieval army. The USA was clearly ready for a new bogeyman and the nomadic biker, an anarchic force in peaceable, picket-fenced, post-war America, fit the bill.

The American Motorcycle Association was quick to condemn the disorder and disassociate itself from those responsible, insisting that the vast majority of motorcyclists were ordinary, law-abiding citizens, with only one percent

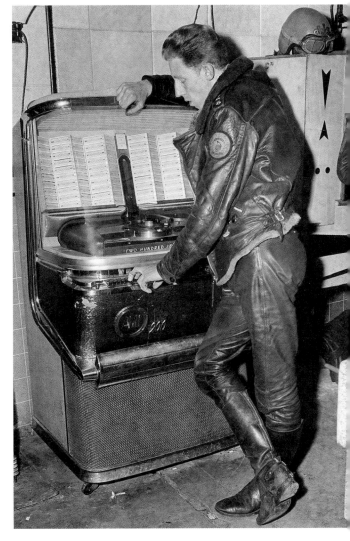

Above: Choosing a disc. American rock'n'roll transformed teenage culture across the globe – not least in the UK.

of bikers representing the maverick minority. Though the AMA has denied ever issuing a statement mentioning any such percentage figure, it became a rallying cry, and those motorcyclists who saw their freewheeling lifestyle as putting them beyond petty rules and regulations began styling themselves '1%ers'. The most famous 1%er club is the Hells Angels, who are often associated with the Hollister incident, though the club wasn't formed until a few years later. Several maverick clubs were present – and in the thick of the

bacchanalia – including the Pissed Off Bastards of Bloomington (several members of which would later help form the original Angels) and the Boozefighters, who describe themselves as a 'drinking club with a motorcycle problem'.

They didn't resemble the modern stereotype of the longhaired, leather-clad biker. The Boozefighters used to wear a distinctive football shirt emblazoned with a green bottle as their club colours. The anonymous subject of Barney Peterson's fateful photo – plump, pie-eyed, his cap askew, his work shirt open to the navel – looks like a regular Joe who's had a few too many. Something else was needed to transform the drunken ruffians of Hollister into the iconic villains of modern popular culture.

The first step towards this came courtesy of a writer named Frank Rooney, who was inspired by the *Life* report to pen a short story entitled 'The Cyclists' Raid'. The bikers in Rooney's fanciful tale act like an army, and wear distinctive green goggles, making them faintly reminiscent of aliens (at a time when invaders from outer space were becoming the vogue in cheap B-movies). When the story was published in *Harper's* magazine in 1951, Hollywood producer Stanley Kramer read Rooney's tale and thought it might make the basis for a powerful movie.

That movie would become *The Wild One* – one of the most important milestones in biker culture – based upon press sensationalism, filtered through outright fantasy. To Kramer's credit, he cast his film carefully and endeavoured to do his research, but such efforts were inevitably compromised by Hollywood convention, lending yet another layer of distortion to the picture. 'These guys were a new breed,' Kramer later recalled of the real

> Dean's status as an icon for tempestuous youth owes much to his dramatic death on Route 466, a tragedy which froze the actor in amber as an eternal teenager.

bikers he spoke to in preparation for the picture, 'and there weren't many of them around . . . They all had girls and were living like nomads. A lot of the dialogue is taken from our actual conversation with them. All the talk about "we gotta go, that's all . . . just gotta move on" was something we heard over and over. And one of the most famous lines in the film came from my conversation with them too. I asked one of the kids, "What are you rebelling against?" and he answered, "What have you got?"'

The actor who delivered that line in the film was Marlon Brando, who plays Johnny, the taciturn, charismatic leader of the fictional Black Rebels Motorcycle Club. When it was released in 1953, reactions to the movie were mixed. Many cinemas refused to screen it (deeming it too subversive even after the studio toned down the plot to reduce any suggestion that the townspeople's bigotry contributed to the violence), which damaged initial box-office takings. Yet Brando's performance was iconic, and several sources suggest that sales of black leather jackets and Triumph motorcycles rose in the wake of *The Wild One*.

One individual influenced by the film was the actor James Dean, who looked up to Brando, buying a Triumph and – inspired by the character of Johnny – even restyling his hair. Dean is the second of three figures instrumental in the development of US youth culture during the fifties. His tragic death in a 1955 car crash, after making only three films (though he also had four uncredited walk-on parts), ensured that the handsome, troubled actor would become a poster boy for the 'live fast, die young' ethos extolled by many teens. In contrast to Brando's cool, brooding outcast,

in his 1955 masterpiece *Rebel Without a Cause* Dean would perfect a sort of every-teen – awkward, conflicted, moody, vulnerable – a romantic figure who adolescents could easily identify with. His role in terms of subculture is debatable, in part due to his wide popularity, and Dean's status as an icon for tempestuous youth owes much to his dramatic death on Route 466, a tragedy which froze the actor in amber as an eternal teenager.

The last of our trio of icons of fifties youth culture – eclipsing even Brando and Dean – is, of course, Elvis Presley. Every aspect of the singer they dubbed 'the King of Rock'n'Roll' has been studied in such minute detail (including scholarship by academics on dedicated courses) as to make saying anything about Elvis almost redundant. Since his death in 1977 he's been both mocked and revered – reinvented as a religious figure, declared a false idol in controversial biographies. According to *American Demographics* magazine, eighty-four percent of Americans feel their lives have been touched by Elvis. In short, to call the singer a subcultural figure, let alone a counterculture icon, makes no sense when he's become an integral part of the American identity at almost every level. By the same token, being a rock'n'roll fan in fifties America didn't make you a rebel so much as a regular teenager. Yet rock'n'roll certainly caused a storm, and however entrenched in the mainstream the music ultimately became, the grease-haired, leather-clad rocker was – and remains – a significant subcultural figure.

Alan Freed lays claim to inventing rock'n'roll as a DJ on an Ohio radio station in 1951. The show was *The Moondog House*, Freed billing himself the King of the Moondoggers, and it pioneered playing black rhythm and blues to a mixed-race audience. In 1952 he hosted the Moondog Coronation Ball at the Cleveland Arena, arguably the first rock'n'roll concert. It was a big success – too big – and the authorities swiftly shut down the gig, as some 20,000

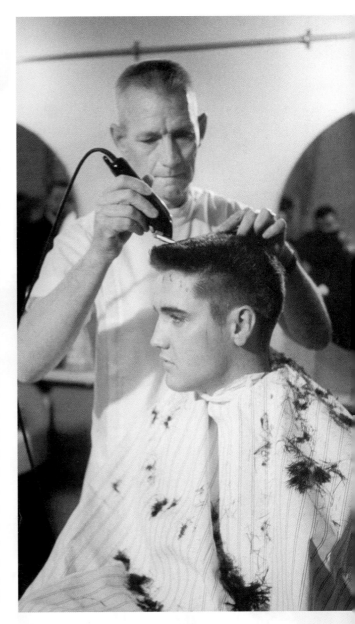

Above: *Elvis has a standard-issue army haircut in 1958, a close shave applauded by many of his conservative critics.*

youngsters arrived at the 10,000-capacity venue. Riots followed, resulting in five arrests and at least one stabbing. Though it appears that it wasn't just the riots that sent a chill up some spines, but the racial profile of the rioters, as the crowd featured a mix of black and white faces. At a time when the civil rights of America's black population were fast rising

up the political agenda, with campaigners beginning to challenge racial segregation, this was potentially incendiary stuff.

White establishment suspicion of black music was nothing new. Politicians, clergymen and the media had been condemning jazz in shockingly racist terms for decades, characterising it as 'jungle music' that might seduce innocent white girls into lives of debauchery. Many believe that the 'War on Drugs' was cynically declared specifically to target jazzmen, who were known for their appetite for exotic intoxicants. 'Rock'n'roll' was originally black slang for sex, and it didn't take too much imagination to decipher the heavy innuendo in many of the lyrics. In 1956 the leading US entertainment trade weekly *Variety* issued 'A Warning to the Music Business', against what it described as music that turned 'dirty postcards into songs', while the same year the UK's venerable

express contempt for the American dream they were too poor to be part of.'

The development of Elvis's career and his various onstage incarnations – from the sinuous, truck-driving Tennessee 'Hillbilly Cat' in 1953, to the bloated figure in a white jumpsuit, entertaining nostalgic middle-aged Las Vegas holidaymakers in the seventies – mirrors the evolution of rock'n'roll itself. The black roots of his music and hysterical effect his performances had on young female fans initially troubled conservative White America. Yet it wasn't long before most parents were reassured that the King of Rock'n'Roll was just a good Christian boy who loved his mama. Elvis finally proved himself to many of his erstwhile critics in 1958 when he was sworn in to do his duty in the US Army, preferring to sign up as Private Presley rather than pull strings to secure a softer posting.

'Rock'n'roll' was originally black slang for sex, and it didn't take too much imagination to decipher the heavy innuendo in many of the lyrics.

Encyclopaedia Britannica defined rock'n'roll as 'insistent savagery . . . deliberately competing with the artistic ideals of the jungle'.

It's often overlooked, but establishment hostility to rock'n'roll wasn't just racist, and singers like Elvis touched on other prejudices among America's elite – towards hillbillies and rednecks, the rural poor from the nation's southern states. 'He was a southerner – in that word's meaning of the combination of rebellion and slow, sweet charm – a version of the character Brando created in *The Wild One*,' recalled the assistant manager at Sun Records, where Presley cut his most legendary recordings. 'Southern high-school girls, the nice ones, called these boys "hoods" [. . .] All outcasts with their contemporary costumes of duck arse haircuts, greasy Levis, motorcycle boots, "t" shirts for day and black leather jackets for evening wear. Even their unfashionably long sideburns [. . .]

Too much, perhaps, has been made of the standard-issue haircut Elvis received when he was inducted into the army back in 1958. While the quiff was certainly an intrinsic part of his image, it wasn't a particularly striking or controversial sartorial statement in fifties America. Presley reportedly copied the style from Tony Curtis, then a popular young matinee idol, but hardly a rebel icon. It was apparently Marlon Brando's sideburns that were often imitated by those who wished to emulate his rebellious outlaw look from *The Wild One*, including James Dean. But while some viewed sideburns as a warning that the wearer might be a delinquent, Hollywood's most obvious shorthand for youthful villainy remained the motorcycle and accompanying black leather jacket. In the wake of the success of *Rebel Without a Cause*, there was a spate of films exploiting the popular fascination with

juvenile delinquency, a hot topic frequently sensationalised by the fifties media. Several followed the lead of *The Wild One* by outfitting the bad guys in leather jackets and perching them on motorbikes. Other noisy teen activities, such as hot-rod racing, might be regarded with suspicion, but not compared to the almost demonic connotations of joining a bike gang. The 1958 movie *Dragstrip Riot*, for example, pits bikers against hot-rod enthusiasts, with the guys on two wheels very much in the role of villains.

Across the Atlantic, British censors banned *The Wild One* upon release in 1953, only passing it with an 'X' adults-only certificate fourteen years later. As we've already witnessed in the previous chapter, the 1955 release of the juvenile delinquent picture *Blackboard Jungle* unleashed rock'n'roll on the nation's eager teenage population, much to the dismay of most of their elders. While in the US rock'n'roll was too ubiquitous to become the basis of a subculture, in the UK its enthusiastic adoption by the already infamous teds gave it more of an edge. The teddy boys' espousal of flamboyant, neo-Edwardian English garb made them stand out, but the Americanism of quiffs also contributed to the disreputable image of teds in the eyes of many conservatives. While the USA had been the UK's ally in the Second World War – saving the British Empire from imminent annihilation – the Empire had fallen, patriotic pride was badly bruised, and some ungrateful Brits hissed that America had entered the war late, leaving battered Britannia struggling to pick up the pieces.

Such sour sentiments often manifested themselves in the conservative voices who huffed that the USA was vulgar, the source of crude exports like gangster movies and rock'n'roll. More forward-looking Brits developed home-grown variants of both cultural imports. Some UK studios produced credible film noir in the forties and fifties, but British rock'n'roll was initially a feeble echo of its American inspiration, with domestic teen idols like Tommy Steele and Cliff Richard swiftly morphing into cuddly family entertainers. However, in 1959 an American rock'n'roll singer would cross the Atlantic, fleeing trouble from his last tour. While, despite his latter-day decline, nobody has credibly challenged Elvis's throne, Gene Vincent was among the first to qualify as rock'n'roll's Prince of Darkness, an increasingly coveted role due to the genre's developing rebel pedigree. Surprisingly, perhaps, Vincent's claim to the crown came courtesy of a BBC TV producer named Jack Good.

Good had managed acts such as Steele and Richard, as well as more credible British talents like Billy Fury. ('Onstage he came over as real evil,' recalls Johnny Stuart in his book *Rockers!*. 'But when not performing he had this little-boy-lost charm.') It was Gene Vincent, however, who became the embodiment of the kind of rebel rock that fuelled rocker fantasies. In 1959, Good convinced Vincent to dress in black leather – then an innovation – and quit concealing the crippling limp he'd received from a serious motorbike accident. 'From looking like a southern, small-town, pool-hall punk, Gene Vincent had been converted into a limping, near-supernatural menace,' writes Mick Farren in *The Black Leather Jacket*. 'His songs became exercises in frenetic agony. Jack Good didn't manage to insert Gene into the mainstream of pop – Gene Vincent was always too weird for any kind of mainstream – but he did elevate him to major cult status in Britain, France and Germany. Huge, baying crowds of teenage boys treated him as an ideal, bad-ass role model, an ultimate leader of the pack.'

While British censors had banned *The Wild One*, there were still UK movies that referenced the burgeoning British biker culture. Most interesting for students of rocker history is *The Leather Boys* (1964), set in London's motorcycle

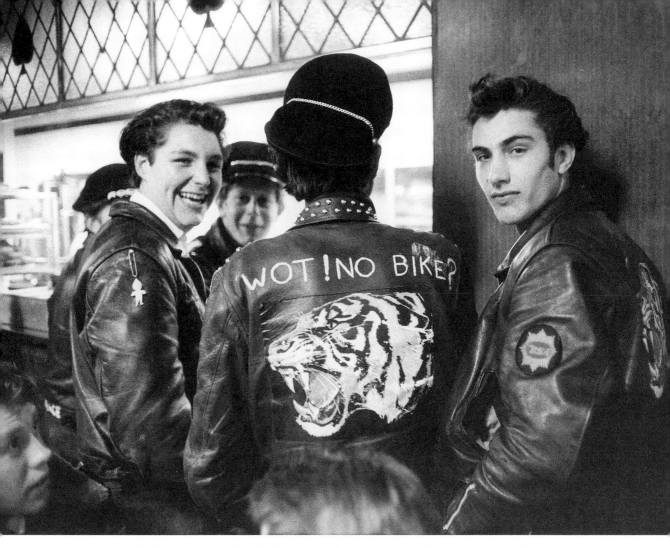

scene. While the ham-fisted homosexual subtext played more to liberal critics than teen audiences, it features authentic rockers and their machines as extras, and employed the Ace Cafe as a location, a humble roadside diner that became a legend in British biker lore.

While American teens could build hot rods or go surfing, for many of their British contemporaries, life seemed dreary. Yet improving employment opportunities and the increasingly easy availability of hire purchase agreements left a growing number with enough money in their pockets to invest in a motorbike. Bikes offered freedom, an opportunity to blow away the cobwebs of a grim working week hurtling at death-defying speeds along the nation's growing road networks. Devotees soon began to congregate at roadside cafes that had previously catered largely to truckers,

Above: Leather jackets became canvases for self-expression – frequently menacing, though equally often whimsical.

to discuss bikes, and issue challenges to race fellow enthusiasts, escaping from the stultifying world of work and family life. Amid the greasy plates of egg and chips and cups of watery coffee, a subculture was born to the tune of the rock'n'roll songs played on jukeboxes installed by cafe owners, grateful for the new trade. However, these young sixties daredevils didn't regard themselves as rockers – they were cafe-racers or ton-up boys (a reference to the ambition to hit 100mph).

Leather gear was a necessity for practical reasons – for protection as well as warmth in the UK's inclement climate – but these embryonic bikers disdained the long leather coats and PVC suits purveyed by most motorcycle dealers. Speed was the priority, and the iconic

sleek black leather jacket became the uniform of the sixties rocker, a garment that was at once wholly practical and a design classic. However, the utilitarian article of clothing soon became a vehicle for display. While few if any British bikers had been given the opportunity to watch *The Wild One*, most had pored over stills from the film in magazines, its forbidden nature adding to the film's totemic appeal. A few rockers would try and improvise versions of Brando's cap from the film, though this was hardly practical if you wanted to wear a helmet, which most did, immersed as they were in a lifestyle in which high-speed spills were an occupational hazard. Like Johnny, they wore jeans rolled up to reveal sturdy bike boots –

biker style. Nazi uniforms had pioneered black leather chic, complete with skulls, and the symbolism was an obvious way of alienating your elders.

The most popular motifs, however, were references to the real passion of any true cafe-racer: the motorcycles they customised and rode – Triumph, BSA, Norton – British companies that had also manufactured the hardware that helped the Allies win the war. These early rockers may have been rebels, but most were patriots, and certainly not fascists. In interviews, several espoused tentative left-wing views, and while there's little evidence of any black rockers, at least one interviewee of the time condemns racial prejudice. Even

The iconic sleek black leather jacket became the uniform of the sixties rocker, a garment that was at once wholly practical and a design classic.

practical attire that also happened to look cool. Most customised their jackets with badges, patches or painted insignia, inspired by photos of *The Wild One*'s iconic anti-hero.

The skull and crossbones emblem on the back of Brando's jacket – the piratical insignia modified for the machine age by substituting bones for bike pistons – was particularly inspirational. Death symbolism was appropriate for a subculture for whom tempting fate on two wheels was a core ritual, whether racing motorists from a traffic light, or taking challenges to complete a prescribed circuit before a record finished on the jukebox. Alongside skulls, Iron Crosses, swastikas and Teutonic eagle motifs began to appear. Initially, perhaps, as trophies from the Second World War, but increasingly designed to shock – if bikers were being portrayed as villains in the media, then why not adopt the pose? Just as teddy boys had echoed the styles of the bad guys in Westerns, so the look of the Nazi villains in war flicks slowly began to figure in embryonic

more surprising – at least from a contemporary perspective – was the '59' patch worn among the forest of studs on many leather jackets. The 59 club was an initiative started in London's deprived East End by a clergyman named Bill Shergold, who decided to reach out to one of the nation's most ostracised communities. Much to his surprise, the bikers responded, unused to being treated with respect by any representative of the establishment. Dances at the 59 club in Paddington became big events on the rocker calendar, and by 1964 Reverend Shergold's leather-clad flock boasted some 7,000 members.

By then, the rockers needed all the friends they could get. Previously, most ordinary Brits had no personal experience of the ton-up boys – most likely only seeing them briefly in their wing mirrors before being overtaken by a black-clad figure hunched over a powerful bike. Rockers weren't welcome in most pubs, and the only other regulars at the out-of-town cafes they frequented tended to be long-distance lorry

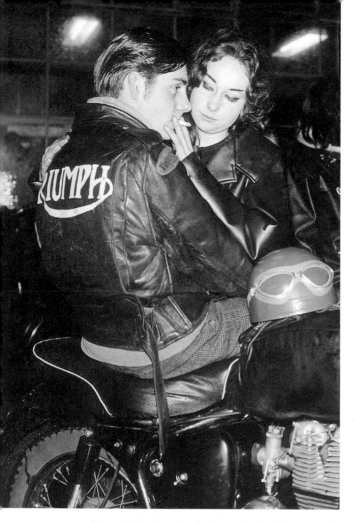

Above: While the rocker subculture celebrated traditional masculine values, some women still found the promise of danger and thrills irresistible.

drivers. However, on the Easter weekend of 1964, rockers hit the headlines for all the wrong reasons. It was also the point at which the term 'rocker' entered common parlance – ironically coined by their new rivals, the mods, the sharp-suited soul fans whose confrontations with the ton-up boys on England's south coast became front-page news. What really happened in places like Clacton and Brighton in May of 1964 has been much contested, though Brits reading about it in the morning papers over tea and toast might've been forgiven for thinking that the nation's favourite holiday resorts had come under attack from two warring barbarian tribes, one side astride powerful British motorbikes, the other perched upon chic Italian scooters.

We'll go into more detail when we come to look at the mods, but for now suffice it to

say there were echoes of the Hollister story, of sensationalist reporting deliberately turning a drama into a crisis. Just as some have suggested that the Barney Peterson photograph wasn't exactly candid, so witnesses claimed to have seen press photographers bribing mods and rockers to pretend to riot in order to create the kind of shots their editors wanted.

Whether to a lesser or greater extent, an ongoing feud between mods and rockers certainly existed, and different causes for this have been identified. According to original rocker Peter Walsh, aka Buttons, 'Our gang was ordinary grease, or what most people called rockers. I wasn't involved enough to be aware of the difference between our group and others, but I soon learned. The mods were on one side. We, the rockers, were on the other, and no one else seemed to matter. The mods were our automatic enemies and we were theirs. Why it came about, I don't know. It was the accepted system – our code of ethics, and we lived and breathed for it only.'

The rockers were traditionalists – a trait often associated with the working classes – who wanted to stick with the formula of rebellious pop culture that worked for them. Mods, by way of contrast, shared the more middle-class passion for change and innovation. There were also conflicting ideas about masculinity that suggest different social classes. To the rockers, being a man was about power and speed – the traditional masculine virtues associated with acts of bravado. The only speed mods were interested in came in pill form – in their world a man asserted his dominance by leading the pack in the fashion stakes and setting style trends, which was anathema to the defiantly unfashionable rocker. However, as the sixties advanced, time was catching up with both subcultures.

The Beatles were fast eclipsing Elvis as the world's leading music sensation. They'd originally worn rocker leathers, but by 1963 had

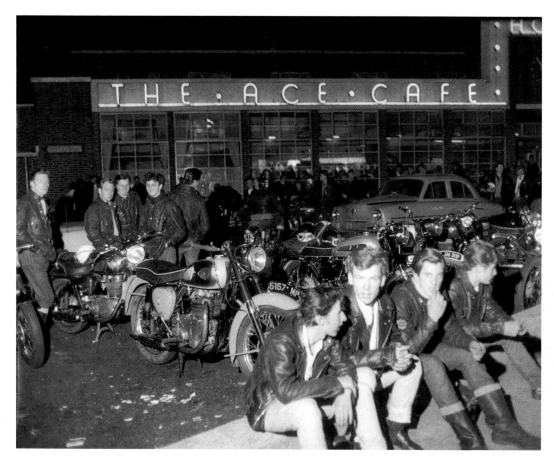

Above: The Ace Café, a legendary rocker hangout in North West London.

adopted more mod-style suits at their manager's suggestion, a clean-cut look that saw the 'Fab Four' begin their ascent to world domination. However, three years later, the quartet began to take a more experimental direction, influenced by the new hippie movement emerging from the US. The inexorable hippie vibe drifting across the Atlantic would impact upon mods and rockers in very different fashions. Some mods, aware that their Italian suits and preppie-style casual wear were swiftly becoming yesterday's news, decided to move with the times and experiment with paisley and psychedelic colour schemes. The rockers, however, became aware of a new evolution in American outlaw motorcycle culture that made *The Wild One* look desperately tame.

'It is the Beatles that can take partial credit for the coming about of the Hells Angels Motorcycle Club, London,' notes the club's website in typically oblique fashion. Both Buttons and Maz Harris would become prominent early British Hells Angels, seduced by sensationalist news reports and lurid films that began to filter through from the US, depicting the club as a violent gang of ultimate outsiders. From the mid-sixties, rockers had begun borrowing elements of the American Hells Angel look, and by 1969 an official chapter was set up in London, which promptly and methodically began stamping out unofficial imitators. The relationship between the peaceable hippies and warlike Hells Angels is a complex and paradoxical one, but suffice it to say, by 1969 a chapter in the history of the biker subculture had ended, and a new one was revving up to begin.

M●DS
My Generation

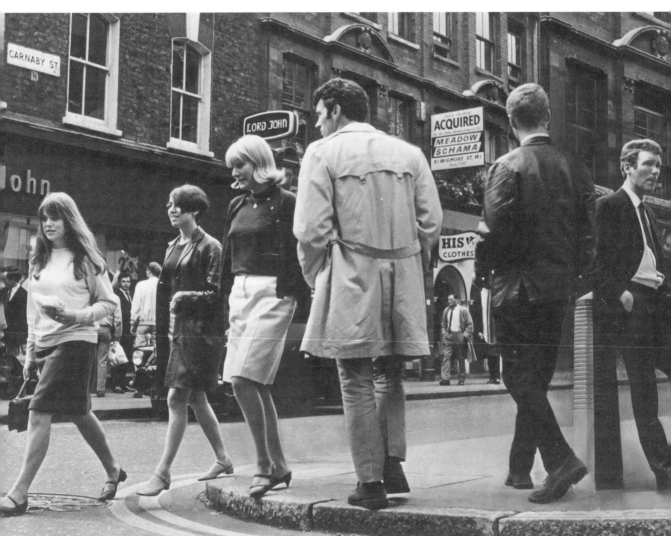

Mod wasn't about fighting 'the system', but demanding the space to celebrate your individuality from within it.

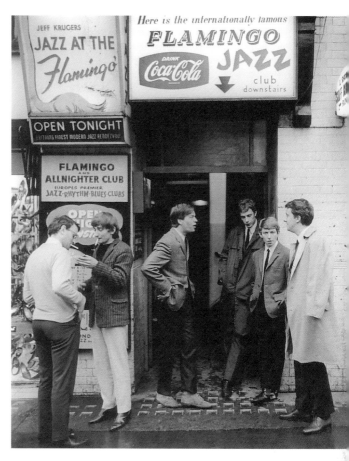

Above: *The Flamingo Jazz Club, a musical Mecca for many early modernists.*

Astride an Italian scooter flamboyantly customised with a halo of headlights and mirrors, swathed in an olive-green parka bedecked in badges and patches celebrating their favourite bands, the mod cuts a distinctive figure. Surely every Brit over a certain age – indeed most streetwise folk across the globe – can identify a mod. They established themselves in street fights on the seafronts of England's south-coast holiday resorts in the sixties, episodes faithfully recreated in the cult movie *Quadrophenia*, adapted from the 1973 album by the Who, the quintessential mod band. A true British original, the mods went into battle emblazoned with the red, white and blue roundel emblem of the RAF, duelling with rockers adorned with Luftwaffe Iron Crosses, as if recreating the Battle of Britain on the English seafront twenty years after the event.

Stirring stuff, which made for good newspaper copy, yet something that has little to do with mod's true spirit in the eyes of many of the movement's founding fathers. Mod's authentic Mecca was to be found far from the smell of sea air and vinegary fish and chips that wafted through England's hackneyed holiday resorts, in the happening smoky Soho clubs and trendy coffee bars at the heart of London's fashionable West End. It is universally agreed that 'mod' is derived from 'modernist', though ironically – at least among diehard purists – few styles are as defiantly retro as today's mod traditionalists, flying the flag for sharp sixties style. Most accounts suggest that the modernist

Opposite: Carnaby Street, London's epicentre of style in the Swinging Sixties.

tag originally referred to devotees of modern jazz, though at best this is only part of the story. To start at the beginning, mod's pre-history takes us back to the terminal months of the forties.

The black American trumpet virtuoso Miles Davis began recording a series of groundbreaking singles in 1949 that were compiled into an album entitled *Birth of the Cool*, released eight years later. Davis was helping pave the way for a new direction in jazz, as pioneered by US musicians like fellow trumpeter Chet Baker and pianist Dave Brubeck. 'Hot' – flamboyant and passionate – had always been the hip term for happening jazz. Yet this new sound took a more experimental direction – introspective and laidback – dubbed 'cool' or 'modern jazz'. Just as important as the new

Mod's authentic Mecca was to be found in the happening smoky Soho clubs and trendy coffee bars at the heart of London's fashionable West End.

sound was a fresh image, which dispensed with the loud, voluminous suits and showy attitudes of bebop in favour of a smoother, more understated and enigmatic vibe.

Many cool jazz icons adopted the sharp Ivy League look, borrowed from the most stylish students at America's elite universities. It suggested casual sophistication and wealth, an ability to transcend racial and social boundaries and strut your stuff among society's cutting-edge in defiance of tradition and prejudice. The Ivy League look is what we might now call 'smart casual' or perhaps 'preppie', combining formal with leisure or even sportswear – say trim suit jackets with smart sweaters and brogues or

even tennis shoes. The style was perhaps best exemplified by Brooks Brothers, the oldest American men's fashion chain, who blended traditional British tailoring with a distinctive dash of US colour (they legendarily refused to sell black suits after Abraham Lincoln was assassinated wearing a bespoke black Brooks frockcoat in 1865).

Back in the UK, many prototypical mods studied the album covers of these new cool jazz LPs – difficult to find in fifties England – just as carefully as they listened to the smooth

Below: From left to right, Steve Marriott, Roger Daltrey, Rod Stewart and Ronnie Lane adopted the mod lifestyle and look.

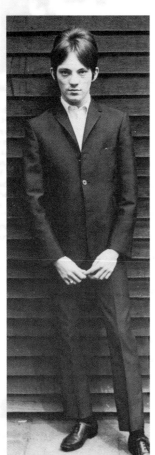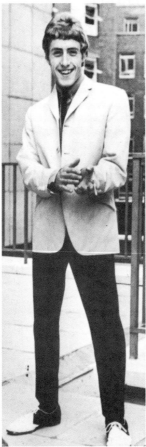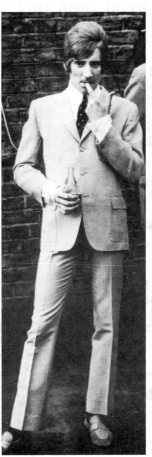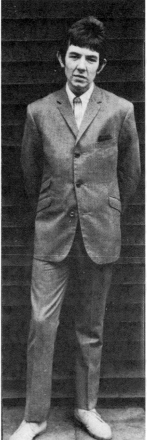

new sounds contained in their grooves. Jazz had enjoyed a disreputable mystique on both sides of the Atlantic for some time – associated with drugs and the taboo temptations of black culture – but its image had become rather dowdy and middle class in the UK by the end of the decade, a world of weekend beatniks and scruffy students bouncing around bare-footed to bebop in straw-boaters, baggy jumpers and beards. The new wave of cool jazz musicians was something different, sounding a clarion call to many restless London youngsters who craved a slice of the sharp style of these unflappable black musicians in their sleek suits.

Modern jazz wasn't the only component of the embryonic mod style, however. Indeed 'modernist' is probably better viewed in its broader context here, for the movement was very much about new looks and new sounds – anything conspicuously modern that represented a break from the drab demands of British traditionalism. At a time when tying your tie with a different knot and wearing brown shoes was sufficient for you to be branded as a suspicious character in many circles, fast fashion from across the Atlantic was intoxicating stuff. Embryonic mods weren't just studying cool jazz album covers for stylistic inspiration, but paying careful attention to the styles adopted by the hippest Hollywood stars like Cary Grant and Montgomery Clift. The legendary Rat Pack developed a spin on the Ivy League look that combined a little Vegas pizzazz (courtesy of Sammy Davis, Jr) with an edge of underworld menace (thanks to Frank Sinatra) and louche lounge-lizard nonchalance (embodied by Dean Martin).

At least as influential were films like the 1953 romantic comedy *Roman Holiday*, in which Gregory Peck took Audrey Hepburn on a Vespa ride through Rome's chic streets. *La Dolce Vita* – 'The Good Life' – wasn't just the name of an acclaimed 1960 film by the celebrated Italian auteur Federico Fellini, but also a stylistic landmark, establishing its Roman setting as Europe's new capital of cool. French cinema was also enjoying a renaissance, and highbrow critics in London lauded *La Nouvelle Vague*, the revolutionary new films from Paris directed by the likes of François Truffaut and Jean-Luc Godard. Chin-stroking intellectuals and dedicated cineastes weren't the only ones taking notes in London's smoky art cinemas. There were also a sprinkling of teenagers in the audience who were bewildered by the plots, but bewitched by the continental style suffusing the screen. 'We did go to all those foreign movies and didn't understand a word,' recalls original modernist and mod fashion guru Johnny Moke in *The Look*. 'We watched the way they smoked a cigarette, how they buttoned their shirts and jackets, which shoes they wore.'

The advent of Italian style had received a frosty reception among British traditionalists. In 1956, when the singer Frankie Laine took to the stage of the London Palladium in the latest Italian look, both his fans and the press were seriously unimpressed. The same year the fashion entrepreneur Cecil Gee came back from Rome with some new designs. Gee had previously pioneered the Ivy League look on London's streets, but this new Latino direction raised numerous eyebrows. John Simons was a modern jazz fan working for Gee at the time, and in 1965 opened the Ivy Shop, a leading mod fashion emporium in Richmond. 'They brought back these cotton suits,' he told Paul Gorman in *The Look*. 'We'd never seen anything like them. They had a natural shoulder and three buttons on the jacket with little vents. That was the beginning of the whole Italian thing here.' So, who were the teenagers buying the Ivy League and Italian suits from Cecil Gee?

Original members estimate that there were dozens, or at most a couple of hundred young modernists that formed the core of the burgeoning mod movement. It's been suggested that they were mainly the sons of East End

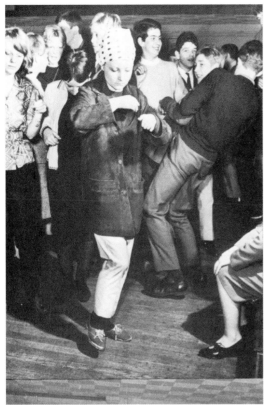

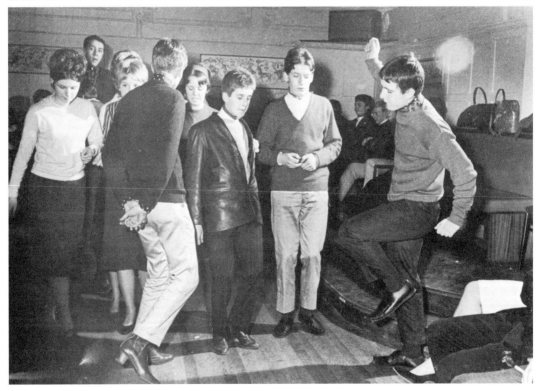

Jewish families. Maybe, but it's surely irrelevant – for they were certainly English youngsters desperate to sever links with a stifling past, to establish their own unique identities defined by difference from their parents and peers. Chic styles from south of the Cliffs of Dover remained suspiciously unmanly and 'foreign' among all British traditionalists, while the impact of American culture was resolutely rejected as uniformly vulgar. Rebellion could mean refusing to wear a suit like the beats or rockers. But it could also mean cutting your suit to your own style. Mod wasn't about fighting 'the system', but demanding the space to celebrate your individuality from within it, to be flasher than anyone born with the proverbial silver spoon in their collective mouths, even if you were a humble teenage office junior.

Class plays a part in all British style rebellion, just as race plays a pivotal role in American culture. Almost all commentators agree that the mod movement could not have emerged without the peculiar economic situation of the UK in the sixties. Looking flash took cash, and while few of the early mods were flush, finding the funds to update your wardrobe on a regular basis was a prerequisite, and most had junior white-collar jobs. For the first time, teenagers had disposable income, and the mods chose to spend it on suave style statements that celebrated their independence and individuality. Of course, by no means all teenage pay packets would stretch to suits from Cecil Gee, let alone Savile Row. (Indeed, many prestige tailors wouldn't take clients without personal recommendations, let

The first Soho mod strongholds were the Scene in Ham Yard and La Discotheque in lower Wardour Street; claustrophobic, sweaty clubs where the young modernists congregated to dance and check out what the leading faces were wearing this week.

alone consider the flash styles the modernists craved.) Improvisation was required, and many early mods took to the streets in suits fashioned or altered by relatives or handmade by obliging backstreet tailors. Such sources had the advantage of both affordability and a willingness to humour the stylistic foibles of these particular young modernists, who had very definite ideas on every detail of the fashion statements they planned to make, from the width of lapels to the precise placing of the pockets.

They also discovered established London tailors who could cater to the unusual demands of these teenaged dandies. Vince's was an offbeat West End gentleman's outfitters that opened in 1954, catering to a bohemian clientele, particularly the district's theatrical community, at a time when 'theatrical' was a euphemism for 'gay'. (The running local joke was that if you went to Vince's for a tie, they'd still measure your inside-leg.) For the embryonic mod scene, Vince's was a valuable source for colourfully unconventional formal wear that contrasted with the dark greys and drab blacks of the high street. (Malcolm McLaren, whose boutique SEX helped launch punk, would later credit the shop as inspirational.) More significant in the evolution of early mod style was a menswear entrepreneur who served a brief apprenticeship at Vince's, before striking out to become one of the leading figures in Swinging Sixties London fashion.

John Stephen was an ambitious, handsome young Glaswegian who set out to establish a fashion empire in London. By 1961, he was managing five shops, significantly four of which were on Carnaby Street in the West End (just around the corner from Vince's). Carnaby

Opposite: Dancing all night was the highlight of the mod weekend – though modettes sometimes felt that the boys spent too much time trying to outshine each other.

Street had long been an unassuming London backstreet. By his own account, John Stephen briefly turned it into the world axis of fashion. It's difficult to refute such grandiose claims, as in his wake Carnaby Street became synonymous with the Swinging Sixties, spiritual home of not just the mod look but the international rise of London as the home of happening fashion. Stephen understood the burgeoning teen market who now had cash burning holes in their pockets, and catered to them in shops blaring out the latest hits. He sold clothes that may have lacked the craftsmanship of nearby Savile Row, but were a fraction of the price and in an ever-changing cavalcade of styles that evolved not just by the season, or even the month, but sometimes overnight.

Beyond being smart and sharp, it's difficult to pin down the blueprint mod look. Short hair in a French crop or Ivy League style, desert boots or perhaps winkle-picker shoes, mohair or tonic suits, maybe even bleached Levi jeans – the essence of early mod style was to combine European continental and modernist American styles in fresh and eye-catching outfits.

Of course, once they'd assembled their killer couture the early mods needed somewhere to see and be seen. Soho was the inevitable choice as the heart of London's film and music industries. It was also home to the capital's vice trade, and a magnet to both immigrants and youngsters who came to London looking for the bright lights, an authentic *demimonde* where career criminals rubbed shoulders with suburban thrill-seekers and unwary tourists; hustlers mixed with slumming socialites and foreign hipsters. Soho's Italian coffee bars and the hangouts frequented by French students were popular, but the heart of early mod culture was the nightclub scene. The first Soho

Chin-stroking intellectuals and dedicated cineastes weren't the only ones taking notes in London's smoky art cinemas.

mod strongholds were the Scene in Ham Yard and La Discotheque in lower Wardour Street; claustrophobic, sweaty clubs where the young modernists congregated to dance and check out what the leading faces were wearing this week, as 'face' quickly became mod lingo for the subculture's trendsetters.

While not exclusively a mod club, the legendary Flamingo Jazz Club on Wardour Street was perhaps Soho's ultimate modernist Mecca. More expensive and exclusive than the edgier Scene and Discotheque, as its name suggests, the Flamingo began as a jazz venue. Initially, white mods frequented the club during the day to listen to cool jazz, making way for a nocturnal clientele of West Indian immigrants and black US GIs, who attended the Flamingo's legendary rhythm and blues all-nighters, featuring the likes of keyboard wizard Georgie Fame. (At this point it's worth distinguishing between original rhythm and blues and contemporary R&B – rhythm and blues was energetic, electrified blues music, basically raw early rock, a million miles from the over-produced schmaltzy ballads that dominate modern charts.) Inevitably, curious mods began to brave the Flamingo's daunting after-dark sessions. American rhythm and blues and Motown and Jamaican Blue Beat began to replace modern jazz as the music of choice on mod dancefloors.

Of course, dancing all night could prove something of a challenge to even the keenest clubber, and the Soho environment offered easy access to black-market pills to pep up the sleepy night owl. Amphetamines were heavily prescribed by the British doctors of the day (2.5 percent of NHS prescriptions were for speed in 1961), while the heavy underworld presence in most West End clubs ensured a plentiful illicit supply. Mods weren't drinkers – many weren't

The advent
of Italian style
had received a
frosty reception
among British
traditionalists.

mods

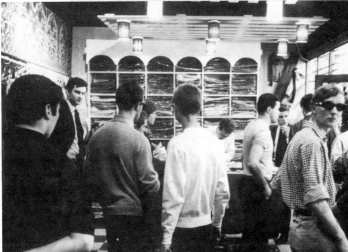

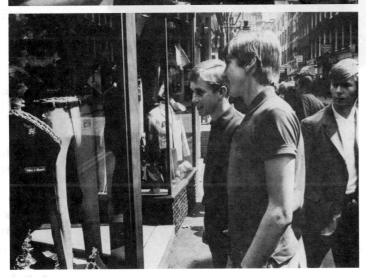

Above and left: Shopping for clothes played a large part in the mod lifestyle – the tireless quest for cutting-edge cool.

Mods notoriously took pills by the fistful, under various nicknames – Purple Hearts, Dexies, Black Bombers, French Blues.

old enough and mod clubs often didn't have alcohol licenses – and orange squash or Coca-Cola was the tipple of choice for many. But mods notoriously took pills by the fistful, under various nicknames – Purple Hearts, Dexies, Black Bombers, French Blues.

'For the mods, amphetamines were symbolically enshrined at the heart of their subculture,' claims Harry Shapiro in his book *Waiting for the Man*, 'fitting into a discrete universe, a system of magical correspondences in which all objects – clothes, music, scooters and drugs – had a precise relationship with one another.'

Italian scooter brands like Vespa and Lambretta were affordable, but fit with the chic, sharp continental image mods aspired to. Some mods soon began applying the same idiosyncratic, competitive approach to customising their clothing to their scooters. Mechanics such as Eddy Grimstead – who ran two shops in London's East End and was a key figure in the early scooter scene – were happy to help, as youngsters ordered scooters modified with everything from flashy new paint jobs and chrome, to extra headlights, mirrors and even foxtails.

The increasing popularity of scooters led to another iconic development in mod fashion. Riding around the streets in a fashionable 'bum-freezer' jacket in the Mediterranean heat of Rome was one thing, but the less temperate climate of London was quite another, particularly when rain had a tendency to ruin your favourite suit. The solution to this practical problem came from across the Atlantic, from the improbable source of US army surplus supplies. A 1965 advert in the music paper *NME* described the garment in question as 'THE UGLY PARKA'. 'That's what the Yanks call it and IT'S THE RAGE OF AMERICA,' explained the ad. Similar ads in *NME* were soon

targeting the parka exclusively at mods, though for some modernists it always remained ugly, rejected as fit only for 'states', where confused priorities valued scooters over sartorial chic.

In the early days mod was almost a secret society – a Soho subset that fell under the media radar, its stylistic rebellion too subtle to do much more than raise the odd eyebrow among anyone but insiders. The subculture's rising profile was regarded with deep ambivalence by elitist modernists, and as the cult slowly spread, many of the originals jumped ship, concerned that the exclusivity of the movement was disappearing, its impeccable standards dropping.

Perhaps most significant in the rising profile of mod was the UK TV programme *Ready Steady Go!*, launched in 1963 to capitalise on the growing youth market. Some mods looked down their noses at the show's amateurish production values and feeble filler, but they couldn't fault the musical line-up, which featured a pioneering roster of soul, and rhythm and blues acts from the UK and US. The production crew scouted dancers for the audience from Soho mod clubs, and the press dubbed the show's popular female presenter Cathy McGowan 'Queen of the Mods'. She pioneered the female mod look – miniskirts or trousers, 'granny shoes', Cleopatra bobs, pale lipstick and false eyelashes – and the increasing female presence on the scene surely contributed to the cult's building popularity, as it edged beyond the hermetic world of Soho to spread across London, and out into the English provinces.

The 'modette' was largely a later development. While the faces certainly had their female admirers, speed is no aphrodisiac, and competing for female attention would be a distraction from the essential activity of trying to outdo male rivals with peacock displays of understated style. 'The guys were so preoccupied

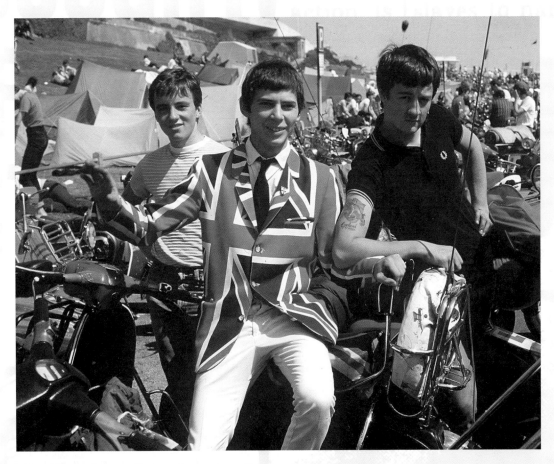

Above: The patriotic pop art iconography pioneered by the Who was adopted by many mods.

with their style,' recalled early modette Sara Brown in Richard Barnes's book *Mods!*. 'It got to be a big deal to have a conversation with a guy and we thought we were very lucky if one of these gorgeous creatures actually *danced* with us!'

While the infamous rivalry between mods and rockers has achieved the status of modern myth, some accounts suggest that the battle lines weren't necessarily so clearly defined. 'Mods were fighting each other,' recalled scene stalwart David Cooke. 'The North London mods hated South London mods. South London mods hated North London mods, and East London mods hated everybody, and everybody hated them.' The same story was reflected across the country, as the mods in different cities became territorial, driving off unwelcome intruders from their clubs. As a rule, conflicts between mods and rockers were unlikely, as they seldom

went to the same places – no mod would be seen dead in a scruffy motorway cafe anymore than a rocker had any interest in visiting a backstreet jazz club. David Cooke was talking on a 2004 BBC radio documentary, released to coincide with the fortieth anniversary of the beachfront riots that made the mods front-page news.

According to Cooke and the other interviewees, much of what people believe about the famous mods-versus-rockers fights of the mid-sixties is pure myth. It's certainly true that the clashes between parka-clad mods and leather-clad rockers have become part of British social history, iconic moments in the history of subculture. What actually happened behind the headlines, however, has become the subject of much debate. In his groundbreaking 1972 work

Folk Devils and Moral Panics, the criminologist and sociologist Stanley Cohen used reporting of the supposed riots to illustrate how the media sensationalise perceived rebellion to reinforce conformity. Subsequent research has reinforced the suspicion that the authorities and the press conspired to turn the disturbances on England's south coast in the sixties from a localised drama into a national crisis, with the nation's youth cast as the villains of the piece. Many witnesses agree that press photographers bribed youngsters to pretend to riot and brawl to get the exciting shots of delinquents in action that their editors demanded.

So what did happen at those legendary holiday clashes on the English south coast, starting at Clacton on the Easter weekend of 1964? As David Cooke has already suggested, much of the original friction was between rival mod gangs, rather than with rockers. 'The streets were not strewn with broken deckchairs,' says Cooke. 'The police herded you up and you ended up walking around Brighton in the great phalanxes of people looking a bit pissed off. The seaside towns were the domain of the rocker, their patch,' he added. 'So a lot of us turning up on scooters, it was asking for trouble. But mods didn't ever get on their scooters and go down to the coast for a fight. Real mods were far too concerned about their clothing. I mean, we're talking about possibly losing buttons – you know, creasing or tearing clothing you'd saved for!'

But there certainly was trouble, and however it started, there were brawls between mods and rockers. 'The Battle of Hastings, about 1965, was quite a big one,' recalled Phil Bradley, a veteran rocker of the era. 'Some scooters and bikes went off the top of the cliff. Margate in 1964 was the worst – the cells filled up. There were only seven coppers in Margate at the time, and one Black Maria [police van] – but there were about 4,000 mods and 500 rockers!'

The press of the day hailed the police as heroes facing a barbarian horde of adolescent fifth columnists, intent on destroying the nation's moral fibre. Subsequent research has suggested that the policing was heavy-handed. Small local forces were initially overwhelmed by the sheer number of youngsters, but once reinforced, resorted to a policy of casual brutality and random arrests. (A suspicion of overreaction was underlined by the highly publicised despatch of London riot police by RAF transport plane.) Sentences for those unfortunate enough to get carted off in a Black Maria were harsh, with bemused mods being lectured by magistrates for being 'long-haired beatniks'. Many youngsters revelled in their newfound infamy, media attention drawing in a legion of eager new recruits to the bank holiday standoffs. 'False mods,' sniffed modernist Chris Covill of those swelling the ranks. 'Just nowhere-kids who weren't dedicated. They wanted to be cool but there was violence in them and they couldn't change.'

In the short term the mods won the battles, both on the beachfronts courtesy of overwhelming numbers, and in the press, as the media found the neatly dressed, aspirational modernists far easier to forgive than their leather-clad counterparts. Even after the events of the previous months, in September 1964, the conservative newspaper the *Daily Mail* printed a sympathetic feature entitled 'It's a Mod, Mod, Mod, Mod World' about the latest designs from John Stephen and the views of his customers. Meanwhile, *Ready Steady Go!* continued to broadcast an image of mods as fun-loving teens, while Carnaby Street had become a tourist attraction. By way of contrast, the 1954 film *The Wild One* was finally granted an X certificate in the UK in 1967, joining a wave of Hells Angels flicks emerging from the US that depicted bikers as savage delinquents. Yet the increasing public acceptance of mod had its downsides. According to Nik Cohn in *Ball the Wall*, 'the press and TV began to use the term indiscriminately . . . In the hands of

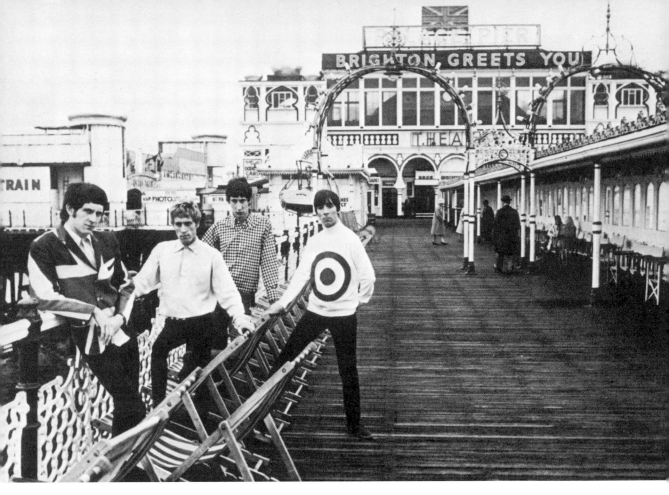

Above: The Who posing in iconic mod style on Brighton pier.

'We didn't fight rockers, we were far more interested in some guy's incredible shoes, or his leather coat.'

admen [mod] became an all-purpose instant adjective, like fab or gear, to be used for pop groups or cornflakes, or dog biscuits alike.'

While such developments may have irked many dedicated mods, for others it represented an opportunity. Step forward Peter Meaden. A leading London face who held court at the scene's hippest Soho nightclubs, while still living with his parents in order to save money to spend on clothes, Meaden once defined the mod ethos to *NME* journalist Steve Turner as 'clean living under difficult circumstances', an aphorism now almost holy writ in some circles.

Pete figured there was money to be made from a band quite literally tailored to the mod market. He picked a hardworking west London rhythm and blues quartet, who accepted Meaden's services as a promoter in early 1964. He gave them a suitably mod name, the High Numbers ('numbers' was slang for the mod rank and file), and took an advance from the band's management in order to transform the four scruffy rock musicians into dandies who would pass muster in front of a mod audience. To complete the transformation, Meaden wrote them two archetypal mod songs, 'I'm the Face' and 'Zoot Suit', released as the band's debut single. It flopped, and Meaden parted ways with the band after just six months, the quartet reverting to their original name, the Who. Playing their own material, the Who began a steady climb to stardom, their album *My Generation* charting at the end of 1965. The eponymous single was adopted as a mod anthem, lead singer Roger Daltrey's deliberate

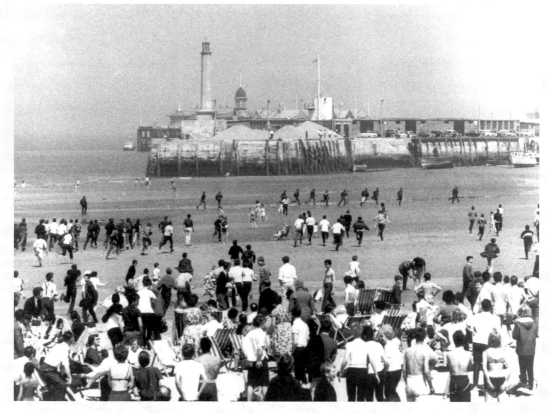

Above: Holidaymakers watch as mods chase rockers across the sand at Margate, May 1964.

stuttering a self-conscious nod to the mod rhythm of speech, brought on by an excess of speed. The Union Jack and RAF roundel motifs adopted by the band were also embraced by many of the Who's new mod fans.

'The Who in the early years weren't really mods,' reflected guitarist Pete Townshend in 1996. 'I was an art student. Roger always calls himself a rocker. Keith [Moon, drummer] was quite a mod-looking kid by today's definition of the word. But John Entwistle was very kind of parochial in the way that he dressed. So we weren't mods but our audience were.' 'My Generation' was widely regarded as the band's farewell to mod. The Who were fast becoming an innovative hard-rock band; though mods continued to follow them, the sound was light years from the modern jazz of the cult's conception. Mod overall was fast becoming yesterday's news, fatal to a scene that styled itself as 'modernist'. Steve Turner asked

Pete Meaden when the tide turned for mod. 'About 1967, when acid came in,' he replied. LSD hit the rocker scene just as hard. While mods and rockers may have disappeared from the headlines, they hadn't died out, but were fragmenting and evolving under the influence of these strange new drugs.

A few diehard elitist modernists had tried to rebrand themselves as 'stylists' or 'individualists', to distinguish themselves from the rowdier, more vulgar element that had diluted the scene. It never really took. More significantly, Granny Takes a Trip, the first of London's trendy hippie boutiques, opened at the unfashionable end of King's Road in early 1966. Among the trio of founders was the Savile Row-trained tailor John Pearse, a mod who pioneered a change of direction, abandoning cutting-edge modernism in favour of styles that harked back

It wasn't an optional outing of boys playing on scooters; it was a vital rebellion.

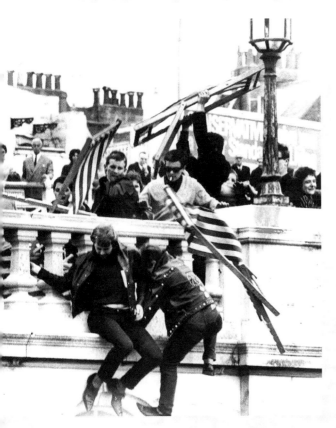

Above: *Bank holiday clashes between mods and rockers on the UK's south-coast holiday resorts dominated headlines in 1964.*

to yesteryear, reinterpreted to appeal to the outrageous hallucinogen-influenced aesthetic of psychedelia. Several of the more style-conscious, affluent mods followed suit, establishing a niche as the chic trendsetters at the well-heeled end of London's nascent hippie scene. Within months Granny Takes a Trip became a sensation, the King's Road stealing Carnaby Street's crown as the capital of Swinging London, as hipsters abandoned sharp suits in favour of bell-bottomed jeans and afro hair.

At the other end of the social spectrum, mod fractured along different lines. Many maintained the scene's obsession with neatness, but abandoned most of the Ivy League and Italian pretensions in favour of styles that borrowed heavily from the West Indian immigrants who were providing much of their favourite dancehall music. Clipping their hair

ever shorter, they became the first skinheads. Some stayed loyal to their passion for scooters, evolving into a semi-independent scooter boy scene. In the north of England, a passion for American soul music defined yet another spark that ignited from the dwindling mod flame. Suffice to say, the seventies proved lean times indeed for mod purists. Salvation would come from an unexpected direction, when the Who decided to revisit their roots with their bleak 1973 coming-of-age rock opera, *Quadrophenia*, set against the backdrop of the mod world of nearly a decade before.

While in many respects an exercise in nostalgia, the genius and passion behind the hit recording was contagious. It became a film in 1979, which helped trigger an authentic mod revival, and then a spectacular stage show – first performed in 2005. The chief musical architect of the album was Who guitarist Pete Townshend, and he talked about the era to the *Times* in an interview to promote the stage version. 'Everything was turned on its head,' he recalled. 'Girls looked like boys, boys wore eyeliner and danced alone or in pairs like girls ... Roger Daltrey often says that mod wouldn't have happened if well-paid work hadn't been available. But what awful work it was, and what antiquated rules and authoritarian systems were still in place ... *Austin Powers* has done a lot of damage to the image of Swinging London, parodying what had already been parodied by lazy American newsreels over the years. So in a sense my mission is to bring back some of the greyness, the bleakness of those years, and demonstrate to the cast that what happened simply had to happen, otherwise we would all have gone nuts. It wasn't an optional outing of boys playing on scooters; it was a vital rebellion.'

HIPPIES

All You Need Is Love

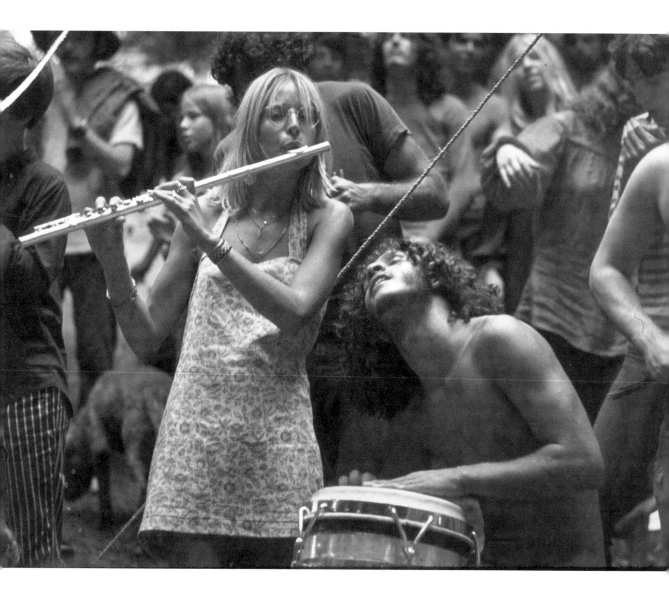

The cliché has it that 'if you remember the sixties, you weren't there'.

Just what, or who, is a hippie? Where did they come from and where did they go? These are deceptively simple questions. For one thing, few of the original hippies described themselves as such – they were 'freaks' or 'heads'. Both names offer interesting clues as to the origin of the species. Freak, because the archetypal hippies were self-conscious outcasts from mainstream society, outsiders who embraced their status, rejected by a culture they considered hopelessly corrupt and inhumane. Head was short for acidhead, indicative of the central role played by LSD in the evolution of this particular subculture. Indeed, it's been suggested that the hippie cult was born in a Swiss laboratory in 1938, when Albert Hofmann concocted lysergic acid diethylamide. He'd been trying to synthesise a stimulant. It lay forgotten for five years until Hofmann ingested a dose purely by chance, experiencing the world's first acid trip and setting off a cultural chain reaction that would change the world forever.

The cliché has it that 'if you remember the sixties, you weren't there'. Yet, repeated on the lips of affluent dinner-party guests everywhere, many of the barefoot rebels who embraced the sex-and-drugs excess of the era have since graduated to positions of influence and power. Thus, the hippie era is a prime example of how a huge social experiment can at once be a catastrophic failure, yet also have a lasting, seismic impact on both the individuals involved and the world around them. For ardent conservatives, however, it remains the point in modern history when everything went wrong, the main milestone on contemporary society's road to hell.

Opposite: In hippie ideology, music took on a spiritual, even sha-manic significance.

Returning to definitions, 'hippie' derives from 'hip' or 'hipster', terms with roots in the black American street slang of the thirties and forties, meaning clued-in with the latest street fashions and trends. It filtered through to white slang courtesy of the beatniks in the fifties, who embraced jazz and also picked up some of the jargon (as well as the exotic intoxicants enjoyed by many early jazzmen). It's interesting to note that some use the alternate spelling 'hep', and it's been suggested that the transition from 'hep' to 'hip' marks the boundary between the beatniks and the hippies.

For many beatniks, hippies represented their irresponsible younger brothers, hopelessly naive – perhaps dangerously so – in their determination to confront the system, a strategy most of the Beat Generation dismissed as futile. The term 'beat' was coined in 1948 by the American writer Jack Kerouac, and popularised by his friend the novelist John Clellon Holmes in the publicity surrounding the publication of his 1952 novel *Go*. 'Everyone I know is kind of furtive, kind of beat,' wrote Holmes. Beat meant downtrodden and exhausted, but also, said Kerouac, hinted at beatitude – the idea that there was something beautiful, even sacred about society's outcasts and losers, that the quest to keep disillusionment and depression at bay with sensation and experience was worth chronicling. By 1958 the term 'beatnik' was coined by the press, a self-conscious attempt to simultaneously mock the anti-materialist beat scene and associate it with communism (the Soviet Union had launched their first Sputnik satellite the previous year, beating the USA in the first round of the Space Race, much to the dismay of patriotic Americans).

By the sixties, the beatnik was a much-caricatured figure of fun, stereotyped as a pseudo-intellectual in a beret, goatee beard and shades who communicated in silly slang borrowed from Harlem jazzmen, and hung out in smoky coffee houses where people read out

In 1957 the term 'psychedelic' was coined to describe the unique quality of the experience of being under the influence of powerful psychoactive drugs like LSD.

nonsensical poetry or played the bongos. Few things are more poisonous to a subculture than sustained mockery, except perhaps commercial exploitation, as trendy suburban couples bought into the lifestyle, becoming beatniks for the weekend as a lark. The teenaged recruits who began swamping the scene, inspired by the media stereotypes rather than beat's original lofty literary ideals, sealed its fate. There was always a heavily fatalistic edge to beat culture. If the beats were pessimistic, the hippies were incurable optimists – the archetypal beatnik wore black, hippie fashions were a rainbow of bright colours. Though they indulged in narcotics that were rife on the jazz scene, the standard beat drugs were 'downers' like alcohol, while the definitive hippie drugs were 'mind-expanding' intoxicants such as LSD and marijuana – the majority of the scene's participants drifting through life in a perpetual fog of pot smoke. Between 1960 and 1970, the number of Americans who admitted using the drug rose from a few hundred thousand to around twelve million.

It was those beats who embraced the acid revolution who would successfully make the transition to the hippie scene, while many others became increasingly bitter and cynical. (Kerouac died in 1969 aged just forty-seven, his body destroyed by drink.) Leading beat poet Allen Ginsberg first took LSD in California in 1959, motivated by a quest for spiritual truth. Having already investigated the Buddhist faith, the poet thought the puzzle might be unlocked by powerful psychoactive drugs. The following year, while at a friend's house, naked except for his trademark thick-rimmed spectacles, Ginsberg phoned Kerouac under the influence of hallucinogenic mushrooms. 'The revolution

is beginning!' he shouted into the receiver. 'Gather all the dark angels of light at once! It's time to seize power over the universe and become the next consciousness!'

His host was psychologist Timothy Leary, an academic at Harvard University. Earlier in the year, intrigued by reports of the supposed revelatory qualities of the Mexican *Psilocybe* mushroom, Leary had travelled to Mexico to sample some. He declared that the consciousness-expanding experience taught him more about the human mind than his previous fifteen years of study and immediately set up a research programme – in which Ginsberg became a willing guinea pig. What began as an investigation into the mushroom's psychological effects swiftly exploded into speculations on its broader implications as a catalyst for artistic creation or even spiritual enlightenment. It was groundbreaking, controversial work, though Ginsberg and Leary were treading a path already travelled – not just by countless generations of Central American shamans, but also an eminent English author named Aldous Huxley.

Huxley took his first dose of LSD in 1955. The results inspired two collections of essays – *The Doors of Perception* (1954) and *Heaven and Hell* (1956) – probing a possible connection between spiritual ecstasy and hallucinogenic drugs. In 1957, his friend, the psychiatrist Humphry Osmond coined the term 'psychedelic' in a letter describing the unique experience of being under the influence of such powerful psychoactive drugs. 'To fathom Hell or soar angelic, just take a pinch of psychedelic,' rhymed Osmond in an immortal couplet.

In 1937, Huxley relocated to California,

Opposite: Ken Kesey spreads the word from his magic bus – destination 'furthur' . . .

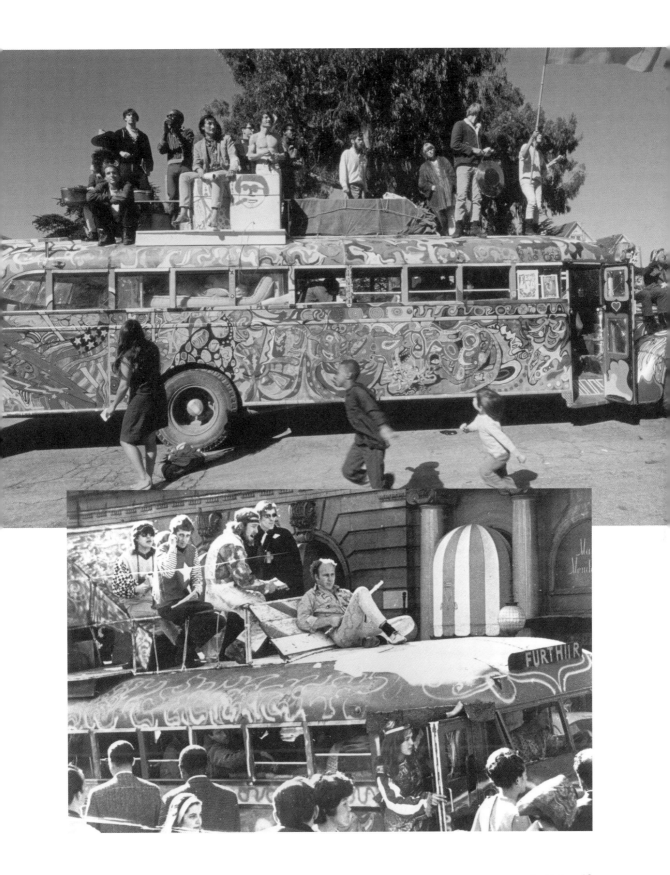

where he inevitably crossed paths with Timothy Leary. Though the two got on, Huxley had his misgivings. While the English author had always emphasised caution while investigating this strange new world, the Californian academic had a chip on his shoulder, and appeared at least as interested in promoting his own ego as advancing human knowledge.

When academia rejected Leary as a result of dangerously bad publicity, the charismatic maverick soon found a new patron, offering him the use of New York State's palatial Millbrook estate. Leary's benefactor was a wealthy young stockbroker named William Hitchcock. In the in the wake of Leary's scandalous progress, the tide of opinion was turning against LSD, but Hitchcock, an astute and adventurous maverick in his own right, was open-minded enough to

in one of the most bizarre experiments, set up brothels in San Francisco, drugged customers, and then filmed the results through two-way mirrors while supping martinis. Less surreal experiments were conducted at the nearby Menlo Park Veterans Hospital, involving paid volunteers, one of whom was a creative-writing student named Ken Kesey. Back in 1959, Kesey was a would-be beat novelist, studying at Stanford and working nightshifts at the hospital to make ends meet. He liked the drug, managing to pocket some for private use, sometimes working his shift and talking to psychiatric patients while under the influence. The result of these experiences inspired Kesey's 1962 bestseller, *One Flew Over the Cuckoo's Nest*. Using an insane asylum as a metaphor for modern America, the book challenges

The hazy idea was that by abandoning the corrupt trappings of post-industrial civilisation, humanity might somehow drift back into a state of peaceful innocence and harmony.

take a chance on something which, at least then, wasn't actually illegal. The mansion at Millbrook soon became Leary's Vatican, a magnet for curious intellectuals and artists, presided over by the new 'High Priest of LSD'.

And they were not the only interested parties. With intelligence to suggest that the Soviets had been purchasing LSD in bulk, the newly formed CIA quickly began conducting research of their own. Might the chemical have useful applications in espionage – as a truth drug or even a way of brainwashing unwitting agents? Initially, CIA scientists experimented on each other, but when the potential dangers of LSD became apparent (one Army researcher threw himself out of a thirteenth-storey window in New York in 1953), they looked further afield for unwitting guinea pigs.

They gave – sometimes terrifyingly large – doses of acid to prisoners, mental patients and,

conventional notions of madness. The royalties bought Kesey a large log cabin at La Honda in the mountains south of San Francisco.

Kesey's idyllic home became a base for his own experiments with LSD, as he invited friends to come over for what he called his 'Acid Tests'. At these predictably bizarre events, the elements of the psychedelic aesthetic began to emerge, as Kesey captained chaotic expeditions into inner space, designed to blow the minds of his curious passengers. Trees were painted in bright, luminous colours and ecstatic celebrants tested the boundaries of sanity to an improvised soundtrack of discordant rock and folk. In 1964, the imminent publication of his next novel obliged Kesey to visit New York, so he bought an old bus, and decided to take his Acid Tests on the road, a pioneering trip to see what America looked like on LSD while preaching the new doctrine of enlightenment

through insanity with a megaphone, via a hole cut in the bus roof for the purpose. They styled the crew the Merry Pranksters, their luridly painted ride adorned with the warning 'Caution: Weird Load', the inhabitants adopting odd monikers like Mal Function and Slime Queen. Their progress across America was recorded in journalist Tom Wolfe's suitably surreal narrative *The Electric Kool-Aid Acid Test*, a 1968 'non-fiction novel' often regarded as the definitive hippie text.

The term 'hippie' was first coined in its modern sense in 1965 by a San Francisco journalist named Michael Fallon to describe the influx of young beats arriving in the city's Haight-Ashbury area, influenced by the philosophies of Timothy Leary and Ken Kesey, living communally, taking psychoactive drugs and spouting ideals of spiritual, sexual and personal freedom, unfettered by government intrusion. In 1965, the Grateful Dead played one of Kesey's Acid Tests in Santa Cruz. With their brand of increasingly experimental, LSD-fuelled improv, they soon became the emerging subculture's unofficial band.

A series of diverse ideologies and practices began to cohere under the broad banner of the New Age – the era in question being the Age of Aquarius – a dawning epoch with literally cosmic significance. Alongside astrology, there was a burgeoning interest in everything from Native American shamanism and Norse runes to Tai Chi and tarot cards: almost anything that promised an alternative outlook to conventional creeds such as capitalism and Christianity. Perhaps the most important and influential philosophy to emerge from this bubbling cauldron of exotic traditions and offbeat ideologies was a newfound reverence for Mother Nature. Anything deemed natural was by implication good – even sacred; anything tainted by artificiality, unworthy and negative. Practices that, somewhat dubiously, were often damned as unnatural ranged from cutting your

hair, shaving or wearing shoes, to working nine-to-five, sexual monogamy and eating meat. The hazy idea was that by abandoning the corrupt trappings of post-industrial civilisation, humanity might somehow drift back into a state of peaceful innocence and harmony.

Millbrook eventually imploded under the combined pressure of interminable internal disputes and constant harassment by government agencies, and in 1966 Leary set up the League for Spiritual Development. It was a creed whose central sacrament was LSD. 'Like every great religion of the past we seek to find the divinity within and to express this revelation in a life of glorification and the worship of God,' explained Leary. 'These ancient goals we define in the metaphor of the present – turn on, tune in, drop out.' While he didn't coin the latter slogan, it became forever associated with Leary, and many disaffected young middle-class Americans took it up as their personal mantra, taking to the road on quests to 'find themselves', pilgrimages that usually took them to San Francisco.

The hippie credo of 'peace and love' proved alluring to many rebellious young Americans. A philosophy that sanctioned sexual license – 'free love' – had an obvious appeal to youngsters with lively libidos. The ideal of peace was also becoming a particularly pressing issue. As the Vietnam War intensified, the US government was sending a rapidly growing number of reluctant young Americans abroad to fight communism in a conflict that was becoming increasingly brutal and controversial. Many conservatives were inclined to regard the hippies and the growing number of anti-war, anti-capitalist, ecological and civil-rights activist groups organising in the USA and Europe during the sixties as part of some unified unwashed leftist legion. There was a substantial overlap – most evident in the Youth International Party, or Yippies, founded in late 1967 – who attempted to unify hippie idealism with political activism.

Jerry Rubin, founder of Yippies, believed that the building popularity of psychoactive drugs 'signifies the total end of the Protestant ethic: screw work, we want to know ourselves', wholly rejecting 'American society's sick notion of work, success, reward and status'. Unofficially dubbed the 'Groucho Marxists', the Yippies staged stunts reminiscent of the anarchic antics of the Merry Pranksters, such as putting up a pig named Pigasus the Immortal as a presidential candidate in 1968. But many hippies regarded political activism of any kind as outmoded compared to the crucial process of changing the nation's consciousness. While serious political revolutionaries despaired at the number of potential young recruits who preferred to drop acid, grow their hair and practise free love rather than become involved in even peaceful protest, let alone direct action.

In October of 1966 LSD was finally made illegal in the State of California. The hippies of Haight-Ashbury responded with a Love Pageant Rally at Golden Gate Park, where several thousand heads, including a Merry Prankster contingent, gathered to take acid in defiance of the new legislation. 'Without confrontation,' explained organiser Allen Cohen, 'we wanted to create a celebration of innocence. We were not guilty of using illegal substances. We were celebrating transcendental consciousness. The beauty of the universe. The beauty of being.' The success of the event prompted the Human Be-In at Golden Gate Park the following January, which attracted crowds in excess of 20,000. It was a landmark event in hippie history, putting the movement to the forefront of the political and cultural agenda and ushering in the legendary Summer of Love.

'We were not guilty of using illegal substances. We were celebrating transcendental consciousness. The beauty of the universe. The beauty of being.'

By 1963, the Beatles had toppled Elvis Presley as the planet's foremost musical sensation, Beatlemania sweeping not just the UK and Europe, but also the USA by the dawn of 1964. Initially clean-cut and besuited, the Fab Four were a cuddly quartet any teen could take home to their mother, but that was about to change. In 1965 they met up with the cult folk-rock artist Bob Dylan at a New York hotel. Dylan introduced them to marijuana, and all four were soon keen smokers. The influence of Dylan was evident on their next album, *Rubber Soul*, as was their new hobby, with Beatle John Lennon describing it as the band's 'pot album'. He described *Revolver*, the groundbreaking follow-up that came out the following year, as its LSD equivalent. 'The first time we took LSD was an accident,' reflected guitarist George Harrison of the band's unusual introduction to acid. 'It happened sometime in 1965, between albums and tours. We were innocent victims of the wicked dentist whom we'd met and had dinner with a few times.'

'I think LSD changes everybody,' reflected drummer Ringo Starr. 'It certainly makes you look at things differently. It makes you look at yourself and your feelings and emotions. And it brought me closer to nature, in a way – the force of nature and its beauty. You realise it's not just a tree; it's a living thing. My outlook certainly changed – and you dress differently, too!' By 1967, the Beatles were a fully-fledged hippie band, releasing the landmark psychedelic album *Sgt. Pepper's Lonely Hearts Club Band*, a commercial and critical hit still regarded by many fans as their masterpiece.

Acid had actually been in recreational circulation for some time in both the US and UK, consumed as a novelty at fashionable

cocktail parties where the hosts had good medical connections (like the dentist who spiked the Beatles in 1965). Despite Lord Stonham's best efforts, London had its share of hippies and some even regarded the city as the scene's true capital. The London scene was more fashion-conscious and chic than its Stateside equivalent, with wealthy rock stars rubbing shoulders with slumming aristocrats and fashionistas, wearing the latest expensive designs from snobby, exclusive boutiques on the capital's fashionable King's Road, like Granny Takes a Trip. In the wake of the success of *Sgt. Pepper's*, psychedelia was becoming another disposable fashion statement for bored playboys.

Not everybody approved. 'The people I hate are the King's Road type,' observed a hippie named Jimmy, interviewed by the sociologist Richard Mills in 1970. 'Chelsea. The ravers. Weekend hippies. They wear what they call groovy clothes. They have long hair. But they're about as plastic as the cover of that tape recorder case. Maybe they have a pair of jeans like me – but when they first get outside you can still smell the moth-balls because they've had them hanging around all year. They're hanging on the peg for fifty weeks of the year and they just take them out and wear them up town one night, smoke one joint and really think they've tuned in, they've done it all.'

London also represented a stopping-off point for many adventurous hippies with wanderlust. Some from mainland Europe took time out there on their way to the USA from France, Italy or Scandinavia. Some American hippies took a break in the British capital on their way east to India, Turkey or Morocco. There were practical reasons for such a trek, as these Asian and North African locations produced the best hashish, which could be enjoyed in the exotic locale, then imported for substantial profits by those willing to take the risk. However there was more to it than that. Even those hippies with no intention of leaving home favoured ethnic

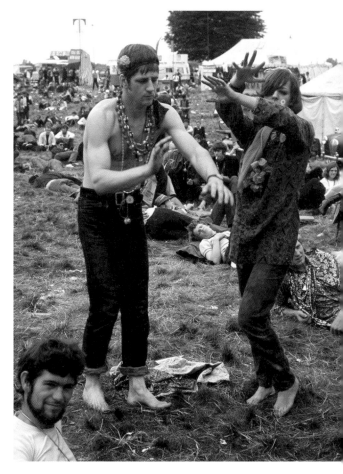

Above: For many hippies, the Age of Aquarius promised a return to a primal, more innocent world.

garments – from Turkish kaftans to Mexican ponchos and Afghan coats – symbolising both a taste for the exotic and respect for foreign cultures. Much hippie philosophy drew heavily from Oriental mysticism – particularly Indian religions – which they felt had much to teach westerners who had been blinded by materialism, rationalism and greed.

Similar ideas lay behind the adoption of styles reminiscent of traditional Native American dress, such as fringed buckskin jackets and headbands. Of course, headbands were also practical wear for anyone with long hair who wanted to keep it out of their eyes, but there was more to it than that. Hippies identified with America's original inhabitants

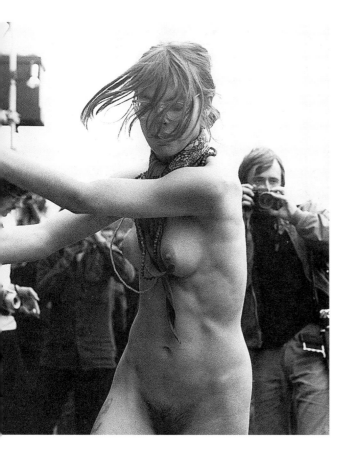

Above: Letting it all hang out: Many hippies regarded nudity as a facet of their quest to return to a more natural state.

The great experiment of peace and love appeared to have failed.

as long hair back then, and the day Elvis Presley had his hair cut when joining the army was celebrated by many traditionalists. When having your hair cropped signals entry into the military – the most regimented environment in modern society – refusing to cut it symbolises the opposite ethos of freedom and dissent, something that took on particular significance as increasing numbers of young Americans were being drafted to serve in Vietnam, many of them never to return.

By 1967 in Haight-Ashbury, the hippie era was reaching its climax during the legendary Summer of Love. It had become a heaving mass of colour and chaos as the district's original population of 10,000 threatened to increase tenfold. According to Professor Lewis Yablonsky, a sociologist who conducted a survey of hippies in that year, there was a hardcore of around 200,000 dedicated hippies in the USA, plus another 200,000 part-time or weekend hippies. The number of 'fellow travellers' – sympathetic to the ideals or receptive to the drugs but unwilling to commit to the lifestyle – numbered in their millions. According to the Diggers far too many of them were in Haight-Ashbury by 1967. The Diggers were a curious combination of a street theatre troupe and an anarchist social movement, who emerged in the district in the early sixties and resolved to put their collectivist ideals into action by providing for those members of the community in need. Using donations from local businesses and sympathetic underground sources like the Brotherhood of Eternal Love (a mystically inclined cabal of hippies who synthesised the purest acid California's head community had ever encountered), the Diggers offered services such as free meals and a free clinic. By the end of the Summer of Love, however, the number of people in need was increasing rapidly. Just as

as noble non-materialists who were oppressed by the government, something played out repeatedly in Hollywood Westerns. The fact that several Native American shamanic traditions included ingesting hallucinogenic cacti as a ceremonial route to enlightenment furthered such feelings of kindredness among many hippies, and numerous hippie groups and communes defined themselves as tribes.

However, long hair remains the definitive hippie statement, and it's easy to see why. The afro, a style adopted by black hipsters as a statement of racial pride, was being copied by some white hippies as an indication of solidarity. Conservatives had been condemning rebellious youngsters for having long hair since the fifties. While rock'n'roll quiffs hardly seem to qualify in modern eyes, they were criticised

donations began to dry up, and exactly a year after the Love Pageant Rally, a Death of Hippie parade was held, complete with symbolic coffin.

Haight-Ashbury was becoming a distinctly unhealthy place to be, as crime soared, and the large number of broke, confused and strung-out teenagers proved to be a magnet for human predators. The district had become a tourist attraction, as ordinary folk came to gawp at the freak show, while busts and violence became increasingly common. In a surprisingly sympathetic 1968 article entitled 'San Francisco: Wilting Flowers', *Time* magazine observed that 'love has fled the Hashbury. Although anti-draft hipsters recently held an amorous assembly knee-deep in a pool near City Hall, love has been replaced by cynical commercialism, loneliness and fear, sporadic brutality and growing militance.' Historian Arthur Marwick, however, suggests that the hippie flame was not so easily extinguished: 'The love had never been all-encompassing; what was happening now was a general move by the true, full-time hippies away from the cities and into rural communes. *Newsweek* fifteen months later (18 August 1969) announced "The Year of the Commune".'

The great experiment of peace and love appeared to have failed. Many hippies retreated to the countryside, where they could follow their chosen lifestyle in peace, while others tired of the subculture's pacifist ethos and decided to bite back. Throughout 1968 the USA and Europe were convulsed by riots and violent confrontations between police and young radicals. In 1969 the Weather Underground formed, a group whose name was inspired by a Bob Dylan lyric, who evolved into what many regarded as a hippie terrorist organisation. (In 1970, they broke Timothy Leary out of jail in return for a fee paid by the Brotherhood of Eternal Love.)

There were still high-profile hippie events to come which represented the movement as a viable philosophy. The Woodstock Festival held in New York State in August of 1969 is widely regarded as a triumph of the hippie spirit, attended by 500,000 revellers. But it was never intended as a free festival, only adopting the role once organisers became aware that trying to keep out the hordes of hippies who arrived without tickets might lead to riot. The *New York Times* estimated that ninety-nine percent of the audience were smoking marijuana, while up to 400 revellers needed medical treatment for bad LSD trips, during which they were plagued by nightmarish hallucinations and prolonged panic attacks. Woodstock was overshadowed by the Altamont Free Concert at the end of the year. Hosted at a speedway track near San Francisco, the event degenerated into disaster due to bad planning, culminating in the stabbing of an audience member by Hells Angels who had been employed by organisers as security. It was widely interpreted as the definitive end of the Summer of Love. A competitor for this dubious accolade was the campaign of brutal, motiveless murders committed by members of a Californian hippie commune in August 1969, supposedly masterminded by their guru, an ex-con named Charles Manson.

Over four decades on, it's easy to see that the reports of the death of the hippie subculture were much exaggerated. In 2007 the UK edition of the conservative family monthly *Reader's Digest* conducted a survey inspired by the fortieth anniversary of hippie's heyday. They titled the results 'Like It or Not You're a Hippie'. Among respondents to the magazine's poll, the sixties was considered the best decade to be a teenager, with over a third opting for the hippie era, more than three times the count for any other decade. 'There was much more to the Summer of Love than taking drugs, sleeping around and shirking responsibility,' said Katherine Walker, the magazine's UK editor-in-chief. 'Our poll shows that the hippie era produced many innovative, enduring ideals that British people of all ages have come to live by. In some ways they really did change the world.'

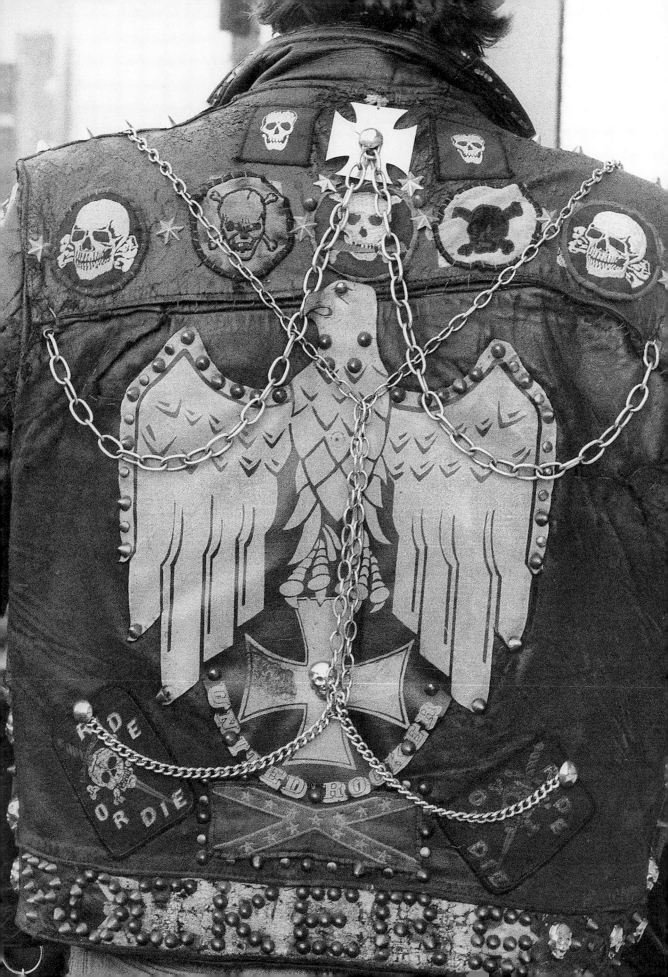

BIKERS
Born to Be Wild

An Angel quoted in an early sixties article divided people into two categories – Hells Angels and people who wished they were Hells Angels.

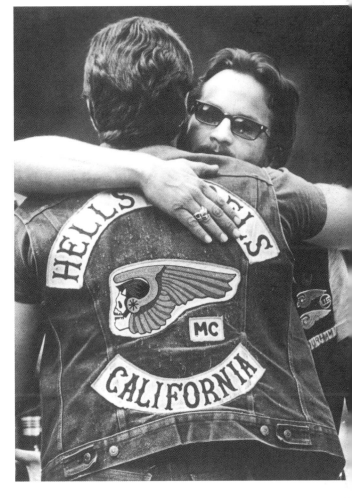

In the sixties, biker culture experienced major changes. By the time England's ton-up boys finally saw the long-banned 1953 film *The Wild One*, fifteen years after American audiences, the film had dated, and many rockers must have wondered what all the fuss was about. However, once they'd finally had the chance to see the movie, rather than just pore over stills in magazines, their fascination with the film's villain Chino, played by Lee Marvin, grew. Playing the film's anti-hero Johnny, in his black leathers and peaked cap, had made Marlon Brando a role model for a generation of rebel motorcyclists, his Black Rebels the prototype for many British

Biker livery has evolved into a catalogue of grim symbols (opposite), yet few are as feared and respected as Hells Angels colours (right).

bikers. But it was Chino and his ragtag gang, the Beetles, who more closely resembled the US bikers involved in the 1947 incident at Hollister that originally inspired the film.

Chino's character was apparently based on 'Wino' Willie, a member of the Boozefighters, one of the bike clubs in the thick of the legendary 'Hollister riots'. As a sign that the town bears no ill will, Willie's image accompanies that of Marlon Brando on a mural at Johnny's Bar & Grill in Hollister, a business cashing in on the town's iconic place in biker – and some might say American – culture. The Boozefighters themselves are adamant that, though one of the oldest surviving bike clubs in the USA and proud of their heritage, they are not 1%ers – not among the motorcycle clubs which, in the aftermath of the Hollister weekend, declared themselves outlaws. They point to the club's original rules, which state as the first two regulations: '1. Get drunk at a race or meet or cycle dance. 2. Throw lemon pie in each other's faces.' 'Now, unless they were communicating in some secret club code, it appears that they pretty much wanted to drink, ride motorcycles, and, yeah [. . .] just have some *fun*,' observes Boozefighter Bill Hayes in *The Original Wild Ones: Tales of the Boozefighters Motorcycle Club*, a book he co-authored with Jim Quattlebaum and Dave Nichols.

But that kind of story, he concludes, doesn't make for good copy, and so journalists inevitably sensationalise events, setting the stage for the transformation of the biker into a dark modern legend. Though numerous motorcycle gangs would be established in the US – the Vagos, Free Souls, Bandidos, Highwaymen, Warlocks, Outlaws, Mongols and Sons of Silence, to name a few – in the mind of many a casual observer, the term 'biker' is, if not interchangeable, then indelibly associated with 'Hells Angel'. That is, if we accept biker as describing someone who

> ‘When we do right, nobody remembers. When we do wrong, nobody forgets.’

sees their motorcycle not merely as a convenient means of transport or an exciting hobby, but as part of their identity, a passport to freedom and rebellion. An Angel quoted in an early sixties article divided people into two categories – Hells Angels and people who wished they were Hells Angels. It is, of course, archetypal Angel braggadocio, but – in biker terms, at least – there's a large element of truth to it.

Many dedicated modern motorcyclists favour colourful, figure-hugging leather gear, colour co-ordinated with their high-performance Japanese machines, styles influenced by competitive racing teams. Yet for most bikers, the oil-black outlaw chic remains part of the lifestyle's appeal, even among those who might (quietly) dismiss the Hells Angels as obnoxious bullies, cycle-mounted sociopaths who have done irreparable damage to the subculture's image. The awkward truth remains that, over the past fifty years, almost every major development in the biker subculture has been as a result of, or in reaction to, hardcore 1%er clubs like the Angels. That history is surprisingly difficult to piece together, in part because it's a subject that is so violently divisive. On the one hand you have the sensationalist media, keen to sell a salacious story, and agents of the authorities, for whom the Angels represent a deviant minority that needs to be eliminated. On the other, you have the spokesmen for the bikers themselves, who have every motive to present their comrades as the innocent victims of bad press and government repression. 'When we do right, nobody remembers. When we do wrong, nobody forgets,' as a popular Hells Angels motto has it.

Secrecy cloaks the world of the Hells Angels with notable effectiveness to this day, and the club is quick to dismiss prurient speculation about their culture and activities, but highly

circumspect about offering convincing alternative explanations. While this might be excused as a keen sense of privacy, the club's many critics charge that it's the inevitable attitude of any criminal organisation. The writer Hunter S. Thompson, only half in jest, compared the Hells Angels to the Freemasons. Thompson was arguably the first outsider to shine a light on the shadowy inner world of the early Angels, a rare figure who occupied the troubled territory between the many virulent critics of the Angels and the club's faithful apologists. He became among the foremost chroniclers of sixties counterculture – his anarchic 'Gonzo' style inspiring a generation of journalists – and Thompson owed his big

Above: Two members of the Vagabonds, an early motorcycle club, in 1948.

break to the Hells Angels. In turn, the writer helped establish the Angels legend.

In 1964, on Labour Day Weekend – the September holiday that had become a traditional time for bikers to ride out in force and party – a large group of Hells Angels headed to the beach at Monterey in California. Over the weekend, it was alleged, the bikers sexually assaulted two teenage girls, and four Angels – including two chapter presidents – were arrested and charged with rape. Eventually the case was dropped and all four suspects released without charge. Yet outraged newspaper reports of the ugly incident had

caught the attention of an influential figure, California Senator Fred S. Farr, who instructed the State's Attorney General Thomas Lynch to compile a report on outlaw motorcycle gang activity. The resultant report was released with some fanfare in March of 1965. It was to be one of the most significant documents in biker history. This is where Hunter S. Thompson comes into the picture. Having recently lost his job, Thompson was given a copy of the report by *Nation* magazine with the suggestion that he write a story on the subject.

The Lynch report had proven to be a gift to the USA news media, which jumped upon its findings, a fifteen-page dossier that depicted the Hells Angels as a burgeoning threat to American society, providing juicy copy for journalists in search of a good story to titillate and terrify their readers. 'No act is too degrading for the pack,' concluded *Time* magazine in their feature 'The Wilder Ones'. Thompson took a different tack, actually troubling to get to know the Angels themselves, concluding that the much-vaunted Lynch report was closer to a nightmare torn from the imagination of hardboiled crime novelist Mickey Spillane than credible research. Though, as his *Nation* piece's subtitle – 'Losers and Outsiders' – suggests, the writer doesn't exactly lionise his subject.

Thompson does quote at length from the Lynch report's description of the typical Angel, and it's worth doing the same here: 'The emblem of the Hell's Angels, termed "colours", consists of an embroidered patch of a winged skull wearing a motorcycle helmet. Just below the wing of the emblem are the letters "MC". Over this is a band bearing the words "Hell's Angels". [. . .] Many affect beards and their hair is usually long and unkempt. Some wear a single earring in a pierced earlobe. Frequently they have been observed to wear belts made of a length of polished motorcycle drive chain which can be unhooked and used as a flexible bludgeon . . .

'Probably the most universal common denominator in identification of Hell's Angels is their generally filthy condition. Investigating officers consistently report these people, both club members and their female associates, seem badly in need of a bath. Fingerprints are a very effective means of identification because a high percentage of Hell's Angels have criminal records.'

One obvious mistake in these passages is that, due to an oversight when the first jackets were stitched, the apostrophe in 'Hell's' was missed out, and the Hells Angels have doggedly stuck to the spelling ever since. That aside, Thompson acknowledged the description as fairly accurate – however, he argued, there were more profound problems with the Lynch report.

While its subjects were certainly no angels (if you'll forgive the pun), Thompson suggested that the Lynch report was far from unbiased, but a deliberate, disingenuous attempt to make bikers into scapegoats for broader problems emerging in society. Perhaps banding together in aggressive, tight-knit brotherhoods was a rational response among men who could see no chance of advancement or status in American society. Maybe the Hells Angels were a visible symptom of the dissatisfaction with the status quo bubbling up fiercely under the surface in the sixties. Most significantly, Thompson also identified ambivalence in popular attitudes to the outlaw bikers, a sense of fascination with, even envy towards, these rebels who seemed to operate under their own rules. The writer later observed that, perversely, rather than crushing the club, the Lynch report and the subsequent high-profile press coverage actually helped establish the Angels. By putting them firmly in the crosshairs of the authorities, the infamy confirmed its target as Public Enemy Number One, paving the way for them to become folk anti-heroes, eclipsing the notoriety of their many rival clubs in the process. Within the realms of rebel subculture, all publicity is good publicity

> *The Hells Angels were a visible symptom of the dissatisfaction with the status quo bubbling up fiercely under the surface in the sixties.*

– particularly bad publicity. In the long run, harassing the biker clubs ultimately served to strengthen their resolve and toughen them up.

Thompson's *Nation* article was well received, and he was commissioned to expand it into a book, which emerged in 1966 as *Hell's Angels: The Strange and Terrible Saga of the Outlaw Motorcycle Gangs*. The book was also a success. It established the author and his style of Gonzo journalism – getting your hands dirty by pitching yourself headlong into your subject, even if that meant riding with outlaws, taking drugs and living with the omnipresent threat of heavy violence. Thompson's association with the Angels led to another momentous meeting. According to some sources, members of the Hells Angels first became involved in dealing speed in order to raise funds to defend the four members accused of rape in 1964. However, the relationship between the Hells Angels – and by association bikers – and illicit substances began in earnest in the summer of the following year. Thompson knew Ken Kesey, the pioneering advocate of LSD, and when Kesey asked him to invite his notorious new friends over to his place at La Honda to meet the Merry Pranksters, against his better judgement Thompson complied.

Contrary to all expectations, the party in early August of 1967 proved to be a blast. The Hells Angels enjoyed Kesey's Acid Test, while Kesey's crew found their notorious guests diverting company. The Pranksters' fondness for

Right: The motorcycle run remains at the heart of the dedicated biker subculture.

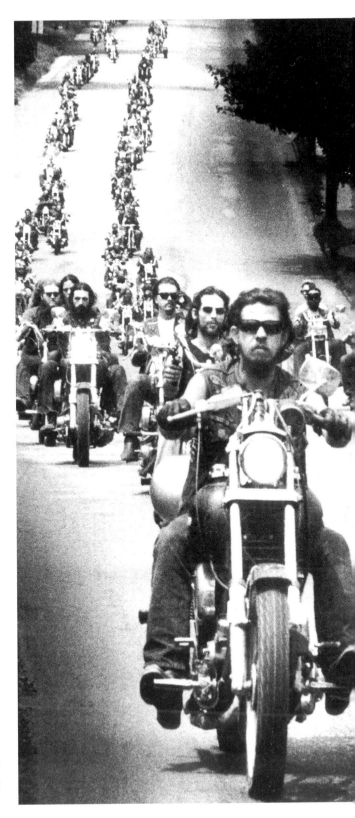

'freaking out the squares' wasn't a million miles from the Angels' attitude of 'showing some class' by alarming ordinary folk with dangerous or disgusting practical jokes or displays of outrageous behaviour. The weekend's success was a feather in the cap for the residents of La Honda, as they appeared to have demonstrated that even the Californian counterculture's most combative denizens could be 'turned on'. Allen Ginsberg even penned a poem about it. It established links between the Angels and the burgeoning hippie counterculture, and some even speculated that these longhaired warriors could prove to be an effective strong arm for the peaceful flower children.

However, not everything was groovy. Relations between the warlike bikers and their flower-power contemporaries had been soured in the autumn of 1965, when the beat poet Allen Ginsberg and Yippie leader Jerry Rubin led a march of some 1,500 anti-war protesters from the University of California Campus at Berkeley, a hotbed of student radicalism, to the Oakland Army Terminal. Oakland was also an Angel stronghold, and when the marchers got there they were met not only by a phalanx of riot police, but by around a dozen Hells Angels. The Angels tore into the peaceful protesters with boots, fists and chains, decrying them as communists. The hippies were shocked and dismayed, but American conservatives were delighted, a number of Republican organisations going out of their way to commend the bikers, even offering to pay the fines of the six Angels arrested during the affray. Attempts were made by hippie representatives to patch up relations with the belligerent biker community, but the peace achieved was clearly fragile, with the Angels promising to stay away from future marches 'because our patriotic concern for what these people are doing to our great nation may provoke us to violent acts'.

Ralph 'Sonny' Barger, president of the Oakland chapter, capped the statement by sending a telegram to President Lyndon B. Johnson volunteering to despatch a squad of Hells Angels to be trained to act as 'guerrillas' behind enemy lines in Vietnam. For anybody who knew much about the background of the developing outlaw biker subculture, their stance on the increasingly divisive war in Vietnam should have come as little surprise. Since the early days, bikers had been largely blue-collar guys with conservative attitudes. Unlike the predominantly middle-class hippies, they didn't want to change society, but live outside it, without necessarily abandoning traditional values – such as patriotism – and exhibiting reactionary attitudes to race and gender that scarcely chimed with the liberal hippie ethos.

More directly, there were a surprisingly large percentage of ex-servicemen involved in the biker lifestyle. 'Just after the Second World War returning veterans seemed to flock to motorcycle clubs,' contends William L. Dulaney (one of many researchers who connect adopting the biker lifestyle with disaffected combat veterans) in 'A More Complete History of the Outlaw Clubs'. Certainly, outlaw bikers started to refer to outsiders as 'civilians' and the name 'Hells Angels' derives from a nickname commonly adopted by US Air Force bomber squadrons, starting in World War One, continuing through World War Two and the Korean War. According to the modern two-wheeled Angels, there is no direct connection between their moniker and their airforce namesake, or indeed the club and military veterans, and modern Angels take particular exception to common suggestions that early members were alcoholic ex-servicemen and military misfits who failed to adjust to life outside the armed services.

Another central aspect of biker subculture that may owe something to the American military is in the iconic status of the 'hog'. In *The Wild One*, the film's anti-hero Johnny and his club are mounted on British bikes, while Chino and the villains favour American machines. The

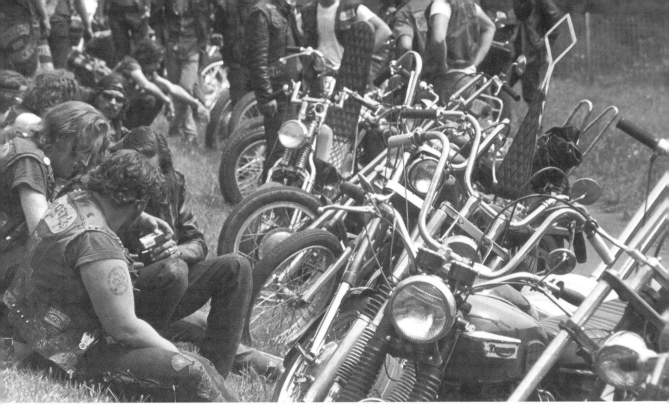

movie's bad guys are closer to the authentic typical American outlaw bikers of the era. During the fifties, British motorcycles had become a succesful export to the US, faster and sleeker than most of the competition, winning a succession of racing trophies. Domestic machines built by Harley-Davidson and Indian were slow and cumbersome by comparison. But they were comparatively cheap back then – used extensively by the US Army during the war, then sold off as surplus – and, ever pragmatic and practical, early American bikers turned this circumstance into a virtue. Harleys were at least solid, well suited to long runs over rough terrain, and had a satisfying, thunderous growl.

While British rockers were adapting their machines for optimal speed and handling in the sixties, their US contemporaries were utilising their skills to customise bikes for the long haul. A motorcycle that offered a laidback ride on endless sun-baked highways simply didn't exist on a rainy little island like Britain. Just as importantly, riding a Harley-Davidson was a patriotic statement, which became a Hells Angel regulation. The transformation, from being hunched over handlebars at breakneck speeds to sitting back and cruising, wasn't just a change in riding style, but an evolution in biker attitudes. The emergence of Japanese motorcycles on the international market, faster and cheaper – but often manufactured by the companies that had supplied Japan's war machines in the Second World War – only hardened such attitudes. Dedicated bikers disdained such 'Jap crap', even if keeping a domestic machine on the road required more mechanical skill and loving care.

Legendary B-movie director Roger Corman decided to cash in on the rash of the publicity the Hells Angels were receiving in the wake of the Lynch report, and when *The Wild Angels* was released in the summer of 1966, it proved to be a major commercial success, though critically it was more controversial. The Angels were unhappy, reportedly threatening to kill the director and sue the studio for $4 million for presenting the club in a negative light. When it was booked to screen as the unofficial American entry on the opening night of the prestigious Venice Film Festival, the US State

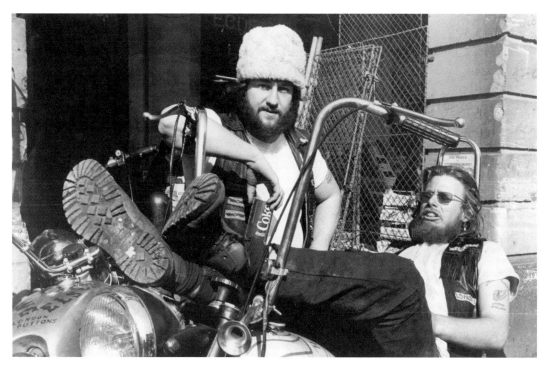

Above: Two early British Hells Angels (the legendary 'Buttons' is on the right).

Department lobbied, unsuccessfully, to have it withdrawn. It was hardly the image of America that the government wanted to promote abroad. 'I wanted to shoot reality and young people,' Corman reflected. 'It was the first biker movie.' Perhaps the first, but certainly not the last, as over the next five years a flood of low-budget films were made, hoping to emulate the success of *The Wild Angels* and featuring marauding biker gangs indulging in orgies of violence, drugs and rough sex. Pulp paperbacks and lurid magazines with similar themes began to proliferate, further fuelling the international notoriety of the Hells Angels and promoting the club's fearsome reputation, though the Angels themselves were ambivalent at best, resenting others making money by exploiting and exaggerating their infamy.

A binding code of etiquette exists among bikers, but the fact that this code remains largely opaque to outsiders – like so many aspects of the outlaw biker way of life – has created a recipe for frequently violent misunderstandings. For the Hells Angels – and other 1%er club members – their club colours are sacred. The jacket on their back, bearing the patches and emblems representing their status in the club – hard-won through harrowing experience – is a very real symbol of the hardcore biker's pride. Inquisitive outsiders who touch an outlaw biker's colours, or even ask too many probing questions about the meaning of the various patches, can find themselves walking on thin ice. (Curiously, 'colours' is a military term referring to a regimental standard, which embodied the unit's pride. For centuries, to lose your standard in battle was a great humiliation; to capture the standard of an enemy regiment the source of enormous pride.)

By the seventies the leading biker clubs were clashing violently over territory. While biker violence had originally resembled Wild West-style bar brawls, clashes between clubs were beginning to resemble medieval battlefields,

Opposite: The 1969 film Easy Rider *had a seismic impact upon the international biker subculture.*

complete with knives, axes, clubs and even swords. Some smaller clubs were closed down by more powerful predatory neighbours, while more promising groups were 're-patched', and absorbed as fresh recruits. The clubs emerging as dominant became known as 'the Big Four' – the Hells Angels, the Bandidos, the Outlaws and the Pagans – a term first coined by law-enforcement bodies in the US and Canada. One significant development in outlaw biker history was the move from peddling acid into dealing speed. Methamphetamine was easier to manufacture, and its stimulant effects fitted better into the biker ethos than the mind-expanding qualities of LSD. By the seventies, according to the authorities, 1%er clubs had largely cornered the market in speed, or 'crank' as it had become known.

According to organisations like the FBI and Canadian Mounted Police, clashes between the Big Four weren't simply about territory, but the opportunity to dominate the lucrative speed trade in contested districts. Part of the problem conventional law-enforcement authorities had in suppressing what they called the Outlaw Motorcycle Gangs (or OMGs) was the flawed

Over the next five years a flood of low-budget films were made, featuring marauding biker gangs indulging in orgies of violence, drugs and rough sex.

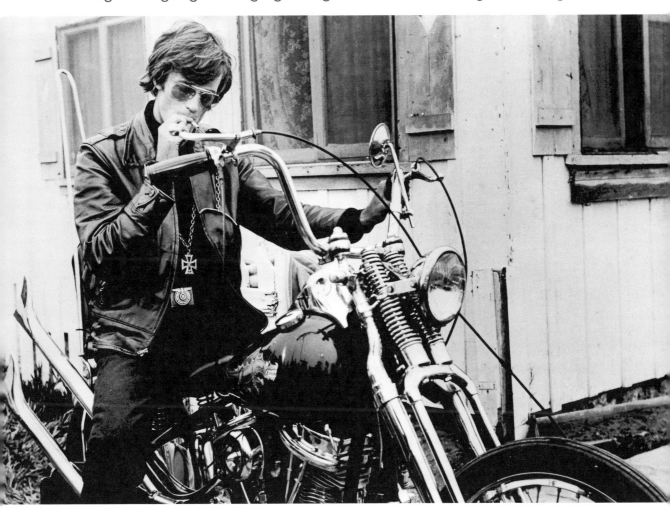

Above: While many bikers claim that baptism by gruesome fluids is a media myth, this 1971 photo from the UK suggests that at least some have taken it seriously.

conflicts became international. In the process, matters escalated. Just as biker conflict had progressed from barroom brawls to medieval melees as the ethos crossed oceans and continents, by the nineties showdowns began to resemble war movies, complete with high explosives and heavy weaponry like rocket launchers.

To draw back for a moment, the international expansion of the Hells Angels began in earnest in the seventies. While record has it that the foreign charter was granted to a New Zealand club in 1961, the first serious overseas venture for the Angels came at the end of the sixties. In 1968 the British rocker Peter Welsh, who became legendary as 'Buttons', established links with the Californians. His first task was to muster his crew to seize the unearned colours of the numerous British bikers wearing the Hells Angels motif on their jackets, whether they liked it or not. Mission accomplished, by 1969 London was home to two new official chapters of the Hells Angels. At the time, British biker subculture was in flux. The rockers had been inspired by *The Wild One*, but the UK censors had long prevented any of them from actually seeing it, and the ton-up, cafe-racer scene had evolved as a quintessentially British subculture. However, shocked reports of the latest outrages by the USA's cycle-mounted barbarians began to have an impact, and the more adventurous British bikers began taking style cues from their American cousins.

According to some, the 1969 movie *Easy Rider* changed the UK biker scene practically overnight. It's a curious film to act as a catalyst for becoming a biker in some respects. While starring Peter Fonda (who played the lead in *The Wild Angels*) alongside Dennis Hopper as two guys who conclude a successful drug deal, then decide to ride across America on customised Harleys, the duo are clearly hippies. The film is an epitaph for the hippie dream, its heroes' quest for freedom brought to a brutal conclusion by bigots, suspicious of anything that seems

assumption that they operated like conventional criminal operations, interested only in profit. But feuds chiefly erupted from the hardcore biker ethos whereby pride was sacrosanct, where no slight could be overlooked, but had to be repaid with brutal retribution. Incidents involving 're-patching' were particularly volatile. As the 1%er subculture expanded, boundaries established in the sixties became redundant, rival clubs – inspired by the notoriety enjoyed by the Angels – emerged, and as the subculture spread, the

different. It is this idea that chimed with bikers on the other side of the Atlantic, that simply living your life as you chose was enough to bring down the retribution of the state, and belonging to a tight-knit collective like the Hells Angels was one way of defending yourself.

Territorial conflicts intensified in the UK in the seventies, climaxing with a notorious 1983 clash in the idyllic rural setting of Cookham Dean in Berkshire.

'We're so prominent it's untrue,' Maz Harris, an original British Hells Angel, told Tony Thompson in an interview for his book *Gangs*. 'We ride about on big bikes and wear patches on our backs to say who we are and where we're from. I mean, if you're hell-bent on collective criminality, it's hardly the way to go about it. We'd all have been arrested years ago. We're not trying to claim that we're all perfect. Nobody ever is, but to suggest that we represent a significant threat to the peace and prosperity of Britain is taking it too far.'

Outside the UK, however, the Angels have generated some shocking headlines during the past couple of decades. Between 1994 and '97, Scandinavia was rocked by a brutal feud between local Angels and Bandidos, which left eleven dead and nearly a hundred seriously injured. Topping this was a Canadian conflict between the Angels and a Quebec club named the Rock Machine which started the same year. No less than 162 were killed in the fray before it finally ended after a series of mass arrests. The same question confronts us as when we began – are these groups clubs or gangs, criminal organisations or volatile champions of freedom who attract the odd explosively bad apple? Another intriguing question is whether they're truly outlaws anymore?

'One of the leaders of the Hells Angels in Ontario said: "We are among the world's top fifteen brands," and I think it's true,' observed Julian Sher, co-author of *Road to Hell*, a book on the Canadian biker wars. 'People know Nike, people know Coca-Cola. You can go to any country in the world and say certain names, like McDonald's or Hells Angels, and people know immediately what you're talking about. Hells Angels is a franchise name that means bikers, it means tough, in many ways it means terror.' By the 21st century, however, the Angels had begun taking their battles to the courtroom, suing companies that used the distinctive logo to be found on the club's colours, taking out suits against Disney in 2007 and the London fashion house Alexander McQueen in 2010. 'The impact of these marks is virtually incomparable, and as a result they have great commercial value,' explained Fritz Clapp, the Angels' attorney. Is the Hells Angels Motorcycle Club in danger of becoming subsumed in the legally registered Hells Angels Motorcycle Corporation?

Some suggest that the Hells Angels look less like rebels these days, but if they do, it's at least as much because so many of us have come to resemble them rather than vice versa. Previous outlaw symbols like tattoos and wraparound shades are now clichéd fashion statements. Motorcycle manufacturers like Harley-Davidson, who initially tried hard to erase any connection with the Angels, now actively promote it, aware that many customers are purchasing their machines in order to buy into a little of the outlaw mythology. An article in the *Royal Canadian Mounted Police Gazette* laments that many high-profile Hollywood celebrities – such as Pamela Anderson, Jean-Claude Van Damme and Sylvester Stallone – employ Hells Angels as security, just one example of their building media presence, as Angels increasingly appear on TV in motorcycle makeover and wrestling shows. 'It's a highly calculated commercial plot designed to portray the bikers as glamorous, slickly vicious role models,' contends the *Gazette*. Perhaps, but it's a plot that probably succeeded decades ago, and one that the Angels can legitimately claim they were initially drawn into against their will.

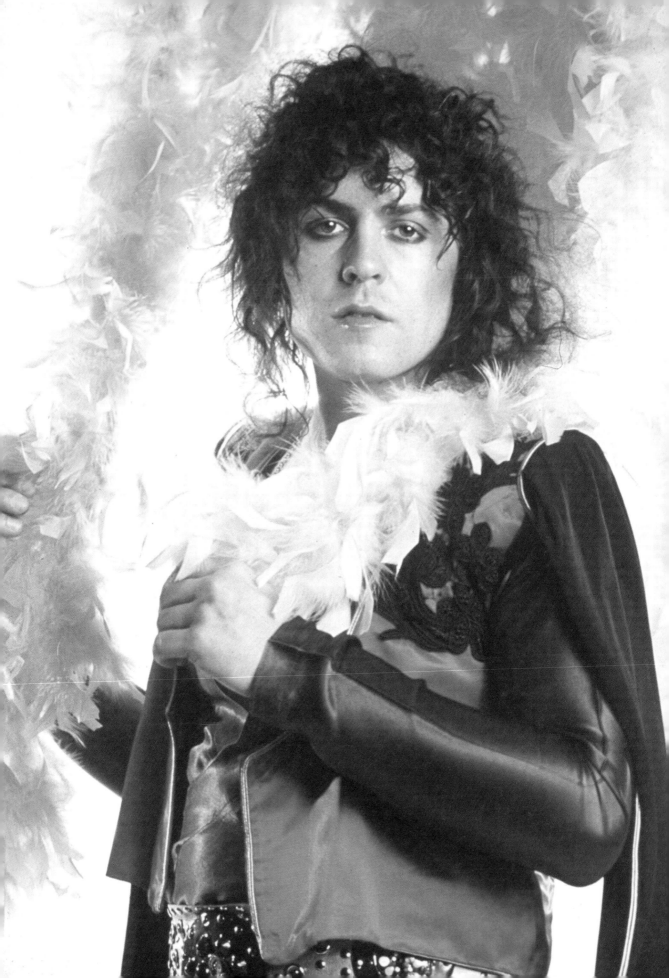

GLAM ROCKERS
Get It On

Air-headed and artistic, kitsch and controversial, glam rock erupted in a glittering cascade of contradictions.

If the seventies were a golden age for fashion crimes, glam rock had its sticky fingerprints all over most of the worst offences, being the main culprit when it came to towering platform boots, sparkly jumpsuits and lurid make-up applied with a trowel. Air-headed and artistic, kitsch and controversial, glam rock erupted in a glittering cascade of contradictions. Though glam revelled in the high camp traditionally associated with gay culture, as far as many of the bands were concerned, the style was a strategy to impress girls. It was a gaudy mix of effeminate mincing and macho swagger, of gold lamé blouses opened to the navel to reveal hairy chests. In its heyday, glam's garish gender-bending and fey flirtations with homosexuality created a seismic shock on the British high

Opposite: The seventies king of camp, Marc Bolan, poses in full glam-rock regalia.

streets. By the mid-seventies, glam had become so ubiquitous as to barely qualify as a subculture, but it paved the way for both the most revered and reviled of the subsequent style cults, in the form of punk rock and hair metal.

Our story starts with the BBC programme *Top of the Pops*. In the years before MTV, when UK TVs had only three channels on the dial, the Thursday-night show, broadcasting a rundown of the week's bestselling singles, was required viewing for seventies teens, and a gateway to stardom for the era's aspirant pop stars. Other scenes and subcultures may trace their roots back to legendary gigs in smoky backstreet venues or underground tape-trading networks. But, almost without fail, glam-rock devotees recall first witnessing a performance on *Top of the Pops* at an impressionable age as their disco-ball light on the road to Damascus.

The bands that made the biggest impact in this more innocent era were those who managed to shock older viewers without getting pulled off the air by the bigwigs at the BBC, and the most effective strategy for raising eyebrows proved to be camping it up in grand style.

Glam rock's birth date was 1971, with the release of the single 'Hot Love' by the London band T. Rex, largely a vehicle for the charismatic singer and guitarist Marc Bolan. Bolan's publicist had been encouraging him to shop in fashionable women's boutiques for increasingly effeminate clothes – embroidered indulgent pretensions of hippie-folk rock, it was snappy, throwaway pop matched with a deliberately disposable, shamelessly artificial and gaudily modern image, a happy accident practically designed for the television screen, which now made and broke music careers.

Androgyny wasn't anything new in pop and rock. When beatnik and then hippie guys had started growing their hair and preaching non-violence, conservative commentators were quick to challenge their masculinity. Perhaps the first rock band to flirt openly with androgyny was the Rolling Stones (though the

Marc Bolan added the crucial ingredient of glamour to the recipe of sexual ambiguity in 1971, triggering an era of lurid theatrical display and camp swagger in British popular culture almost literally overnight.

satin, colourful silk and feather boas – to emphasise his androgynous good looks. On a whim, to perform 'Hot Love' on *Top of the Pops*, she also put glitter under his eyes. It was the night that launched glam rock. 'As soon as he got on TV, basically it all took off,' recalls David Enthoven, then managing T. Rex. 'Marc definitely started it. He was the first to put glitter on his face . . .'

Few descriptions of Marc Bolan fail to use the adjective 'elfin' – the slender, young singer had charisma that transcended gender, pretty and petite with a mane of dark corkscrew curls and girlish good looks. It was an image that fit well with the hippie movement's affection for fantasies influenced by author J.R.R. Tolkien's popular *Lord of the Rings* trilogy, filled with goblins and wizardry. Initially Tyrannosaurus Rex were a psychedelic folk act, with Bolan claiming inspiration from a wizard he'd met in Paris. But sensing a burgeoning new trend, the singer abandoned the acoustic guitar and went electric, scoring a minor hit in 1970 with 'Ride a White Swan', under the new, catchier moniker T. Rex. In contrast to the epic, self-legendary, bisexual black rocker Little Richard should also take a bow for introducing an electric charge of camp into the rock'n'roll recipe as far back as the fifties). Mick Jagger's stage persona was certainly somewhat sexually ambivalent, the singer's lascivious pouting and strutting sufficient to inspire comments about his manliness from unsympathetic critics.

Marc Bolan added the crucial ingredient of glamour to the recipe of sexual ambiguity in 1971, triggering an era of lurid theatrical display and camp swagger in British popular culture almost literally overnight. 'As soon as the camera got hold of him it was obvious,' recalls Enthoven of the impact of T. Rex's trendsetting *Top of the Pops* performance of 'Hot Love'. 'He was very telegenic, but he was asexual too. He looked like a girl but he was a boy. It was perfect – it captured the moment and it was what the kids wanted. It was completely different to all the studious hippies that were around at the time. It was sexy.'

It may have been sexy, but the vast majority of converts to the burgeoning glam crusade were youngsters, incapable of growing a

hippie beard or Zapata moustache even if they wanted to. If glam was to make a mark, to represent more than a blip on the cultural radar, it needed an artist capable of recording material with more substance than T. Rex's two-minute boogies. Bolan's disarmingly ditzy singles – with their cool yet utterly nonsensical lyrics – were perfect for filling the dancefloor, but less likely to impress critics. Waiting in the wings was David Bowie, an artist with a strikingly similar pedigree to Marc Bolan. Like Bolan, Bowie was a talented chameleon who had adapted with the times in his quest for fame, a subcultural butterfly who had flitted from mod to hippie psychedelia (under his given name, Mark Feld, Bolan was the young mod interviewed in the influential 1962 magazine article 'Faces Without Shadows'). Like Bolan, Bowie had androgynous good looks, and in the burgeoning glam-rock era, he spread his wings, launching one of the most influential careers in modern pop culture.

Significantly, while Marc Bolan's sex appeal was ambiguous, many would describe David Bowie's erotic chemistry as practically alien. The world was in the grip of the space age. While regular folk were transfixed by the amazing achievements of NASA, putting a man on the moon in 1969, freaks speculated on the possibilities of life from other galaxies and what they might teach us, watching the skies for extraterrestrial visitors. David Bowie exploited both fascinations with his oddball prog-rock album *Space Oddity*, and the BBC played the title song over footage of the moon landing, securing the singer a minor hit. For his next album, *The Man Who Sold the World*, in 1970, Bowie was depicted on the cover in what looked like drag, though the singer himself insisted he was wearing 'a man's dress'. Darker and deeper than T. Rex's disposable pop, some champion Bowie's frock rather than the glitter under Bolan's eyes as the true visual trigger for the glam revolution, though the album enjoyed

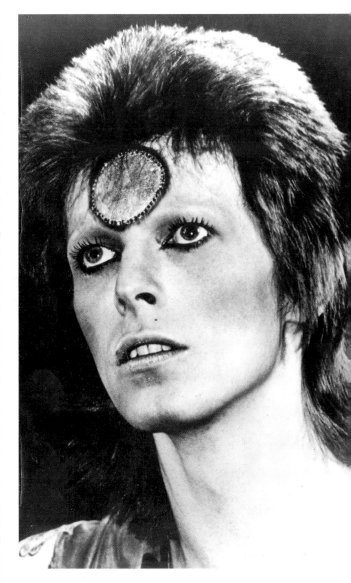

Above: *David Bowie, the pop chameleon who gave glam some artistic substance.*

more critical approval than commercial success. Friendly rivalry would characterise the relationship between the two rising stars who led the glam revolution fermenting in British youth culture.

David Bowie's status as a glam icon was assured with the 1972 release of *The Rise and Fall of Ziggy Stardust and the Spiders from Mars*, a loose concept album concerning a rock star whose building popularity somehow foreshadows

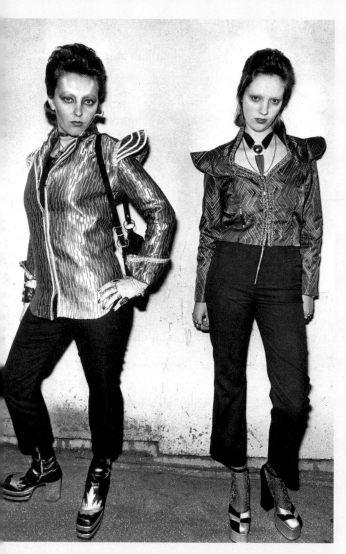

Above: Two Bowie fans rock the futuristic androgyny look in 1973.

Like Bolan, Bowie had androgynous good looks, and in the burgeoning glam-rock era, he spread his wings, launching one of the most significant careers in modern pop culture.

both an extraterrestrial visitation and the end of the world. In the subsequent exhaustive promotional tour Bowie *became* Ziggy, a cadaverously slender, gender-ambiguous rock god from another planet, complete with a wardrobe of outrageous outfits and equally provocative onstage antics. The singer was resplendent in a range of lurid jumpsuits and figure-hugging metallic stage gear, topped with an arresting tangerine coiffure and unearthly make-up. Glam was emerging as a style that wasn't so much modern as campily futuristic,

Bowie's influence introducing a science-fiction element into the embryonic glam style. While the hippies of the sixties championed a back-to-nature look, nostalgic for the lost innocence of days long past, these new young rebels embraced the space age, with all of its artificial glitz and plastic sheen.

By 1973, in the wake of his successful follow-up album *Aladdin Sane*, the magazine *Music Scene* observed that Bowie was followed by a legion of 'imitators. All across the country on his last tour, boys and girls, men and women were turning up in their Bowie make-up and garb. The zig-zag from the *Aladdin Sane* sleeve, and the gold studded spot in the centre of the forehead, which Bowie used throughout the tour, were to be seen flashing from all parts of the auditorium.'

In his book, *Seventies*, Howard Sounes suggests that Bowie's camp influence manifested in the most unexpected places, that even such bastions of masculinity as the hooligan element at Manchester United football matches were caught up in Ziggymania, adopting elements of the singer's charismatic androgynous alien style: 'from football terraces to sixth-form common rooms, liking Bowie was totally acceptable and, indeed, fashionable for British teenagers in 1972'.

In the wake of Bowie and Bolan, *Top of the Pops* swiftly experienced an alien invasion of bands seeking to emulate the success of T. Rexstasy and Ziggymania. At the forefront of this new wave of unconvincing transvestites were the

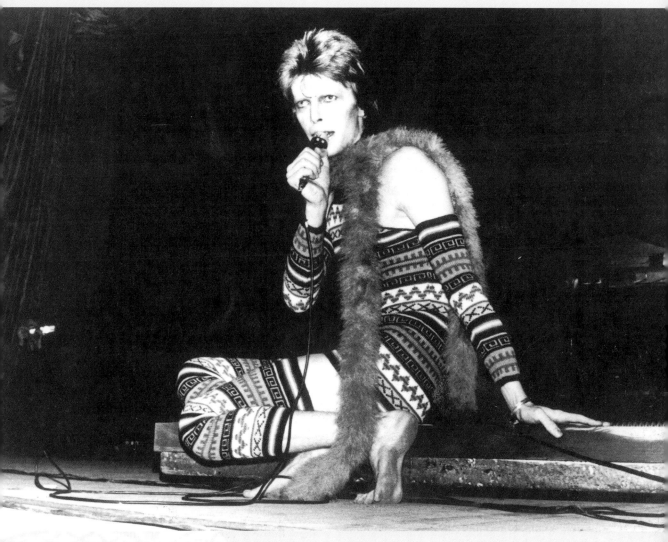

bands that became known as the Chinnichap acts – musicians taken under the wing of the songwriting team of Nicky Chinn and Mike Chapman. This dynamic duo dominated the charts in the early seventies with a salvo of cheap and cheesy manufactured pop, most of it hoisted onto platform boots and dusted with the glitter pioneered by Bolan and Bowie. Perhaps the most successful of the Chinnichap bands were the Sweet. 'Glam was something that came out of everyone's rehearsal sessions and their meetings with their own managers,' Sweet frontman Brian Connolly told authors Jeremy Novick and Mick Middles. 'We would

Above: A fashion nightmare in knitwear – only Bowie could have gotten away with it unscathed.

watch the other bands like hawks and they'd watch us. So we'd all be planning what to wear, getting increasingly outrageous, trying to out-shock the other bands.'

A short shelf life was almost part of the essence of glam rock. The best argument for it being more than a gaudy passing fad is that it opened eyes to sexual possibilities, kicking down gender boundaries with its absurdly theatrical platform boots. While the likes of the Chinnichap bands may have vulgarised the lofty artistic aspirations of David Bowie's

These new young rebels embraced the space age,
with all of its artificial glitz and plastic sheen.

apocalyptic visions, making it all into something of a joke, they also democratised glam, bringing it within the reach of kids in the street.

While the US charts remained suspicious of domestic glam (it never really took off in the States, where it was known as glitter rock, the way it did in the UK), David Bowie and the Sweet enjoyed some transatlantic success.

Faddish Los Angelinos even began to fetishise camp Anglophilia, and in the autumn of 1972, music publicist Rodney Bingenheimer opened his English Disco on the notorious Sunset Strip at Bowie's suggestion. It became the hip place to be, and visiting British singers discovered that all you needed to score with the chicks was an English accent. The English Disco

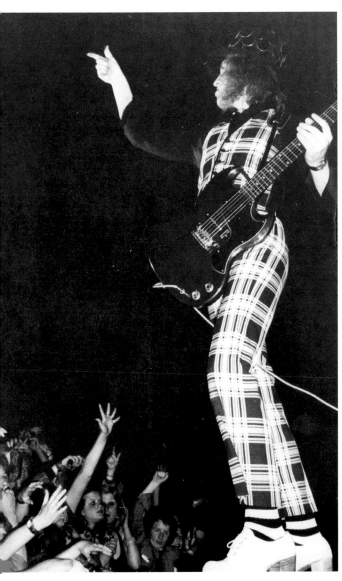

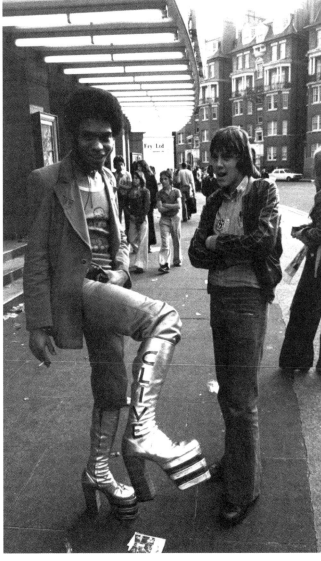

took glam's decadence and lurid worship of youth to decidedly unsavoury extremes. 'The dancefloor is a dizzy kaleidoscope of lamé hotpants, sequined halters, rhinestone-studded cheeks, thrift-store anythings and see-through everythings,' reported *Newsweek* magazine in January of 1974.

By then the movement was already on its last legs. In October of 1974, the Hollywood Palladium hosted a 'Death of Glitter' night, and glam was fast running out of steam in its British birthplace too. It had always been a novelty, and once that novelty began to wear thin, glam's days were numbered. David Bowie – an increasingly astute observer of burgeoning trends – abandoned the second of his glam personas, Aladdin Sane, in 1974 for a radical image rethink. Marc Bolan was beginning to look increasingly short of ideas, the original T. Rex line-up disintegrating while hits began drying up. In a sign that in retrospect looks a lot like desperation, most of the UK's glam acts began recording anaemic ballads. A notable exception was the Sweet, who dispensed with the services of Chinn and Chapman and pointed the way forward for glam with their drive into the realms of hard rock. It was the New York band Kiss who conquered US charts in the late seventies with a blend of kitsch heavy metal and spectacular stage shows that wowed American teens. They were followed by a wave of bands that became known as hair metal, and for much of the eighties the American charts played host to rock acts with macho attitudes and carefully-coiffured manes. It was an incongruous development that left both metal traditionalists and mainstream music critics equally unimpressed. Somehow, the gaudy gender-bending of English glam's innocent pop era had opened the door for some of rock's most unreconstructed chauvinists, albeit sexists wearing more make-up than their legions of groupies.

Glam's other legacy is less unloved by rock historians. The New York Dolls were a notably ill-fated band, their authentically self-destructive lifestyle leaving four members dead in their chaotic wake. But they paved the way for the birth pangs of New York punk, that would in turn blossom into the the London scene. The Sex Pistols' vocalist Johnny 'Rotten' Lydon has lauded the bold outrageousness of Ziggy Stardust, which impressed him as a kid. Bowie himself was unambivalent regarding his character's impact on the iconic punk: 'Ziggy Stardust had a mutant bastard offspring and his name was Johnny Rotten.' According to the music journalist Charles Shaar Murray, Ziggy had a similarly galvanising effect on a generation of teens, providing 'the impetus for kids to dye their hair fantasy colours like blue, green, scarlet and purple . . . to wear clothes based on *Flash Gordon* comics and thirties movies, to be exactly what they wanted to be and screw reality, Jack!'

> The gaudy gender-bending of English glam's innocent pop era had opened the door for some of rock's most unreconstructed chauvinists.

Opposite left: Loveably laddish glam-rocker Noddy Holder, lead singer of Slade, performs onstage. Opposite right: Some of the band's suitably stylish fans outside the venue.

SKINHEADS
Boots and Braces

By the eighties, skins had earned a reputation as the street soldiers of the UK's militant, racist right wing.

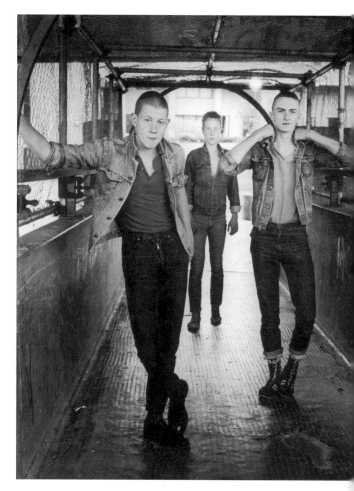

Above: The Redskins, a left-wing band who were keen to challenge the stereotype of skinheads as mindless fascist thugs.

There were few more daunting sights on the streets of seventies Britain than the approach of a group of skinheads. Booted, braced, bald-headed, strutting Myrmidons, they exuded an omnipresent aura of violence – and they knew it. At the time, few stopped to wonder as to the origins of this new tribe; when the skins made their uniquely anti-social presence felt, most preferred to make themselves scarce. By the eighties, skins had earned a reputation as the street soldiers of the UK's militant, racist right wing, making them beyond the pale as far as most journalists and social commentators were concerned. Only in recent years have some outsiders paused to wonder just what spawned the skinhead movement, their curiosity abetted by the emergence of several creative figures with skinhead pasts. Going public with accounts of their shaven-headed teenage years, they've confounded the cliché that all skins were brainless thugs.

'The skinheads' look was striking. These guys had charisma . . . all you had to do, it seemed, was shave your head and put on some big boots and people would be scared of you,' recalls Shane Meadows, a Glaswegian skin who grew up to become an acclaimed writer and filmmaker. His most successful film to date, 2006's *This is England*, draws upon his own experiences to paint a picture of the UK in 1983 from the point of view of a twelve-year-old skinhead. Meadows himself drifted away from the subculture after witnessing a brutal and pointless assault on a fellow skin. The

Opposite: The popular image of the skinhead movement remains one of intimidating belligerence.

perpetrator was an older skin Meadows once idolised. 'I am still, through my films, exorcising the guilt and shame I feel over provoking that beating,' confesses Meadows. The ambivalence implicit in his acclaimed film – *This is England* is largely sympathetic to the subculture – reflects a growing tendency to re-evaluate the skinhead movement as something more than a cult of defiant ignorance and mindless brutality.

Skinhead was born of that quintessentially British subculture, mod. The mod scene started to unravel in the wake of the widely reported disturbances on the south coast in 1964. Disgusted by the whole debacle, many original mods began to drift from the movement,

gravitating slowly towards the colourful psychedelia of California's burgeoning hippie movement. Others, however – weary of the endless espresso-bar sartorial one-upmanship of the Soho dandies – relished the excitement of these beachside confrontations. As mod spread beyond London's fashionable West End, regional rivalries emerged, with violence between mods becoming at least as common as their headline-grabbing rumbles with rockers.

The figures at the forefront of such battles became known as 'hard mods', to distinguish them from the traditionalists (dubbed 'peacocks' or 'soft mods') still clinging to the idea that impeccable tailoring remained the essence of mod. Sharp suits began to take a backseat in the hard mod wardrobe. While the archetypal mod wouldn't leave the house without the latest threads, these embryonic skinheads kept their suits for special occasions, such as nights out, developing a new uniform for everyday wear that owed more to manual work clothes. The evolution of mod reflected the changing economic reality of life in the UK, as employment opportunities began to dry up and social mobility diminished.

There were elements of class conflict in the legendary clashes between the mods and rockers, of upwardly mobile modernists challenging defiantly blue-collar bikers. The emergence of the skinhead movement reflected similar tensions within mod itself, as an influx of working-class recruits swelled the subculture's ranks. By 1964, many of the scene's new members simply didn't have the funds to compete in the style stakes, even if they had wanted to. Many didn't. If nothing else, it was becoming old hat, the Ivy League and Italian fashions now commonplace and commercialised. As mod spread and rivalries between factions from different towns and districts grew, many gravitated towards styles that were both more affordable and practical in an environment where being a mod involved defending your turf as much as dancing all night.

Hard mods were sometimes dismissively described as 'peanuts', in reference to their increasingly close-cropped scalps. Short, neat haircuts had been part of the mod look from the start, but this new breed favoured cuts that went ever closer to clean shaven. While classic mod hairstyles might appear foppish or showy, this was a trend with a confrontational edge. Shaved heads were traditionally associated with convicts or soldiers – a utilitarian style that emphasised difference from mainstream society – a style statement for outcasts and warriors in direct contrast to the preening neatness of the original mods. Some have seen an element of class warfare in the shaven scalps of the working-class skinhead revolution – a deliberate antithesis of the long locks of the emerging middle-class hippie subculture.

Skinhead chroniclers have challenged this, pointing out that hard mods began cropping their hair before the first wisps of flower power began to drift across the Atlantic. On the other hand, some beatniks wore their hair long in the early sixties, and a sense certainly developed among the skins that their neat appearance was in sharp contrast with such deliberately unkempt 'drop outs', who had abandoned a privileged world beyond the ambitions of the many working-class youngsters languishing in neglected housing estates. The Summer of Love was a party they were never likely to be invited to. The response of many hard mods and skinheads, however, was visceral and tribal; middle-class beatniks and hippies and proletarian rockers were all dirty 'hairies' – to be treated with equal contempt.

While the original mods aspired to lives of leisure, at pains to conceal any trace of a blue-collar background, skinheads were proud to flaunt their humble roots.

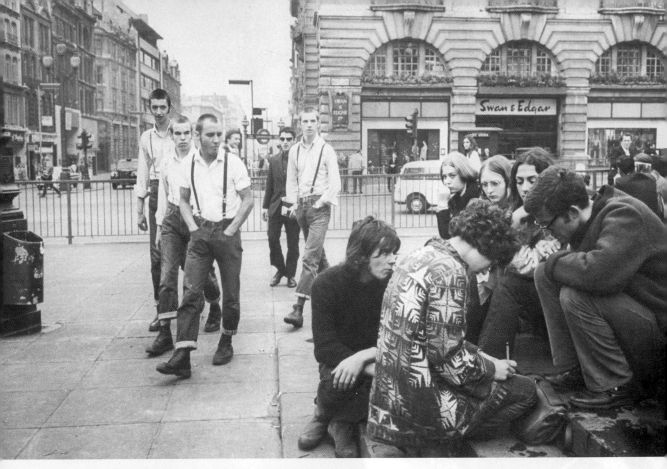

Hard mods began to favour designer garments with a British pedigree, such as Fred Perry tennis tops, Harrington jackets, Ben Sherman shirts and Crombie coats. While their cosmopolitan mod forebears had little time for patriotism, this became a defining feature of the embryonic skinhead subculture, in tandem with fierce working-class pride. While the original mods aspired to lives of leisure, at pains to conceal any trace of a blue-collar background, skinheads were proud to flaunt their humble roots.

The defining skinhead fashion statement was another classic British brand, the Dr Martens boot: working men's footwear that few West End dandies would even consider. Like the close-cropped hair, Dr Martens were also more practical in a street-fight, and the steel toe-capped boot became iconic within the subculture. While mods sought to express themselves with sartorial display, the skinhead look was becoming a uniform for disenfranchised youth, only able to assert themselves with their fists and feet. The final factor in the formation of skinhead was West Indian culture. Surprisingly, given the movement's modern reputation for racism, Caribbean culture was a crucial ingredient in the original skinhead cocktail – specifically the rude boys. Courtesy of increased immigration rates in the fifties, these Jamaican gangs were a fixture on inner-city streets across the country.

Rude boy styles – including skinny ties, trilbies and pork-pie hats (influenced in turn by classic gangster flicks) – all fed into the early skinhead look. Sixties skins were drawn to the vibrant musical scene blossoming in Britain's black dancehalls – where the rude boys' soundtrack was ska, rocksteady and reggae. One pivotal moment came in 1967, when Jamaican singer-songwriter Desmond Dekker undertook a UK tour. 'When we brought Desmond over we gave him a suit, but he insisted that the bottom six inches of the trousers should be cut off,' recalls promoter Tony Cousins. 'Then the kids began

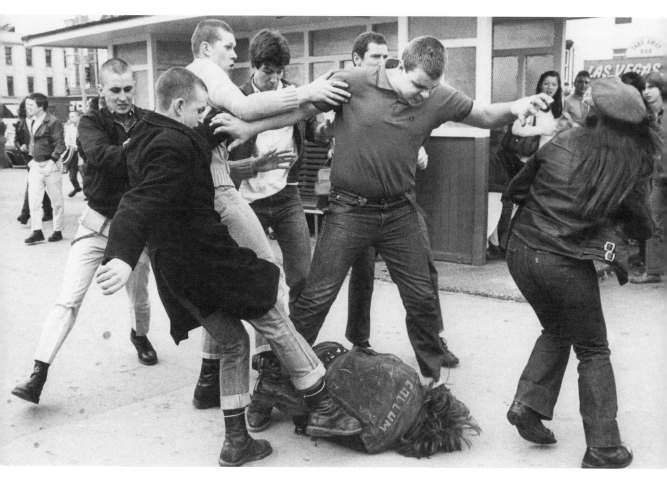

Above: Violent clashes continued in England's south-coast resorts long after the sixties, though skins replaced mods as combatants – seen here attacking a rocker in Southend in 1980.

to follow him.' Add a pair of braces to hold up the Levi's jeans, rolled up to reveal a pair of lovingly polished Dr Martens, and the classic skinhead uniform was complete.

The late sixties marked a craze for a specific style of Jamaican-born music called skinhead reggae. 'I used to have a lot of skinheads come to listen to me too,' recalls Laurel Aitken, the Cuban-Jamaican singer who's been dubbed 'the godfather of ska'. 'I was playing the music that they wanted to hear . . . skinhead reggae or ska. I used to be a skinhead, with my porkpie hat and my suits and everything, and yeah, there were lots of black skinheads.'

Quite when skinhead became a distinct subculture, severing its links with mod, is difficult to say. As early as 1968, the burgeoning movement was attracting enough attention to

inspire a report by ITN. 'I'd rather be a skinhead than anything else,' explained their young, shaven-headed interviewee, emphasising the cult's pride in appearance – often overlooked by critics who couldn't see past its macho swagger. 'He's a much smarter dressed person than a hippie or a rocker – he looks smarter, his hair always looks cleaner – his appearance is much cleaner I think.'

For some skinhead traditionalists, the year 1969 became iconic – the subculture's heyday before it became fragmented and entangled in political extremism. Those who rejected racism in favour of endorsing the movement's Caribbean roots styled themselves 'Trojan

skinheads' – in reference to a record label specialising in reggae, ska and rocksteady. 'The Spirit of 1969' has become something of a rallying cry among Trojan skins, popularised by the Glaswegian skinhead George Marshall, who published a book under that title in 1994. 'We coined the catchphrase "Spirit of '69" because the image of Nazi boneheads had nothing to do with what skinheads were about,' he explained. 'You can't have roots in black music and be into white power. We wanted to remind people of our roots in 1969 – of smartly dressed kids into ska.'

Trojan skinheads began to employ the term 'bonehead' for their fascist counterparts, reflecting both the tendency among Neo-Nazi skins to shave their heads down to the scalp and their reputation for mindless thuggery. To further complicate the picture, by 1969 another subset had emerged known as suedeheads, who adopted a smarter, less extreme version of the skinhead look, with suits, hair still long enough to comb and brogues instead of boots. While skinhead was an overwhelmingly masculine subculture, girls did join, adopting either the modette look – A-line skirts and bobs – or, increasingly, a feminised take on classic male skin attire. Some favoured the shorter Monkey Boot over the classic Dr Martens (both traditionally manufactured by the same UK firm). The feather-cut (or Chelsea cut) – a hairstyle that's cropped on top, with a longer fringe at the front, back and sides – gradually became popular. Some skin girls emphasised their femininity further with miniskirts and stockings, especially fishnet.

By 1970 skinheads were making the international news. The nauseating term 'Paki-bashing' was coined for unprovoked attacks on Asian immigrants – associated with shaven-headed thugs – and in April of that year it claimed its first life, as a man was beaten to death in London. The early skins' respect for the Caribbean community often didn't extend to Indian and Pakistani immigrants. The following month Pakistan's high commissioner met with the British government, to warn that such racist violence threatened relations between the two nations. The skinhead subculture was threatening to become the subject of an international incident. By June, America's *Time* magazine had picked up on the story, painting a far from pretty picture of the new youth cult as a bigoted, violent presence on Britain's streets: 'While they favour the boot as a primary weapon, they also use their heads to "nut" or butt a victim, and whatever other weapons come to hand: bricks, rocks, bottles, knives and razors.'

The skinhead look was becoming a uniform for disenfranchised youth, only able to assert themselves with their fists and feet.

While some might dismiss such reportage as a typical example of the biased coverage that has plagued the skinhead movement, even the most sympathetic commentator can't deny that the subculture has never shied away from confrontation. At the very least, skinheads were becoming involved in the class and racial friction building in the UK. 'Last week more than 2,000 Pakistanis marched on Number 10 Downing Street to protest skinhead attacks, which have numbered more than fifty in recent weeks,' reported *Time*.

As is so often the case, the tabloid media were busy creating a self-fulfilling prophecy. The more the press reported and sensationalised skinhead violence, the more volatile youngsters were drawn to the subculture, while established skins were goaded into living up to their building infamy. Pulp paperbacks – influential teen entertainment in the days before VCRs, DVDs and home computers – also rose to the challenge,

The more the press reported and sensationalised skinhead violence, the more volatile youngsters were drawn to the subculture.

particularly those produced by the New English Library. Specialising in the literary equivalent of lurid, low-budget movies, this publisher began targeting the teen market with graphic, violent, sleazy paperbacks themed by various subcultures.

Having already enjoyed success with sensational biker novels like *The Sex and Savagery of Hell's Angels*, NEL had another big hit in 1970 with *Skinhead*, a novel depicting the fictional excesses of its sadistic, shaven-headed anti-hero, Joe Hawkins. It sold over a million copies, spawning a series of follow-ups by author Richard Allen (real name James Moffat), mostly recounting the further misadventures of the repellent Hawkins. Moffat's books became required reading among skins, acting as recruitment literature for adolescent thrill-seekers.

In addition to the skinhead books, he penned potboilers on suedeheads, sorts (female suedeheads), punks, mods, smoothies, boot boys and terrace terrors. The first of Moffat's skinhead books was written after his editors at NEL suggested he write a novel based in the world of football hooliganism. It's surely no coincidence that the rise of the original skinhead subculture parallels that of the British soccer hooligan. Hooliganism is as old as football itself (as early as 1314 King Edward II banned the sport as a catalyst for violent disorder), with sporadic outbreaks of fan violence occurring throughout the game's history, but it wasn't until the late sixties that fighting between rival supporters became a regular feature. England's victory in the 1966 World Cup hugely invigorated enthusiasm for the game in its English birthplace, and attendance soared. In tandem with this, improved transport meant travelling to away-games became a requirement for any dedicated

fan, and as rival fans met in numbers, incidents of violence escalated.

The hardcore of this aggressive new breed set about organising themselves into 'firms' and thus, football hooliganism emerged as 'the English disease' of the seventies.

Football, long a pillar of working-class culture, began to eclipse music as the most significant recreational pursuit among skinheads. The increasing number of shaved heads to be seen on the terraces fuelled fears of a growing skinhead army. There was also cross-pollination, as pugnacious fans with no previous link to the subculture began to adopt elements of its menacing uniform – more practical in a fight than fashionable long hair and flares. Such quasi-skins earned themselves the appropriately blunt moniker of 'boot boys'. Yet, while the distinctive boot-boy look might intimidate rivals, it also alerted the police, who began confiscating braces and shoelaces at matches, reasoning that it would leave potential troublemakers too busy keeping their boots on and trousers up to start fights.

A turning point came in 1977, when Liverpool fans looted fashion stores in France. The expensive designer clothes they stole became trophies of battle. Fashions previously mocked as 'effeminate' in the macho culture of the terraces were now legitimised, and the casual was born. Casual combined the aggression of skinhead with the mod penchant for exclusive clothing, but lacked the substance to qualify as a subculture, merely representing the violent component of mainstream football fandom in the eighties. Like the smoothies – another loosely defined group that favoured the trends of the era (most notably pastel shades and lop-sided 'wedge' fringes) – casuals were conformists

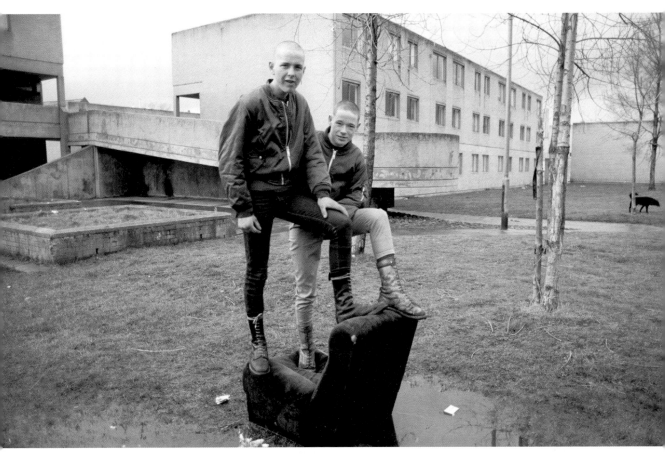

Above: Skinhead is all about working-class pride – these two youngsters are pictured in a Newcastle estate in 1985.

in every respect except for their appetite for violence. Not so much a counterculture as an indication of just how anti-social it's possible to become within the mainstream; so long as you had an expensive label on your sweater, you'd never be branded an outcast.

The evolution of skinhead in the turbulent seventies is equally entangled with the rise of the racist right. The National Front was founded in 1967 as a patriotic party opposed to immigration and socialism, though opponents condemned the movement as Neo-Nazi. Racism was on the rise and an increasingly visible presence at the NF's notoriously volatile rallies had shaved heads and Dr Martens boots. As already noted, by no means all skinheads were – or are – racists, but even the most optimistic apologist cannot deny that many skins joined the right-wing surge in the seventies.

Matters came to a head in the summer of 1977, when a deliberately provocative NF march through the racially diverse borough of Lewisham in London climaxed in a riot, with over 200 arrests and in excess of 100 injuries. While the National Front portrayed itself as successfully standing up for free speech in the face of anti-fascist hostility, it proved a turning point, and as the British public began to associate the NF with street violence, the Front's influence declined.

The Lewisham riot happened as punk was reaching its climax in British culture. Just as it had proven a galvanising force in so many other subcultures, punk had an impact on the skinhead movement. Punk's amorphous, nihilistic tone left it wide open for interpretation. While many

Football, long a pillar of working-class culture, began to eclipse music as the most significant recreational pursuit among skinheads.

of the scene's pioneers would later claim that they employed swastikas purely for shock value, they lent Nazi iconography a certain rebellious chic, making shock statements that wouldn't have looked out of place in an NF pamphlet. (The Sex Pistols' 'Belsen Was a Gas' represents a notable nadir in taste.) The liberal press had been assiduously attempting to steer punk in a left-leaning direction, purportedly searching for the authentic voice of the deprived youth. When they got it, it proved to be something of a shock. Since punk had toyed with violence and taboo imagery, it was inevitable that something would come along and spoil the game.

It came in the shape of Oi!, a wave of music that erupted from the underground in punk's immediate wake. Devoid of fashionable political pretensions, these bands sung about street-fights, pubs and soccer with a crude anthemic sound that combined basic punk thrash with football-chanting vocals. After an abortive start in 1976, the band Sham 69 proved to be scene forefathers, releasing their debut single 'I Don't Wanna' the following year. The band abandoned touring in 1978, after excessive violence at their shows, initiated by National Front boneheads. Sham 69 became desperate to shake their unwelcome fascist following, playing Rock Against Racism benefits. But numerous other bands were entering the fray, happy to embrace such volatile audiences. The most notorious of these was Skrewdriver, who formed in 1976 and, after experimenting with punk and biker rock, emerged as the archetypal Oi! band. If Oi! was initially apolitical – insiders maintain that violence at the early gigs was related to soccer rivalries – by the eighties the scene was indelibly

Above: Tough as . . . Dr Martens indestructible footwear remains a staple within the skinhead wardrobe.

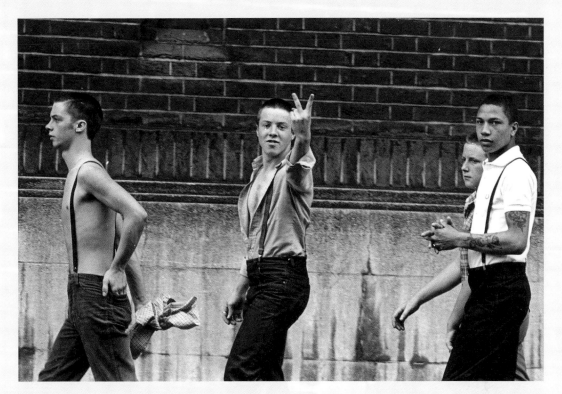

linked with the Nazi skinhead hardcore. Skinhead fashion of the era evolved to include elements of army surplus gear, particularly bomber jackets in khaki or black, while swastikas and Iron Crosses became part of scene iconography.

This swing to the right did not go unchallenged. Oi! had been important in sustaining the skinhead spirit by finally providing the subculture with a soundtrack played explicitly for skins by skins. It also finally severed the scene's musical connection to the UK's Caribbean immigrant community. Running parallel to this, however, was a movement to return to skinhead roots, manifest as a ska revival. It constituted a counterbalance to the increasingly militaristic skin style, offering instead a return to the rude-boy look. These new skins gathered beneath the two-tone banner. Two-tone reflected not just the multi-racial make-up of the new ska bands, but also a sharp aesthetic, dominated by blacks and whites as well as the shades, tight suits and trilbies of the rude-boy style. The foremost two-tone band was the Specials, formed in the fervid atmosphere of the dying years of the seventies, its members painfully aware that music was coming to signify something more than mere entertainment on the punk and skinhead scenes.

'In Bracknell, the Sham army turned up, got onstage and attacked the lead singer of Suicide, the other support band,' keyboardist Jerry Dammers recalled. 'That was the night the Specials concept was born. I idealistically thought, "We have to get through to these people." It was obvious that a mod and skinhead revival was coming and I was trying to find a way to make sure it didn't go the way of the National Front and the British movement [. . .] It seemed to be a bit more healthy to have an integrated kind of British music, rather than white people playing rock and black people playing their music. Ska was an integration of the two.'

Ska, crucially, was much more fun than the angry anthems of Oi!, particularly as performed by Madness, the clown princes of two-tone. The band's building mainstream popularity and madcap humour didn't stop Madness gigs becoming a magnet for skins of all persuasions.

'There were times when you'd see 3,000 people sieg heiling,' recalled vocalist Graham 'Suggs' McPherson. 'That was a pretty unpleasant situation.' Madness tried to sidestep any political questions, but pressure from the media and fighting at gigs made it increasingly difficult. In 1979 ten people were hospitalised at their gig at Hatfield Polytechnic when a contingent of Anti-Fascist League thugs broke in and attacked the audience, claiming their targets were NF members. The Specials, with their multi-racial line-up, became a magnet for trouble, with the NF actively recruiting at gigs, which routinely led

dirge to soundtrack that bleak, angry summer.

Paradoxically, perhaps, it was the election of Margaret Thatcher to the leadership of the Conservative Party that broke the National Front. She steered her party to the right, providing a respectable political option for voters tempted by NF policies but alienated by their skinhead street presence. The Front's policy of recruiting on football terraces and at Oi! and ska gigs was a sign of desperation, as membership plummeted. By this time, the ska revival was also foundering and – despite the best efforts of bands like the Specials – skinheads were indelibly tarred as a

Skinhead fashion of the era evolved to include elements of army surplus gear, particularly bomber jackets in khaki or black, while swastikas and Iron Crosses became part of scene iconography.

to violent confrontations. 'You're in this amazing, fantastic group making this wonderful music and you can't play it any more because people are hitting each other,' sighed bassist Horace Panter.

The Specials began to fragment under the pressure of such trying touring conditions, but before the classic line-up split, they released the single widely regarded as their masterpiece. The haunting 'Ghost Town' describes a nation in crisis, the youth fighting among themselves as opportunities evaporate in desolate urban wastelands. By the time it came out, in the summer of 1981, Britain's inner cities were exploding into violence as riots broke out across the nation. The same simmering racial tensions that had divided the skinhead movement finally came to a head. Combined with prime minister Margaret Thatcher's austerity policies – which sent youth unemployment spiralling – it created an incendiary situation which exploded in London, Birmingham, Liverpool, Leeds and a host of smaller towns and cities. 'Ghost Town' hit number one in the charts in July, at the climax of the unrest – an eerily appropriate, danceable

cult of brutal racists in most eyes. 'Ten years ago, the politicians moved into the youth market, and some skinheads started to follow right-wing politics,' lamented George Marshall in 1992. 'They were the ones who got the publicity. Organisations such as SHARP [Skinheads Against Racial Prejudice] were formed, but it got to the stage where if you weren't in an anti-Nazi group, people accused you of being a Nazi.'

'The skinheads evolved in America during the 1980s from first being viewed as another counter-cultural component somehow connected to the punk music scene, to being recognised as a separate group outliving the reformation or virtual death of that scene and developing a specific political agenda drawing skinheads closer to right-wing hate movements in the United States, England and Europe,' writes Jack B. Moore in *Skinheads Shaved for Battle: A Cultural History of American Skinheads*. 'This transformation was accompanied by a growth throughout the decade in the number of skinheads but far more markedly in skinhead commission of hate crimes [. . .] motivated by a spirit or ideology of hostility

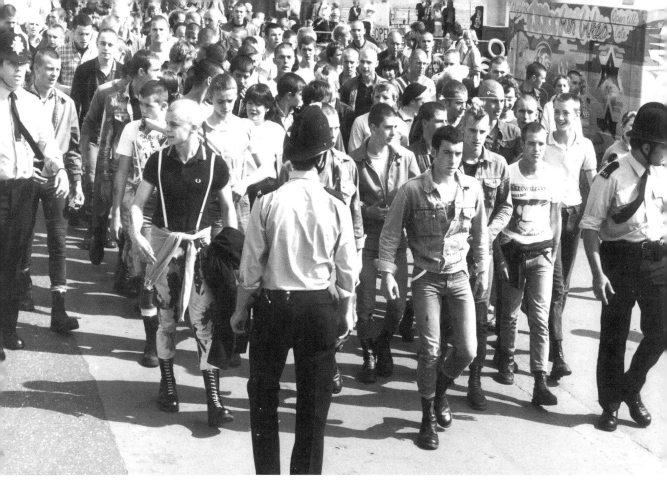

against victims because of their race, national origin, religion, or sexual orientation. By the end of the 1980s they achieved a reputation as the most violent extremist group in the country.'

Certainly, it was the more visible white power version of the movement that travelled in the eighties. Yet, again, this didn't go unopposed. Skinheads Against Racial Prejudice (SHARP) was founded in New York in 1987 specifically to counter the impression that the subculture was implicitly racist, and fly the Trojan flag. The problem was that, by then, the cliché had become a self-fulfilling prophecy. The cult's racist reputation attracted bigoted youngsters to the scene, while more pliable established members were targeted in recruitment drives by radical right-wing groups who – like the NF in the seventies – saw the skinhead movement as a fertile source of intimidating foot soldiers. Sad to say, much of the story of the skinhead movement over the past two decades belongs in the realms of international political extremism

Above: Since the movement's birth, numerous right-wing political groups have attempted to exploit the skinheads as foot soldiers.

and true crime, rather than a study of subcultures such as this book.

Yet to yield the field to the bonehead contingent sells the subculture short. There are perhaps more different stripes of skinhead – black skins, Asian skins, even gay skins – today than there ever were in the movement's heyday. If skinheads are less conspicuous today, it may at least in part be because like so many of the successful subcultures described in these pages, they have become assimilated by the high street. Dr Martens boots are now widely accepted as British design classics, while shaven heads – which once caused people to cross the street to avoid you – are an everyday male fashion. 'The irony is that everybody now thinks skinheads are these big, bonehead Nazis,' shrugs Marshall. 'When we walk into a pub, everybody thinks we're squaddies. Very few people actually think we're skinheads.'

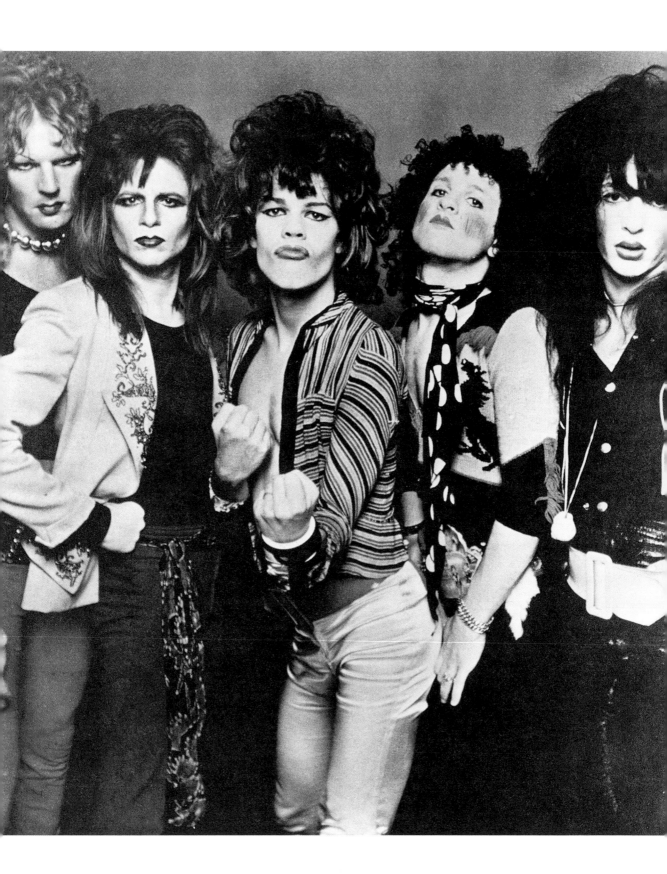

PUNKS

Anarchy in the UK

Literally overnight, punk had become a national phenomenon.

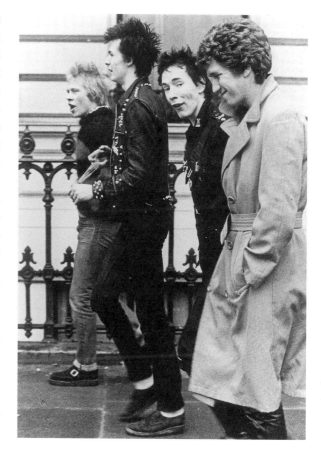

Punk is the archetypal counterculture, the anarchic youth movement against which all subsequent rebel subcultures have been measured, and found wanting. Peruse the music shelves of your local bookshop, and you'll find no shortage of books dedicated to punk. Many are lavish volumes, where the grainy photo-collages and scrappy 'ransom note'-style script, punk's visual trademarks, conspicuously contrast with the expensive paper and production values. Serious studies of the 20th century, which find no space to mention the other subcultures detailed in these pages, routinely detail punk's emergence in late seventies Britain as an event of historic significance. The press that once lambasted punk as an aberration today pay tribute to the cult in their fashion and culture pages. Even the *Daily Mail*, reactionary scourge of all things deviant, lauded ex-prime minister Margaret Thatcher as 'The Punk Rock Premier' in a 2008 feature by A. N. Wilson, a pillar of the establishment by any estimation.

Opposite: *The New York Dolls, the missing link between punk and glam rock.* **Right:** *The Sex Pistols, ready to make cash from chaos.*

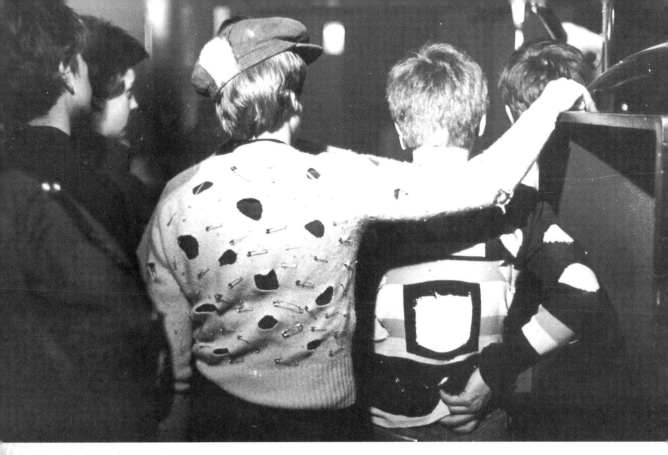

Above: The punk 'uniform' took some time to develop – earlier anti-fashion statements were more eclectic.

A more conventional endorsement of punk's significance can be found in the *Guardian*, in an extensive 2001 retrospective on the movement. Among their interviewees is the BBC DJ John Peel. 'It changed everything more than any other youth movement,' he observed. 'It spread very quickly through every aspect of the culture, and it made things possible for people – bands realised that if they robbed a phone box and the bass player sold his moped, they could make a record and didn't have to come down to London and sign to Warner's.' Peel's seal of approval is significant – the soft-spoken BBC Radio One DJ was a UK alternative legend due to his defiantly eclectic playlist – yet the real challenge in the 21st century is finding anyone with anything bad to say about punk, a supposedly shocking movement that everybody now seems comfortable with. The street rebels with their coloured hair, once castigated as wreckers of civilisation, now charge money to pose for photographs, as much a part of the London tourist experience as Big Ben.

Curiously, and perhaps appropriately, you must consult the cult's originators to hear an alternative – you might even say punk – view on punk. 'The punk movement – it was just a fashion that became a marketing opportunity for people,' the fashion designer Vivienne Westwood told the *Guardian* in 2011. 'It's great nowadays to see young people dressed as a punk, because it's entered into the iconography of "I am a rebel, and that's what I look like if I want to be that kind of rebel", but for somebody my age to think it's got any credibility in any way – no, it hasn't – it's just an excuse for people to run around, without thought.' According to the London entrepreneur Malcolm McLaren, 'Punk was just a way to sell trousers,' while in 1986 John Lydon told the *Observer*, 'Punks in their silly leather jackets are a cliché, I never liked the term and have never discussed it. I just got on with and got out of it when it became a competition.'

For the benefit of those unfamiliar with the cast, Westwood and McLaren ran the fashion boutique SEX on London's fashionable King's

Road. Its principal claim to fame was launching the career of the Sex Pistols, the band that ultimately established Lydon – via his brief career as Pistols vocalist Johnny Rotten – as one of England's most unlikely popular icons. In many respects, the story of the meteoric rise and fall of the Sex Pistols between 1975 and 1978 is the story of punk. Some, however, contend that the raucous Essex pub-rock band Eddie and the Hot Rods are the original punks. Others insist that the movement was born on the other side of the Atlantic, courtesy of gutter glam-rockers like the New York Dolls or the aggressively minimalist pop of the Ramones. Yet without the fervid media frenzy generated by the Sex Pistols, punk would never have achieved its status as an international phenomenon, a bellow of outrage that changed the face of pop culture forever, the sneer that launched a thousand careers.

Even accepting the Sex Pistols as the embodiment of punk, however, the true nature of the movement's seismic impact remains controversial. Or, more specifically, its true author. Was punk a calculated stunt masterminded from behind the scenes by the band's manager Malcolm McLaren, or a street-level rebellion inspired by Pistols vocalist John Lydon? The last great modern art movement or just a cultural safety valve that allowed frustrated teenagers to let off steam? A grassroots political explosion or a giant practical joke that got out of hand? All – or indeed none – of these may be true. It depends on who you ask, where you stand, or perhaps what intoxicants you were on at the relevant moment. To further confuse the picture, the archetypal punk most of us would recognise – studded leather jacket, Doc Marten boots, and Mohican crest – didn't emerge until after the movement had expired in the eyes of many of its originators.

Above right: Malcolm McLaren and Vivienne Westwood and (below right) a suitably provocative promotional shoot for their fashion boutique SEX.

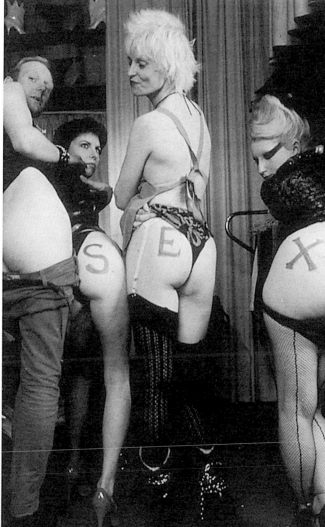

'Punk' began as an old word for prostitute. In American prison slang it became an insult referring to the passive partner in a homosexual sex act. Hollywood scriptwriters picked up on the word as a term of abuse safe to use in gangster films, primarily because censors would allow it, blissfully unaware of its true meaning. Most audiences also assumed that 'punk' was simply mobster slang for a gutter-level hoodlum, slowly eroding its true, rather more colourful and obscene original meaning among the underworld fraternity.

Its probable first use in the sense in which we understand it today was in a 1970 essay for the US magazine *Fusion* by journalist Nick Tosches. Entitled 'The Punk Muse: The True Story of Protopathic Spiff Including the Lowdown on the Trouble-Making Five-Percent of America's Youth', the piece addresses music

Above: The Sex Pistols exploded into the spotlight with a speed that surprised everyone, including the band themselves.

Tosches refers to as 'visionary expiation, a cry into the abyss of one's own mordant bullshit', music with poetry that is 'puked not plotted'. Some have identified this as an early blueprint for the punk manifesto, and the bands Tosches refers to (including the New York Dolls, Iggy and the Stooges, and the Velvet Underground) as prototypical punks. 'Maybe I did coin that term, or at least the "punk" part of it, without knowing it,' reflected the journalist himself when questioned on his role in the invention of the term 'punk rock' in the 2007 book *Midnight Mavericks*. 'The [essay's] title referred to the spirit of rock'n'roll in general, not to what later become known as punk rock.'

We begin our story proper in London in 1971 when, in partnership with Vivienne Westwood,

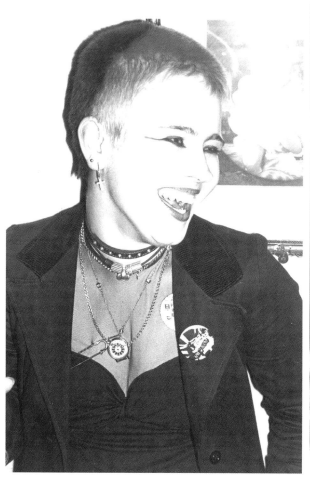

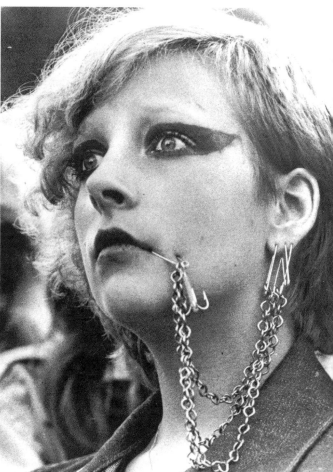

Above: Punk challenged conventional ideas of feminine beauty.

Was punk the last great modern art movement or just a cultural safety valve that allowed frustrated teenagers to let off steam?

Malcolm McLaren opened a fashion boutique on the King's Road called Let It Rock. McLaren was an art student fascinated by rebellious youth subcultures, while Westwood provided the practical input to make the business a success. Let It Rock initially catered to the capital's diehard teddy boys, peddling drape jackets and crepe shoes. Yet the boutique's stubbornly conservative customers were a disappointment to the radical aspirations of the owners, while also proving a

little unruly on occasion, getting out of hand and helping themselves to stock. The principal turning point came in 1972, when McLaren went to New York to a trade fair. He claims to have met American glam rockers the New York Dolls previously, when they visited his London shop ('lurex tops, bumfreezer leggings and high heels, this gang with red-painted lips and rouged cheeks and hair coiffed high ran riot'), but this time McLaren actually talked to the band, who invited him to hear their new album. 'I thought they were so, so bad, they were brilliant,' he wrote in 2004. McLaren had a tendency to mythologise, and his claim to have subsequently managed the New York Dolls has been disputed. But most concede that he directed the chaotic quartet's image briefly at least, advising them to

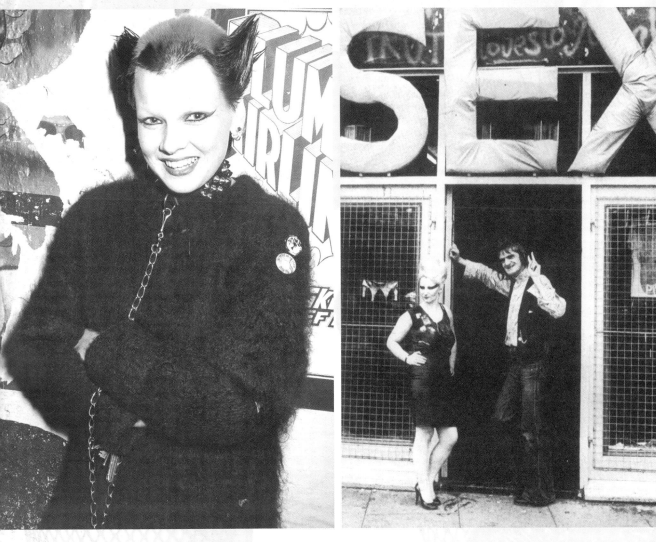

Above left: Soo Catwoman, one of the original icons of punk.
Above right: Jordan, another early punk pin-up, outside the SEX boutique, where she worked.

take the stage dressed in red, like 'patent leather communist dolls', beneath a hammer and sickle backdrop. It shocked many Americans, but wasn't a success, and the group – already fragmenting in a fug of drug abuse – broke up shortly afterwards, in April of 1975.

McLaren's enthusiasm for the band's blend of authentic street attitude and sleazy outrageousness remained undimmed. He was inspired to give his boutique a radical overhaul, renaming it SEX, selling kinky clothing designs

inspired by fetish gear – then still very much a taboo – and t-shirts adorned with imagery and slogans intended to offend. Nazi and communist iconography was combined with pornographic imagery and, most notoriously, a naked child and visual references to the Cambridge Rapist, a prolific, recently convicted sex criminal. 'An emporium of perversity,' McLaren later reflected of his boutique's new decor. 'It would look like a cross between a school gym and a padded cell.'

The boutique became a magnet for London's oddballs and misfits, some of whom shopped there, while others were employed in the shop. Among the latter was Glen Matlock, who told

the *Guardian* in 2001 that 'Steve Jones and Paul Cook started coming in. Steve was a petty thief, with his mate Wally, but it was suggested that instead of nicking anything else they nick guitars and form a group. We pestered Malcolm to become the manager, and about a year later John walked into the shop, and we changed the name from Swankers or Strand into the Sex Pistols.' John was, of course, John Lydon, who joined the group as Johnny Rotten in the summer of 1975. He embodied much of the bizarre aesthetic evolving in the SEX boutique: the jaded nihilism, the sarcastic hostility to not just the established order, but yesterday's rebels, most notably the hippies (Rotten having scrawled 'I hate' on a Pink Floyd t-shirt he was wearing, which was held together with safety pins, all topped off with a shock of green hair).

Rotten proved capable of exuding an air of boredom and spite simultaneously, his vocal delivery veering between a sneer, a threat and a whine, backed by a manic stare that promised unpredictability. It was a promise on which the increasingly confident vocalist began to deliver live. He left the stage, threw chairs, attacked fans, vandalised equipment. If a gig looked in danger of lacking the chaos that was becoming the band's trademark, Westwood and McLaren weren't above provoking fights in the audience. The Pistols live was, concluded an *NME* review from February 1976, 'a musical experience with the emphasis on Experience'. Unsurprisingly, however, word soon got out that the Sex Pistols were trouble, and it became increasingly difficult to find venues.

A hardcore of fans was developing, but it was some time before Pistols followers would adopt any kind of dress code that might suggest a coherent subculture. Often the only things that might initially differentiate embryonic punks from the more sceptical members of the audience were scruffy short hair and tight

Right: In contrast to the flamboyant camp of glam, punk heralded a shift towards tomboyish androgyny.

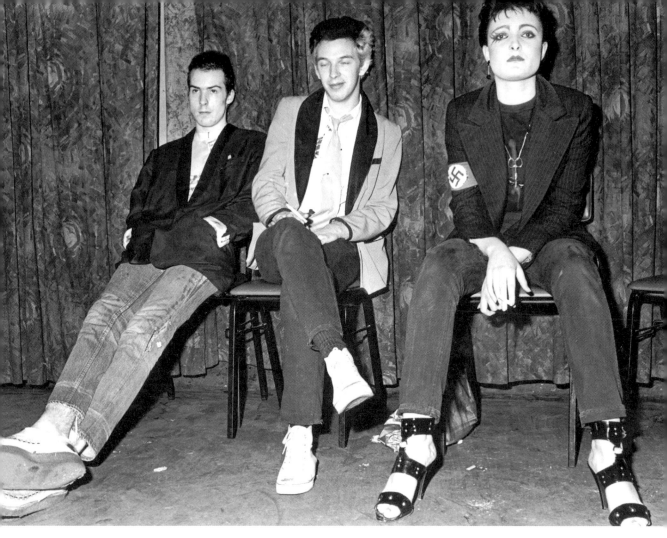

Above: As well as completing the classic Sex Pistols line-up, Sid Vicious *(left) was briefly an early member of Siouxsie and the Banshees.*

trousers, in contrast to the flares and luxuriant locks then fashionable for both sexes. The Sex Pistols cannibalised a number of previous subcultural looks, including teddy boys, rocker and mod. As with mod, speed quickly became an intrinsic part of the punk lifestyle. Yet while the original mods typically washed their pills down with a glass of Coca Cola, strong booze was also part of the punk diet. On their own, amphetamines encouraged dancing all night and the obsessive attention to detail that were key to mod. Add alcohol, however, and you get the aggressive unpredictability, wired volatility and – eventually – paranoia that would come to characterise the stereotypical punk.

The other form of intoxication that later became associated with punk was inhaling household products with mind-altering properties, such as solvents and glue, which triggered hallucinations, but also had a reputation for inspiring aggression. The practice fit with the punk ethos by being defiantly grotty and cheap, lacking any of the romance associated with many narcotics.

The clothes the Sex Pistols were loaned by McLaren and Westwood certainly influenced the early punk look. 'The shop did create such a great buzz about the band,' reflected Pamela Rooke, who worked at SEX and, as Jordan, became an early punk icon. 'The clothes were an important part of their make-up, but also a lot of things were sold because of them. Initially the Sex Pistols were just a vehicle. The real t-shirt boom came after the group came along: that was the vehicle to sell the band.' Many fans couldn't afford the SEX boutique's steep prices and improvised. 'Nobody

knew what to wear; I remember one night at the Roxy a bloke turned up with a moustache and a diving mask, and he fell down the stairs because he couldn't see where he was going,' recalls the columnist and author Tony Parsons, who was then working as a music writer.

'Could their attention be focused on the bright pink hair?' wrote music journalist Jonh [sic] Ingham in a 1976 article for *Sounds*, speculating on why the early punks turned so many heads. 'Perhaps it's the rubber stockings or seamed fishnet stockings, or the shiny black stilettos with bondage overtones. Perhaps it's the sheets of PVC rubber safety-pinned onto t-shirts, or is it the ripped t-shirts, the baggy pants ending in tight cuffs, the winkle-pickers, the weird shades?'

While the national notoriety McLaren craved for the Sex Pistols still proved elusive, numerous bands were emerging from the woodwork beneath the punk banner they'd raised. Eight of whom appeared at the landmark Punk Special held at the 100 Club on Oxford Street in September of 1976, headlined by the Pistols. Of the line-up, the Damned proved the first to get out a punk single ('New Rose' in October of 1976) and punk album (*Damned, Damned, Damned* in February of 1977). Siouxsie Sioux, one of the most striking figures among the Pistols' following, with her confrontational dominatrix image, formed a band for the event that would ultimately evolve into the Banshees. The Buzzcocks, who hailed from Bolton, proved that punk was reaching far beyond the capital, while the Stinky Toys from France indicated that the movement was now becoming international. Perhaps most significant were the Clash, a London band formed with the express intention of rivalling the Sex Pistols, who were soon snapping at the heels of their inspiration.

Significantly, unlike the Pistols, whose ethos was essentially inward-looking and nihilistic – whatever their manager might've claimed in press releases – the Clash had a

Johnny Rotten proved capable of exuding an air of boredom and spite simultaneously, his vocal delivery veering between a sneer, a threat and a whine.

left-leaning political agenda. The Clash were rebels with a cause. Any hopes that punk might form a coherent youth movement, however, were quickly dashed as inter-band rivalry degenerated into feuds and even fistfights in an increasingly factional and incestuous scene. The Punk Special ended in tragedy, when a Pistols fan threw a glass at the Damned during their set. It missed the band and blinded a teenage girl in one eye. The 100 Club subsequently joined the long list of venues where punks were no longer welcome (though the ban was later revoked). Yet the festival had the desired effect for McLaren, its chief co-ordinator, catching the attention of some influential music journalists and confirming the Sex Pistols as the leaders of the fledgling punk pack. McLaren soon had a bidding war on his hands, signing a lucrative contract with EMI, resulting in the release of the Pistols' debut single 'Anarchy in the UK' on 26 November 1976.

The most significant event in the band's history – if not the history of punk itself – occurred on 1 December that year, in a television interview to promote the release. When the band Queen dropped out of an appearance on the regional news and discussion programme *Today*, EMI offered the Sex Pistols as suitable replacements. The show's presenter, Bill Grundy, was evidently unimpressed and decided to goad the band into living up to their bad reputation (while taking a shine to one of the Pistols entourage, in the shape of Siouxsie Sioux). The result was pure car-crash TV, finishing Grundy's career, as the band obliged the smug, bumbling host by

swearing, somewhat half-heartedly, on the live show. It was the definitive storm-in-a-teacup, as the press leapt upon it, filling the following morning's front pages with hysterical headlines like 'The Filth and the Fury', and declaring open season on the band that had briefly turned the airwaves blue.

Literally overnight, punk had become a national phenomenon. Even if the Sex Pistols hadn't really brought anarchy to the UK, the media were prepared to act as if they had in the hope of selling papers. For many it was the beginning of punk, as countless British teenagers began ripping their clothes, scrawling anarchy signs on their jackets and adapting safety pins and razor blades into fashion accessories. Curiously enough, for others, it represented the end of punk. Just as punk's date of birth is much contested, from here on in there were many eager to record an accurate time of death. It wasn't just the more fickle and faddish fans who were uncomfortable with the spotlight that had suddenly fallen on the Sex Pistols. Senior voices at EMI were wary of potential damage to the company's image, while even Malcolm McLaren briefly worried that they might have gone too far, as it looked like their label might drop the band. Yet the punk bandwagon was well and truly in motion, and whatever McLaren pretended in public pronouncements, it was now running out of control.

The subsequent tour was a chaotic farce, as yet more venues refused to let the band play and EMI employees began refusing to handle Pistols product. By January 1977, EMI had had enough, and after a lurid newspaper report suggested that the band had vomited and spat at fellow passengers at Heathrow Airport on their way to a brief Dutch tour, cancelled their contract. The Sex Pistols now had no label, few places to play, and little prospect of recording their planned debut album. Undaunted, McLaren began courting other labels with the feverish media coverage that his protégés had attracted. Remarkably, he succeeded. On 10 March, the Sex Pistols signed another lucrative contract. This time with A&M Records, hosted outside the gates of Buckingham Palace – a publicity stunt that foreshadowed the band's intent to exploit the upcoming celebrations of the Queen's Silver Jubilee as a promotional opportunity.

Meanwhile, the Clash had also secured a deal with a major label in January 1977, but in setting themselves up as punk's political conscience, they were wide open to accusations of 'selling out' to big business – a concept punks had inherited from their hippie forebears. 'Punk died the day the Clash signed to CBS,' sighed Mark Perry, editor of the influential fanzine *Sniffin' Glue*. Despite such scepticism, the London quartet's self-titled album was both a critical and commercial success, establishing the Clash – guitar-wielding urban guerrillas in army surplus gear stencilled with political slogans – as credible rivals to the Sex Pistols' toxic carnival.

Back in the Pistols camp, bassist Glen Matlock had been sacked in February of 1977, replaced by Simon Ritchie, better known as Sid Vicious, one of the band's most fanatical fans. Significantly, the new recruit certainly wasn't selected for his musical ability, remaining unplugged for many performances. McLaren welcomed the new addition as another chaotic ingredient to add to the roiling mix; the spike-headed, snot-and-blood-smeared embodiment of unchecked juvenile delinquency, Sid was a curious crossbreed of innocence and obnoxiousness. Johnny Rotten, who was feeling increasingly isolated in the band, hoped he might have an ally in his old friend Sid, though inevitably the pair quickly fell out.

> The Sex Pistols cannibalised a number of previous subcultural looks, including teddy boy, rocker and mod.

Above: The Sex Pistols launch their Silver Jubilee campaign by signing a contract with A&M Records outside Buckingham Palace.

Someone who wasn't enthusiastic about the new recruit was the Pistols' contact at the band's new label A&M. Matlock had been the musical backbone to the group, who were getting tighter through practice and gigging, and his replacement by a bassist for apparently arbitrary, even negative, reasons didn't bode well. Such suspicions were soon confirmed, as the band lasted less than a fortnight on A&M. An intoxicated rampage at the label's offices – where Vicious played a leading role – and a drunken death threat to a leading BBC DJ by a member of the Pistols' crew at a nightclub were enough to convince A&M to cancel the contract and destroy almost every copy of the band's anti-monarchist anthem 'God Save the Queen'.

Surprisingly, perhaps, McLaren managed to strike one last deal – this time with Virgin Records – and events swiftly moved to a fervid climax. While royalist Brits eagerly anticipated the upcoming Jubilee celebrations, the nation's building legions of punks looked forward to the Sex Pistols' counterblast with equal enthusiasm, the band now presiding over a showdown between patriotic pride and anarchic fury. For some punks it was a political statement, a rejection of the archaic system of privilege that left a generation of youth languishing in ever-lengthening dole queues. For others, it was simply an opportunity to enjoy wrecking a party they'd never be invited to.

The atmosphere was getting increasingly heated, as both the Pistols and their fans became the targets of violent assaults in the streets. Predictably, there were production problems yet again, as many Virgin employees objected to handling the new version of 'God Save the Queen', with its provocative cover depicting a disfigured portrait of the lady in question, while many high-street shops refused to stock it, and most radio DJs declined to play it. Despite this – or more likely because of it – some voices in the media were predicting that

the single would top the charts upon release, deliberately timed to coincide with the climax of the Jubilee celebrations.

It didn't. Or did it? Evidence strongly suggests that the charts were rigged on the crucial weekend to prevent the royalist-baiting release from occupying the top slot at this symbolic moment in British history. Even if this conspiracy theory is untrue, many believed there had been an establishment fix behind the scenes, which if anything, made the record's bitter, angry tone even more resonant. There was to be no such doubt over the band's debut album, *Never Mind the Bollocks, Here's the Sex Pistols*, which emerged in October and soared straight to the top of the charts. It was a remarkable achievement, capturing the band's splenetic splendour in just under forty minutes of caustic bile, recorded in the face of mounting hostility from both outside and within the band, rapidly becoming a fixture on 'greatest ever' album lists compiled by journalists and fans alike. It was, however, to be downhill for the Pistols from here on in.

The band's American tour got off to a bad start when the opening dates, scheduled for the close of 1977, had to be cancelled after US officials attempted to prevent the Pistols entering the country. Come January 1978, the Sex Pistols found themselves playing in America's conservative Deep South, facing increasingly belligerent and bemused crowds in venues that were coming to resemble combat zones. The tour was beginning to resemble a suicide mission, as Vicious in particular – looking more and more like a man with a death wish – baited crowds in an atmosphere of building violence, both on and offstage. It was a minor miracle that the exhausted English quartet made it to their

Alcohol and amphetamines created the aggressive unpredictability, wired volatility and paranoia that would come to characterise the stereotypical punk.

final date in San Francisco on 14 January. As the gig drew to a close, Johnny Rotten uttered the immortal words, 'Ever get the feeling you've been cheated?'

It was his last statement as a Sex Pistol (reunion tours notwithstanding) or indeed as Johnny Rotten – he reverted to plain old John Lydon for future projects. Relations with McLaren had broken down entirely, and the Sex Pistols were teetering on the edge. McLaren attempted to draft Sid in as the band's new focus. But while he had a certain squalid charisma, Vicious lacked Rotten's inimical, acerbic wit. More importantly, Sid's priorities were now his heroin habit and his American girlfriend Nancy Spungen. In a grim postscript to the story, in October 1978 Spungen was murdered while staying at New York's famous Hotel Chelsea.

Inevitably, Vicious was the chief suspect, though in his drug-addled state appeared not to remember what happened on the fateful night. While on bail, he took a fatal overdose on the night of 1 February 1979. It appears to have been deliberate, and assured Vicious immortality, a sordid martyr to the self-destructive lifestyle the Pistols had pioneered.

Inevitably, Johnny Rotten's split with the band and Sid's subsequent squalid demise were both also interpreted by many purists as omens of punk's extinction. Yet this would have been news to the thousands of punks now to be found on Britain's streets. The Clash still had several productive years ahead of them, as did other politically-minded punks, like Crass, who regarded the likes of the Clash and the Pistols as sell-outs. Yet for the idealists in the subculture, it was difficult not to see the election of prime minister Margaret Thatcher in 1979

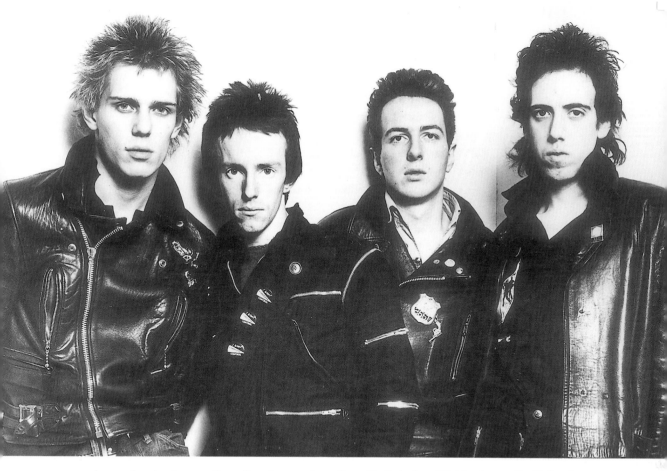

as a victory for the forces of conformity, punk heralding not anarchy in the UK, but over a decade of right-wing rule.

There were still diehards keeping the punk flame alive in the eighties. In 1981 the Scottish punk band the Exploited released the album *Punk's Not Dead*. The Exploited formed in 1979 – just as many were reading the last rites over punk. They're now acknowledged as standard-bearers of what became known as second wave punk or street punk. Purists have often dismissed such bands as caricatures of the original movement, while the street punks have charged that most of the original bands betrayed the subculture's original ideals. Heavy metal, disdained by most punk bands in the seventies, became an influence on street punk's sound and look. These are the punks who best fit the popular image of punk – coloured Mohican haircuts, studded leather jackets, Doc Marten boots and tattoos – though the fact that a uniform had developed at all went against the movement's anarchic spirit of self-expression in

Above: The Clash, who established themselves as punk's political conscience.

the eyes of many of punk's originators. Yet it's difficult to argue with the passion of bands like the Exploited, who are still touring today, over thirty years on.

After reforming the Sex Pistols in 1996, John Lydon successfully launched a 21st-century media career that gave fuel to those punks who accused the iconic figure of selling out. Hosting radio shows and appearing in TV nature documentaries, the original punk was now widely hailed as a national treasure. Does this kind of mainstream embrace of one of the UK's most controversial iconoclasts invalidate punk or rather suggest that its survival has always rested on its adaptability? In 2008 Lydon surprised many by announcing that he planned to collaborate with the pop star Cliff Richard. 'I like people who stand up for what they believe in, and Cliff's always done that,' he explained to the startled interviewer. 'That's what punk is all about.'

METALHEADS
Denim and Leather

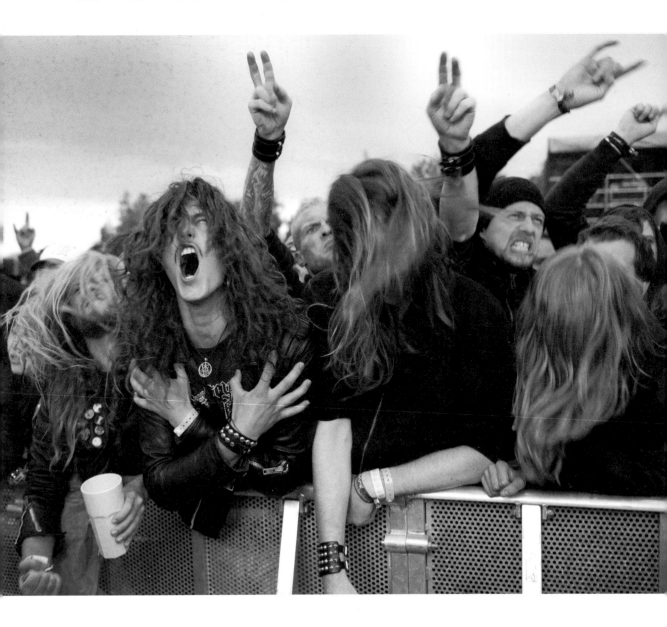

Metal celebrates bombastic fantasy, egotism, power and fun in an explosion of dark melodrama and shamelessly cheap hedonism.

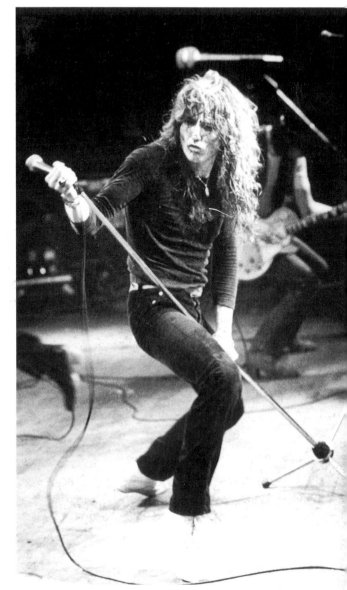

Black leather and bad attitudes, Satanism and sexual deviance – the popular image of heavy metal might appear to be the essence of rebellion. Yet the very idea of heavy-metal music as alternative or underground, or its long-haired, denim-clad fans as members of a subculture, cuts little ice in most books. Metal as an entity is broadly apolitical – a turn-off for scholars and hacks alike. Representing the final severance of rock from the blues, metal celebrates bombastic fantasy, (particularly male) egotism, power and fun in an explosion of dark melodrama and shamelessly cheap hedonism. In the eyes of its detractors this translates as trivial, crude, racist, sexist, thuggish, sadistic and – above all – dumb. Metal fans were the unloved stepchildren of the subcultural family, bastard offspring of the hippie and biker movements, the embarrassing relative airbrushed from family photos in favour of more photogenic subjects.

For much of its forty-year history, heavy metal has occupied a curious place on the countercultural map, its fans consigned to a social no-man's-land. With the music itself too popular to attract any kind of underground kudos, but too vulgar and antisocial to enjoy mainstream approval, metal subculture has long been obliged to survive on its own grassroots appeal. This has proven one of its true strengths. For a long time, there were no percentages in being a metal fan – it meant embracing

Opposite: Perhaps the most overlooked and unloved subculture, the metalhead lifestyle has survived though fierce dedication and passion.
Above: *Whitesnake singer David Coverdale onstage in 1980.*

unloved outcast status, which at least meant that everybody involved was there out of pure passion for the music. Spawned in the loftier reaches of the seventies album charts, the metalhead scene only really established itself as a counterculture at the end of the decade, when record sales were dwindling and a crop of new youth tribes were dancing merrily upon its grave.

'Heavy metal' has become such a common term that we seldom stop to question the origins of this bewilderingly abstract phrase.

In his 1962 novel *The Soft Machine*, maverick beat author William Burroughs includes a character called 'the Heavy Metal Kid'. The hippies inherited the term 'heavy' from the beats as slang for something grave and ominous, though the origins of 'metal' in such a context are less obvious. Chas Chandler, Jimi Hendrix's manager, suggests the term 'heavy metal' was employed by a journalist to describe the impact of one of the guitar prodigy's solos. Steppenwolf's song, 'Born to Be Wild' – featured in 1968's cult biker flick *Easy Rider* – tells of '*heavy metal thunder*'.

The speculation continues, but the truth surely hangs somewhere among these diverse allusions – rooted in the darker fringes of the hippie subculture; the aggressive freedom of the biker ethos; the transcendent experience of an electrified guitar solo – ineffably tinged with references to deviant literature and illicit substances. Hippie ideals were fuelled by acid, but if there is a quintessential heavy-metal drug then it is surely alcohol. Newcastle Brown Ale, Jack Daniel's whisky, Jägermeister – these mundane intoxicants have all achieved iconic status within the subculture. Yet, more potent than any illicit drug, the heart of metal subculture has always been in the scene's much maligned music.

The metal story starts back in 1969 with the release of Black Sabbath's self-titled debut – a toxic reaction to preceding mantras of peace and love. A band of working-class lads from the depressed suburbs of industrial Birmingham, Sabbath's name comes from their popular doomed anthem. Inspired by a horror movie, 'Black Sabbath' relates the protagonist's terrifying encounter with a demonic presence. The rest of the album conveyed a similarly ominous tone – both in its sound and gothic packaging – complete with an inverted cross emblazoned on the inner sleeve (added, the band later emphasised, without their knowledge). Donning garish crucifixes, Sabbath took pains to distance themselves from their

Led Zeppelin's orgiastic sound entranced a generation, and tales of their decadent backstage excesses of sex and drug indulgence became part of rock lore.

satanic reputation, but the demonic mystique chimed with fans like a funereal bell, leaving metal forever branded as the devil's music – and proving that misery doesn't just love company; it also craves a soundtrack.

By no means every rock fan was in thrall to this depressive miasma. And Sabbath's early career was spent in the shadow of such hedonistic acts as Led Zeppelin and Kiss. Two vastly different phenomena, both these bands came to symbolise the excess of the day, heralding the era of stadium rock, when the small gap between the musicians onstage and the audience below yawned into an unbridgeable chasm between lofty rock gods and adoring worshippers.

Led Zeppelin took the raw material of traditional blues and energised it with an electrifyingly erotic charge that made them seem at once unstoppable and untouchable. Immune to hostile critics courtesy of the almost occult power of their music – a heady brew of sexual swagger and epic fantasy drawn from the pages of *The Lord of the Rings* and Norse sagas – Led Zeppelin's orgiastic sound entranced a generation, and tales of their decadent backstage excess became part of rock lore.

Meanwhile, Stateside, Kiss were pimping a very American – that is, highly commercial – crossbreed of glam rock and heavy metal. Perhaps the most important ingredient in the Kiss recipe for success was a lurid comic-book aesthetic. Kiss took to the stage amidst salvos

of thunderous pyrotechnics, in outlandish black and silver costumes and distinctive face-paint. In the style of true superheroes – or, more accurately, supervillains – they even took on secret identities. Yet, few kids were much interested in guitarists Starchild and Spaceman; it was the blood-spitting, fire-breathing 'Demon' who seized centre stage, aka the irrepressible frontman Gene Simmons.

Heavy metal has always rooted for the villain, and Simmons happily adopted the mantle, though Kiss's villainy was largely theatre. While the fundamentalist Christian movement vainly spread rumours that 'Kiss' was an acronym for 'Knights In Satan's Service', saner critics understood that the band's only true sins were cynical vulgarity and a cheerful disregard for the niceties of artistic integrity. 'A successful rock'n'roll band is a well-oiled machine. It's a good business,' said Simmons, to the horror of rock revolutionaries everywhere.

Just as hippie entered the mainstream by osmosis, long hair and denim were gradually becoming standard-issue for the wayward American teens of the seventies. T-shirt designs or patches on jeans or jackets might indicate affiliation to a particular band, but aside from members of the Kiss Army attending concerts in costume, there was nothing to distinguish the dedicated metal enthusiast from their peers.

As for the gods they worshipped, un-diagnosed depression, drug abuse and the pressures of endless touring were taking their toll on Sabbath, culminating in the sackings of vocalist Ozzy Osbourne in 1979, and drummer Bill Ward the following year. Many thought this would spell the end for Sabbath. In 1980, Led Zeppelin's drummer John Bonham choked on his own vomit after an alcohol binge, and the band decided to call it a day. Kiss was also in

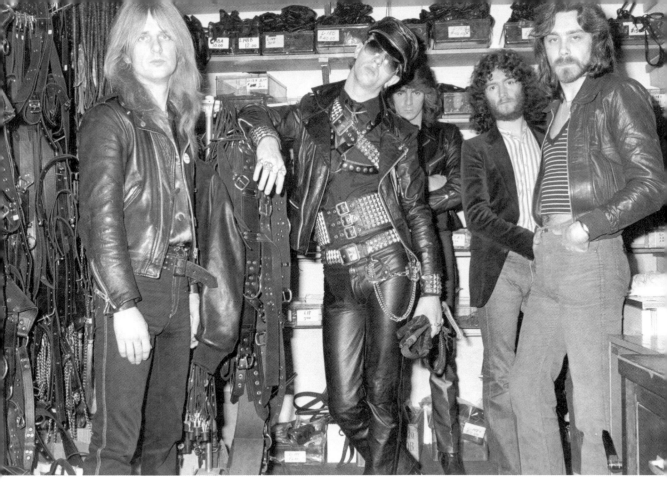

crisis. Their act was getting stale and there was increasingly obvious internal friction. 'It used to be really bad,' recalled Peter 'Catman' Criss. 'I would get up onstage and literally want to throw a drumstick at the back of Gene's head.'

Yet new bands were already waiting in the wings, fresh blood destined to give the nascent subculture a vital shot in the arm. The core of this hungry new breed hailed from the cradle of English metal – the same unfashionable backstreet pubs that birthed the genre. Perennially overshadowed by punk, a generation of British hard-rock bands were swimming against the current, making progress through sheer dogged pluck. Perhaps the most significant was Judas Priest. Named after a Bob Dylan track, Priest had been paying their dues since the late sixties, before finding their voice on *Sad Wings of Destiny* in 1976. That voice – a stream of increasingly bombastic falsetto fury – belonged to Rob Halford. Yet, the frontman's visual input is at least as significant.

Above: Judas Priest pioneered the introduction of leather, studs and chains imagery to metal's increasingly aggressive sound.

Halford began draping himself in leather, chains and spikes, superficially referencing metal's link with macho biker subculture, but in reality purchased from sex shops catering to the kinky S&M underground. 'I took that as a way of expressing the music . . . because metal, when I began, had no visual connection,' the singer later reflected. 'Here was a look . . . an image that completely tied into the sound and the power and the drama of the heavy metal itself.' Halford's strong visual identity proved wildly popular. Adopted by bandmates and fans alike, it swiftly became part of the metalhead uniform.

As with Kiss, their performance was pure theatre. But Priest never failed to play from the heart, offering an outlet to many fans unimpressed by the political sloganeering of their punk contemporaries. Unlike many of the middle-class journalists manning imaginary barricades to fight 'the system', Judas Priest

hailed from deprived suburbs and rubbish-strewn council estates, as did many of their fans. Halford's apolitical outlook – that music should be about emotions not ideologies – is a core metal value. Spiralling unemployment in eighties Britain certainly contributed to a feeling of frustration and despair – all of which bands like Priest tapped into. Instead of offering political solutions, metal's response was to try and raise the listener's spirits and strengthen their resolve with defiant escapism – to inspire and empower rather than preach.

While many bikers regarded metalheads as embarrassing younger brothers, (owners of biker jackets but no bikes), one British band that had little trouble passing muster with the biking fraternity was Motörhead. It's tempting to read the superfluous umlaut in this band's name as a

Teutonic eagles, something inherited from their forebears in the rocker and biker scenes. Like the bikers, most metalheads insist that such iconography has no political significance – it's just provocative historical shorthand for darkness that happens to look cool. 'I'll tell you something about history,' Lemmy observed, voicing metal's apolitical fascination with villainy. 'From the beginning of time, the bad guys always had the best uniforms. Napoleon, the Confederates, the Nazis. They all had killer uniforms. I mean, the SS uniform is fucking brilliant! They were the rock stars of that time. What are you gonna do? They just look good. Don't tell me I'm a Nazi 'cause I have uniforms. In 1967 I had my first black girlfriend and a lot more ever since then. I just don't understand racism; I never thought it was an option.'

If there is a quintessential heavy-metal drug then it is surely alcohol.

mark of respect for archaic tradition or an act of wilful difference. However, 'I only put it in there to look mean,' singer Lemmy Kilmister later shrugged. Something of a subcultural cliché, the umlaut's metal career began with Blue Öyster Cult, a highly literate US act, cut from similarly darkened cloth as Sabbath. According to rock critic Richard Meltzer, it was he who first suggested the affectation back in 1970. 'I said, "How about an umlaut over the O?" Metal had a Wagnerian aspect anyway,' Meltzer claimed. Certainly, heavy metal has much in common with the legendary operas of the 19th-century German composer Richard Wagner. Like Wagner, metal musicians are fascinated by dark Teutonic mythology and like to turn overblown melodic dramas into full-blown blood-and-thunder musical crises, and like Wagner, metal has been dogged by suggestions of fascist overtones. Lemmy's hobby of collecting Axis militaria from the Second World War hasn't helped matters; nor has the frequent use of Iron Crosses and

Motörhead's dogged progress was mirrored by a generation of heavy-metal bands, springing up in Britain's less fashionable towns and cities. In London, record-company executives were dazzled by the sensational advent of punk, and style pundits wrote off heavy metal as overdue for extinction. But in the provinces, passion for the genre's overblown blend of guitar histrionics and blood-and-thunder swagger was building. By 1979 it was generating a cacophony on the UK underground that few could ignore, even if most commentators preferred to sneer in the hope that this loud, grassroots rebellion would drown in its own testosterone. According to Lemmy, the metal bandwagon was developing an unstoppable momentum: 'Back then all of a sudden everything was heavy metal,' he told metal historian John Tucker. 'We were heavy metal, Journey were heavy metal, Hawkwind were heavy metal. Very strange.'

None could contest that Saxon are heavy metal. Perennially unfashionable genre workhorses, they personify metal's persistence,

with a moniker that's emblematic of the scene's penchant for dark medievalist themes. Yet, ironically (for a band whose greatest hits include *Denim and Leather*), Saxon are also credited with pioneering the vogue for colourful skin-tight spandex jeans. A synthetic material with powerful elasticity, this is the stuff of which superhero costumes are made. On a practical level, its stretchy quality meant it was perfect for making clothes that didn't tear, sag or impede movement if you needed to be acrobatic onstage. On a more dubious sartorial note, spandex jeans cling to the body in a fashion that leaves little to the imagination, making them an appropriate choice for those individuals who like to advertise their credentials.

If one eighties metal style languishes even deeper in fashion purgatory than spandex pants, it's the hairstyle that became derisively known as 'the mullet'. Long at the back and short in front, it's a practical style for anyone who wants long hair but doesn't want to be constantly brushing it out of their eyes. In truth, lots of guys had mullets. But by the eighties long hair was disappearing from the high streets and the mullet became emblematic of metal's refusal to move with the times; the defiant traditionalism of its fans embodied in a hairstyle that became hipster shorthand for the terminally unfashionable.

An aspect of the evolving metal identity that survives more successfully in popular culture is the devil's horns hand sign – index and little finger extended from a clenched fist – as an approving salute. Its origins in youth culture are obscure, with some claiming John Lennon is clearly making the sign on the cover of the 1969 Beatles album, *Yellow Submarine*. The identity of the performer responsible for establishing the devil's horns as a quintessential metal salute remains controversial. Many believe it was Ronny James Dio, who took over as Sabbath's vocalist after Ozzy's departure. Dio explained that he learned it from his Italian grandmother – in Italy the gesture is used to both ward off and cast curses. (It's also an insult, implying that the man it's pointed at has an unfaithful wife.) Gene Simmons has also laid claim to the salute, as a feature of how he held his pick and in imitation of the Marvel superheroes Spider-Man and Dr Strange. 'Gene Simmons will tell you that he invented it, but then again Gene invented breathing and shoes and everything you know,' observed Dio archly of the less-than-bashful bassist. Either way, by the eighties, it had become a commonplace gesture of approval among metalheads, however seriously or otherwise they might take the unholy sentiments associated with this satanic salute.

Demonic or not, the original metalheads were frequently derided as greasy and dirty, even smelly. Either way, these long-haired legions were certainly tatty. Denim and leather garments weren't fit to be seen in until they'd been broken in, ideally through hard wear, though many metalheads weren't above advancing the process by scuffing clothes with gravel or even employing such unlikely substances as cigarette ash to get the ideal distressed look. Rips and tears were optional. 'Cut-off' denim jackets had the arms removed, sometimes worn over a leather jacket, often decorated with studs or badges and patches advertising allegiance to favoured bands, complemented with tour t-shirts proudly announcing the dates the wearer had been out to support their heroes. Jeans were typically tight and frayed. A frequent fashion among English metalheads was to patch split jeans with bar towels advertising the wearer's favourite brew. Common accessories included studded wrist-bands, biker jewellery, mirrored aviator shades and bullet belts, with cowboy or combat boots completing the look.

> Rock was all about faded denim, pyrotechnics, edgy streetwise attitude, amphetamines and alcohol.

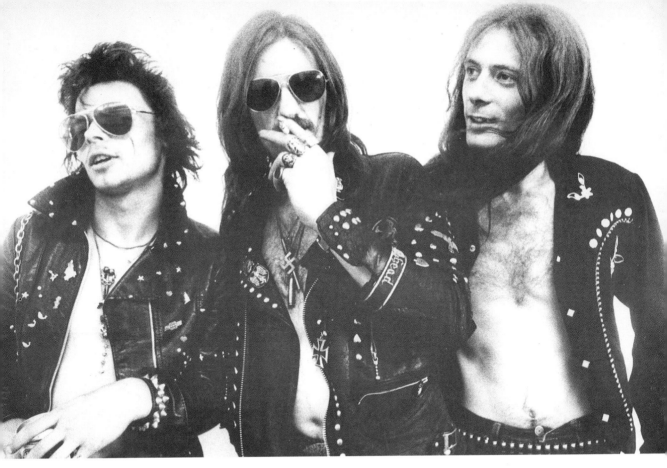

Above: *Motörhead was unusual in crossing genre boundaries, appealing to punks, bikers and metalheads.*

The intended image was definitively rough-and-ready machismo, a testosterone-heavy rejection of style, a defiant celebration of alienation in the face of bland conformism – real men didn't do fashion. While metal has remained predominantly male for much of its existence, there were certainly female metalheads. Fashions for the fairer sex were either a less butch variant on the masculine metal uniform of leather jackets and tight jeans, or a look that might best be described as 'lady of the night' femme fatale. Think heavy make-up, leather mini-skirts, thigh-high boots, bustiers and skin-tight spandex.

One thing that distinguished heavy metal from most subcultures was the scene's disinterest in dancing. Certainly, the aggressive tempo of much of the music, and the introspective nature of the moods evoked, didn't invite the listener to take to the floor. However, fans wanted to respond to the sounds, and two distinctive metal moves evolved. The first was 'air guitar' – mimicking the action of the guitarist on a favourite track on an imaginary instrument as a way of sharing in the exuberance. A purely personal experience – nobody played air guitar to attract a mate or impress a crowd – it swiftly became the subject of mockery among outsiders. Scarcely less derided and equally unsocial was 'headbanging' – shaking or swinging your head violently in time to the music – a visceral reaction to the power and fantastic imagery of metal that mystified outsiders, while 'headbanger' emerged as a term to describe fans.

While I have used 'metalhead', it's indicative of the scene's tenacity and widespread grassroots popularity that no single tag has been universally accepted. Inevitably, in the increasingly tribal environment of youth culture in the eighties, the metal scene evolved into a full-blown subculture, for protection as much as anything. In eighties Britain, long hair and a leather jacket meant not only being

Above: Metalheads playing air guitar at an Iron Maiden concert in 1980.

In the summer of 1981, as the media were reading last rites over the **NWOBHM**, *Sounds* published a heavy-metal special, its cover emblazoned with the tentative promise that it came from the only **UK** music weekly 'that doesn't sneer at the world of the headbanger'. It was entitled *Kerrang!* – supposedly the sound made by a power chord on an electric guitar. The experiment proved an immediate success, and *Kerrang!* became a regular monthly title, going fortnightly and then weekly by 1987. Metalheads finally had their own magazine, yet many contributors were far more interested in writing about themselves than the music and when they did address the music they frequently missed the mark by miles. Purists feel that *Kerrang!* did as much harm as good to the domestic metal scene.

Much has been made of punk's influence on the NWOBHM – both in terms of rawness and the ethic of bypassing businessmen in favour of doing it yourself. Metal fanzines, which became an international phenomenon, with titles appearing all over Europe, are certainly an example of that. Another was releasing your own material, though ironically many metal bands were left with little choice. Established labels were only interested in signing punk bands, still being hailed by the press as 'the next big thing'. On the streets, it was the same story, with tension between the two scenes ready to ignite.

One of the few bands to cross the divide was Motörhead, with Lemmy even endeavouring (unsuccessfully) to teach Sex Pistols bassist Sid Vicious to actually play his instrument. 'I got to know Sid because we all hung out at the same places – the Embassy Club, the Roxy,' Lemmy recalled. 'Neither band could get a gig. We should have been enemies because the punks and the longhairs were not supposed to see eye to eye, and they did used to beat the shit out of each other a lot, but Motörhead appealed to the punks too because of the aggression in the music.'

refused service in many pubs and potential trouble from fashionably-dressed 'smoothies', but friction with members of other alternative tribes whose dress-sense didn't conform to the standards of the day.

The term 'New Wave of British Heavy Metal' was coined in 1979 by Geoff Barton, a journalist then working for the UK music paper *Sounds*. *Sounds* wasn't a heavy-metal paper; just the only **UK** music weekly to give the genre any coverage at all. Unlike most journalistic tags coined to classify burgeoning scenes, it actually proved prescient, and the ungainly acronym 'NWOBHM' came to define the generation of bands that emerged during this fertile period in the metal underground.

Transcending industry indifference is no mean feat, but one NWOBHM act who beat the odds is Iron Maiden. Theirs is the archetypal story of metal success: after three years of endeavouring to attract label interest, Maiden recorded an EP under their own steam. *The Soundhouse Tapes* became a runaway success on the underground scene in late 1979. In terms of fan enthusiasm alone, Iron Maiden went on to become one of the most highly regarded rock acts on the planet, selling in excess of 80 million records worldwide with none of the hype heaped upon their more 'credible' contemporaries.

Loaded with rich cultural references, the band's lyrics set a new trend within metal, attracting legions of bookish fans to the subculture. Written from the point of view of the underdog rather than the anti-hero, these were songs of lone individuals facing insurmountable odds – victims of the cruellest kind of fate. This unique form of escapism chimed with many British youngsters facing ever-growing queues outside the nation's dole offices. Yet, such subtleties were wasted on the critics. Inevitably, it was Maiden's rare forays into the occult that attracted most attention. Hitting the US in 1982 – just as the culture wars between conservatives and liberals began in earnest – *The Number of the Beast* was nothing short of a breakthrough, putting a reluctant Maiden directly in the firing line. Accused by American Christians of recruiting innocent teens for Satan, they certainly weren't alone. Other, largely innocuous NWOBHM bands such as Grim Reaper and Satan found themselves the subject of unwelcome attention from fundamentalist Christians, determined to prove that America was under attack from some secret satanic conspiracy.

Metal musicians are fascinated by dark Teutonic mythology and like to turn overblown melodic dramas into full-blown blood-and-thunder musical crises.

Like Sabbath and Maiden before them, most bands attempted to distance themselves from any authentic satanic sentiments when targeted by America's latter-day witch-hunters. Yet some feisty young musicians and disaffected fans saw the potential in such luridly bad press – intoxicated by the thrill of sending chills down conservative American spines – and did court demonic reputations. None more so than Venom, a trio from the northern English city of Newcastle. On the very cutting-edge of metal innovation, Venom's 1982 album *Black Metal* would lend its name to the most controversial and pugnacious presence on the modern metal map. Far from the most accomplished musicians, Venom's recipe was basic, crude even. Yet, what they lacked in skill, they made up for in furious speed and naked belligerence. Clad in spiked leather outfits that made Judas Priest look like wallflowers, their lyrics took Sabbath's tentative references to Lucifer into the realms of exuberant blasphemy. Never big sellers, Venom made an impact nonetheless. 'We were just an "addition to" heavy metal, weren't we?' vocalist and bassist Cronos explained to Martin Popoff in his *Top 500 Heavy Metal Albums of All Time* (*Black Metal* comes in at number fifty). 'That's why it was fun. We didn't kill Motörhead; we didn't kill Judas Priest. I kind of figure if we hadn't [have created] the explosion we created [. . .] bands like Motörhead and Judas Priest and the whole heavy-metal thing in general would have pissed itself. Because it wasn't dangerous enough; it wasn't going anywhere. The sort of spandex-and-make-up thing was getting really limp.'

'Limp' or not, another band was set to launch a very lucrative career indeed wearing spandex and make-up – taking similar advantage of the

satanic hysteria. Mötley Crüe took over where Kiss left off, adding a toxic edge of sneering street attitude to the villainous showmanship of their platform-booted predecessors. In the words of the band's irrepressible bassist, Nikki Sixx, 'We never were heavy metal. We were always, like, sleazy.' Even if Mötley Crüe were wary of the heavy-metal label, they were clearly keen to profit from some of the genre's building notoriety, though they quickly ditched the satanic imagery once *Shout at the Devil* earned them a place in the limelight.

Many traditional metalheads were suspicious of Mötley Crüe, yet they were doing lucrative business on both sides of the Atlantic, and their outrageous antics (enough to challenge the worst excesses of Led Zeppelin) made for good press. More importantly, Crüe had rediscovered the glam secret that chicks dig androgynous guys, bringing a fresh influx of ladies into the stubbornly masculine metal world – with a new infusion of camp male metalheads in pursuit – and leaving tatty traditionalists to growl gloomily into their pints about sell-outs and sissies. During the late eighties this glam look began to manifest on the international metal

scene. Boys spent longer getting ready than their girlfriends, strutting their stuff in make-up and skin-tight duds; their hair, silk scarves and bandanas blowing in the wind (or at least a fan placed just off camera). Glam metal was tailor-made for the fledgling MTV generation, with its ethos of peacock display over substance.

The UK press leapt upon the glam bandwagon with enthusiasm, and sympathetic observers were forced to concede that the NWOBHM – the musical movement that first defined 'metalhead' – was finally facing defeat in the glare of media indifference and bigger-budget competition from abroad. 'By the end of 1984, for the second time in forty years, the Americans (as the old wartime adage had it) were over-sexed, overpaid and over here, although this time they were bringing more than just stockings and chewing gum (Mötley Crüe aside),' observes John Tucker in *Suzie Smiled*. The spit-and-sawdust escapism offered by most British metal bands couldn't compete with the camp macho swagger of glamorous competition from across the Atlantic who 'conjured up a world far removed from dismal wet Britain with the miners' strike, mass unemployment and extremely bleak prospects'.

While it may have signalled the end of an important chapter in metal history, it also represented the start of an even more significant era. By no means was every American metalhead impressed by the vogue for hairspray and make-up enveloping the scene. Many took the NWOBHM seriously – rather more seriously perhaps than it was taken by most in its native country – and launched a counter-revolution that would take metal back to its gritty roots.

Across the Atlantic, an authentic cross-pollination was taking place among a new generation of hungry young musicians. For them, the raw technical skill of imported European metal represented a refreshing alternative to Mötley Crüe's dominant brand of glam-sleaze. Combined with one other crucial influence – the musical punch of hardcore punk – the bastard offspring was thrash metal. 'I recall going to school wearing a Scorpions shirt and punk sunglasses and getting shit from both sides – "Well, fuck you man, I like 'em both,"' said Metallica's James Hetfield. 'That's the feeling behind the early Metallica songs.' The debut he's referring to, bluntly titled *Kill 'Em All*, made serious waves when it was released in 1983, the hammer and pool of blood on the sleeve suggestive of its bludgeoning impact on the metal subculture.

Almost as significant were the shots of the members featured on the back of the record, showing Metallica for what they truly were: four ordinary Bay-Area metal fanatics, barely out of their teens, with unimpressive facial hair, poor complexions and ratty denim jackets. In short, they looked like many of the kids who bought the album, and thrash would signal a return to metal's grassroots, a desire to blast spandex, hairspray and strutting out of the subculture. It was the sheer velocity of the music, however, that truly blew the cobwebs away. Some traditionalists dismissed the album as a gimmick, while others rejected it as an overheated mess. But to fresh young converts, it sounded like the future. Alongside the 'unlistenably intense' Metallica, a trio of other thrash acts – Megadeth, Slayer and Anthrax – emerged to dominate eighties metal. Together they became known as 'the Big Four'.

Their style was an obvious development of the biker-influenced, long-hair-leather-jacket-and-jeans combo. The jeans were tight, and bullet belts were popular, while high-top basketball boots began to replace the

The mullet became emblematic of metal's refusal to move with the times.

traditional cowboy boot as favoured footwear. The band who really rang the changes were Anthrax, who in 1987 had an image overhaul that reflected their passion for skateboarding, a popular pastime amongst hardcore punks. The grim demeanour and black colour schemes of traditional metal went out the window, as Anthrax adopted a madcap style that helped introduce baseball caps and Bermuda shorts to the thrash scene. It was a divisive move (regarded by some traditionalists as a tacky promotional stunt), but it certainly got Anthrax noticed. The most important cultural shift thrash brought

influences on darkly romantic songs about loss and despair. Beauty-and-the-beast style, many juxtaposed growled male vocals with an angelic female voice. And most fans dressed to match, combining shirts and even suits with the metal staples of long hair and black leather. Female fans meanwhile adopted flowing gowns and the more romantic styles of the goth subculture. Gothic metal was just one of a bewildering range of crossovers and schismatic subgenres emerging as the millennium approached, from barbaric battle metal (with a Viking-influenced look and sound) to stoner metal (which focused

The intended image was definitely rough and ready machismo, a testosterone-heavy rejection of style.

to heavy metal, however, was in the live arena. With its even fiercer tempo, thrash required a new form of physical expression, which it found in moshing (audience members hurling themselves at each other in a 'pit' in front of the stage) and stage-diving.

By the end of the eighties, a new wave of bands was emerging, who regarded the ballistic speeds of thrash as too pedestrian. They became known as death metal, thanks to the band that pioneered the subgenre, Death. Recreating absurdly grisly scenes from imaginary horror flicks, death metal is perhaps the most nihilistic metal subgenre, characterised by distorted guitars, hammering blast-beats and vocals so gruff as to be unintelligible. Visually however, death tends to be rather unimaginative, favouring the standard thrash uniform of trainers, tight jeans and a band t-shirt. While death metal was defiantly masculine to the point of macho nihilism, by the early nineties metal's cutting-edge began to discover its feminine side.

This manifested in the gothic or doom-metal movement, which did the unthinkable – slowing down while employing classical

on marijuana-themed lyrics and adopted retro, seventies-style duds, complete with hippie flares).

Dominating charts and headlines alike, the influence of hip-hop on nineties metal was perhaps inevitable. Nu-metal sprang into life circa 1994 with the release of Korn's self-titled debut. Though Korn themselves were quick to disown the tag, nu-metal introduced a series of new looks into metal, many adapted from hip-hop, including impractically baggy jeans, designer sportswear, luridly-coloured hair or dreadlocks, and heavy wallet-chains.

By the 21st century, nu-metal was old news, but metal overall was in rude health, enjoying a level of mainstream acceptance never before afforded to the genre. The millennial metal fan was a diverse species. Some cut their hair and others shaved their heads, while fearsome beards became popular. Leather trench coats became almost as ubiquitous as the classic biker jacket. Metal had inherited an appetite for tattoos from bikers, and when tattooing became mainstream alongside the growing acceptability of body-modification, metal fans were enthusiastic canvases for body-art and candidates for piercing. Army

Above: Metallica brought metal back to the streets with their irreverent attitudes and unkempt disdain for style and fashion.

surplus khaki and cargo shorts have become common street wear, as have combat boots, though aside from the omnipresent black band t-shirt, it is becoming increasingly difficult to tell a dedicated metal fan from their clothes alone. Inevitably, not everybody appreciated the scene's increasing acceptance into the mainstream, and the main challenge to this came from a most unexpected quarter.

Black metal began as an offshoot of NWOBHM, popular in Scandinavia, but much mocked in the music press. By the end of the eighties, most such bands had been written off as a footnote in metal history. Yet a few diehards in Norway refused to let the flame expire. This tight-knit, increasingly deviant cabal of musicians took the fantasy rhetoric of the original black-metal bands as gospel, a curious

process which climaxed in a series of high-profile acts of arson and murder. The principal culprits, members of Burzum, Mayhem and Emperor, were arrested in 1993. Yet this bizarre criminal case is far from being filed away.

Publicised to a fascinated readership, 1998's *Lords of Chaos* transformed the antisocial attitudes of the perpetrators into a coherent philosophy of national pride and resistance to corrupt capitalism and religious oppression – spawning countless imitators across the globe. Wielding medieval weaponry, their faces daubed with black-and-white 'corpse-paint' they've helped make black metal one of today's most innovative musical movements – with a history steeped in horrifyingly authentic carnage.

NEW ROMANTICS
Prince Charming

There were few rules aside from studied theatricality and display. The idea wasn't to be yourself, but to be someone else.

In a 2009 *Observer* article on the birth of the new romantics, David Johnson recalls coming across the scene in early 1980: 'Every Tuesday for a year, [organiser, Steve] Strange had been declaring a "private party" in the shabby Blitz wine bar off Covent Garden. Outrage secured entry. Inside, precocious nineteen-year-olds presented an eye-stopping collage, posing away in wondrous ensembles, emphatic make-up and in-flight haircuts that made you feel normality was a sin.' The curious creatures that pioneered the new romantic movement came in a kaleidoscope of colours and costumes that changed on a weekly basis.

There were few rules aside from studied theatricality and display. The scene was tantamount to a competitive fancy-dress party, though despite frequent pretensions of aristocratic elegance, most performers were financing their costumes on student grants. 'We'd spend the whole week preparing our

Opposite: The new romantics originally went under a range of names, from Blitz kids to poseurs.

outfits for the club,' recalls Siobhan Fahey, a Blitz regular who later went on to chart success with the pop groups Bananarama and Shakespears Sister. 'We'd go and buy fabrics, customise our leather jackets, make cummerbunds, find old military things and throw them together in a mix of glam, military and strangeness. It was all DIY because we didn't really have any money to properly eat.'

Within the vast majority of the cults described in this book, describing someone as a 'poseur' is an insult, suggesting they're a phoney, merely wearing the trappings of the movement. Yet 'poseur' was one of the tags bandied around to name the subculture, before 'new romantic' was generally accepted. Few subcultures have enjoyed as many different proposed monikers. In his article Johnson – then editing what he describes as 'a ring-fenced page of cool' for London's *Evening Standard* – notes that, alongside his own suggestion of 'the now crowd', others had put forward 'herald angels', 'dandy dilettantes', 'new dandies',

'romantic rebels' and 'Blitz kids' as labels for the burgeoning movement, before an article in *Sounds* in September of 1980 dubbed them new romantics, and it stuck. But Blitz kids and poseurs were surely more appropriate.

Blitz kids because the movement was indelibly tied to the Blitz nightclub in London's Covent Garden. (Some still use the title to refer to the scene's original leading lights as distinct from later or more peripheral members.) Poseur because it makes little sense to accuse new romantics of favouring style or appearance over substance – style was the substance, and being a poseur meant being true to the movement's authentic spirit. The number of monikers proposed for the subculture is revealing. The whole scene was artfully crafted to make good copy and provide colourful photo opportunities – to act as a launching pad for those hungry for fame – and it worked. Few cults have played the fashionable London media with as much skill as the new romantics, entering into an incestuous relationship with the capital's fashion editors, photographers and journalists, all of whom were determined not to miss the next sensation as the dust from punk's cantankerous rise and fall finally settled.

Associating the new romantics with punk is not as incongruous as it may first appear. On the surface, the punks, with their deliberately dishevelled appearance and confrontational attitudes, seem the total antithesis of the effete new romantics, with their camp preoccupation with style. Yet, almost without exception, the original new romantics had punk backgrounds. These were the fashion punks, who enjoyed punk's exhibitionism, abandoning it when it became dull and the rough, working-class street punks started to take over. 'I was getting bored of the punk thing – it got violent with the skinheads – so me and Rusty talked about opening our own venue, with our own music,' Steve Strange told the *Independent* in 2011. 'The Blitz club was about creating this vibe of who could dress most outrageous: was it me or Boy George – who worked the cloakroom – or Stephen Jones, the hat-maker? Rusty and I shared the same vision of who came in, how they should look and the music selection.'

Rusty was Rusty Egan, a musician who'd drummed with the Rich Kids, the band Glen Matlock formed after being dumped by the Sex Pistols. Together with Strange in 1979, Egan founded the Tuesday-night events that gave birth to the new romantic movement. Egan's eclectic playlist was heavily slanted towards David Bowie – it was even initially known as Bowie night – as well as Roxy Music, the artiest of the glam-rock bands. The new romantics shared glam's flamboyant taste for cross-dressing, though not glam's egalitarian sense of fun. While glam erupted from within the pop-music industry, new romantic was born from London's art and fashion colleges, the Blitz kids a self-styled sartorial elite, something Steve Strange enforced with his draconian door policy. 'I wanted creative-minded pioneers there who looked like a walking piece of art, not some drunken beery lads,' says Strange. 'People would ask, "Why aren't we getting in?" and I'd hold a mirror up and say, "Have you looked at yourself?" It would actually make a lot of people try a lot harder to get in and maybe a week or two later, they would be able to come in.'

Famously, Strange's exacting door policy even extended to Mick Jagger, who was refused entry. The Blitz doorman would later confess that the club was already at capacity, and having been warned about overcrowding by

> 'We'd go and buy fabrics, customise our leather jackets, make cummerbunds, find old military things and throw them together in a mix of glam, military and strangeness.'

Above left and right: *The only dress code was outrageous flamboyance, from flouncing mock dandies to fetishistic military camp.*

the local authorities, he daren't let the Rolling Stone and his large entourage in for fear of being closed down. But as far as the gossip columns in the following morning's papers were concerned, the nation's biggest rock star had been turned away as insufficiently cool for the capital's hippest new club night. 'It was the best publicity we could have had,' Strange later

recalled. 'Overnight, Blitz became the club for the new young elite and the legend of the new romantics was born.' But there can be little doubt that, no matter how full Blitz had been, there's no chance that he would have turned away David Bowie. When the singer visited the

Above: Preparation – planning your outfit, primping and preening – was an integral new romantic ritual. **Opposite:** *Boy George (right) was just one of a legion of popular figures who began their careers at legendary new romantic haunts like the Blitz.*

The whole scene was artfully crafted to make good copy and provide colourful photo opportunities – to act as a launching pad for those hungry for fame.

club in 1980, he was treated with starstruck reverence, as every significant Blitz regular had grown up a Bowie fanatic.

The man himself was smuggled up to a private table in the VIP area, while Strange needed to muster extra security to keep the new romantics downstairs at bay, all of whom – thrilled to be in the same building as their idol – momentarily let their masks of disdainful cool slip. Much to Strange's delight, Bowie explained that he was scouting for extras for the video he was filming the next day. Might Strange be interested, and if so could he find three more, suitably arresting-looking individuals to take part? The Blitz founder didn't need asking twice and rounded up a trio of Blitz regulars for

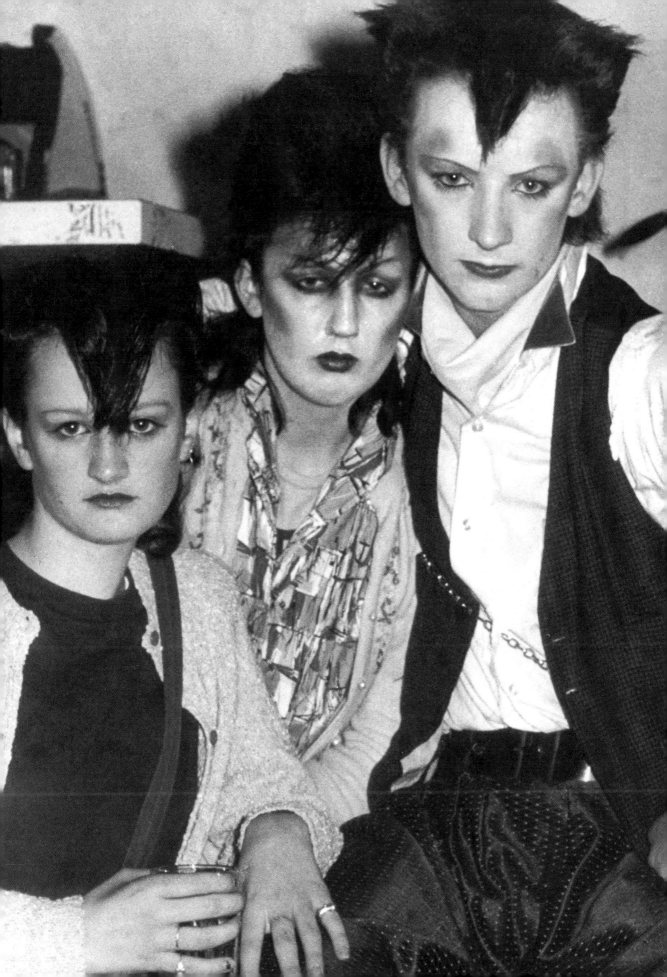

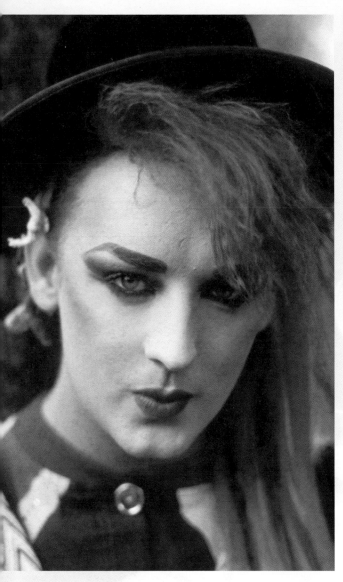

Above: A Blitz club regular who went on to achieve international stardom fronting Culture Club, Boy George appears on French television in 1984.

later claim that the singer's look was inspired by one of his own favourite Blitz outfits, though Bowie had been toying with the Pierrot persona for some time. Whatever the case, being part of the promo was predictably inspiring for the Blitz crowd, and they adopted Bowie's follow-up single, 'Fashion', as an unofficial anthem. Ironically, some suggest that the song and its accompanying video were actually a sly parody of the shallow snobbery and pretentious vanity of the nascent new romantic scene. If so, this either went over their heads, or was taken as a perverse compliment by the clubbers, many of whom took pride in their decadent dedication to disdainful display.

Yet, as Bowie began exploring new directions, it was clearly time for the movement to create a soundtrack of its own, taking cues from Bowie's glamorously surreal visuals and innovative use of new musical technology, most notably synthesisers. The first unofficial house band was Visage, a studio project fronted by Strange, though they would soon be eclipsed by Spandau Ballet, both entering the charts in 1980. Significantly, 1980 also saw the foundation of *The Face* and *i-D*, trendy London magazines dedicated to stylish coverage of pop culture, allowing the new romantic bands to forge successful careers without recourse to the drab conventional music press, who remained suspicious of this new wave of pouting peacocks. Well-suited to the emerging video age, the flamboyant synth-pop bands associated with the new romantic movement began to dominate the charts in the UK and beyond. Particularly Duran Duran, initially billed as 'Birmingham's answer to Spandau Ballet', who rose to become an international phenomenon, no longer a localised fad tied to exclusive London clubs.

The initially inappropriate moniker of new romantic was fast becoming a self-fulfilling prophecy, associated with a look that drew increasingly upon popular ideas of clichéd

the job. Strange commented, 'Bowie's known as a very clever thief, that's why he turned to the Blitz, because he wanted to be part of London's most happening scene.'

The video was a promo for the single 'Ashes to Ashes', and with a budget of £25,000 was the most expensive such production ever filmed at the time. The highly stylised video featured an exploding kitchen and a bulldozer, with Bowie performing in a Pierrot costume. Strange would

romantic heroes – poets in billowing shirts, dashing highwaymen, and swashbuckling pirates. In 1981, Vivienne Westwood, the fashion designer previously best known for helping launch the confrontational punk look, released her glamorous Pirate collection. The band who best exemplified this rakish blend of foppish 18th-century style and rock attitude was Adam and the Ants, another product of the disaffected fashion-punk movement. They purveyed a more traditional guitar sound than their synth-based rivals, an anthemic peacock strut pumping with tribal drums. The band's 1981 hit single 'Prince Charming' – with its *'ridicule is nothing to be scared of'* line – became the

material that appeared to celebrate luxury in the face of ever-growing dole queues on the streets.

Boy George had graduated from manning the Blitz cloakroom to fronting Culture Club, who topped charts across the world in 1982 with the anodyne reggae number 'Do You Really Want to Hurt Me'. 'The music scene was healthier than it had been in a long time,' he claimed. 'Suddenly it was okay to be rich, famous and feel no shame. Some saw it as a natural consequence of Thatcherism.'

Whatever you make of such debates, the new romantics remain icons of the eighties, and one of the most colourful style cults in British

We wanted to be successful, we wanted to be famous, and we didn't see why we should be embarrassed about it.

mantra of a new romantic movement that had outgrown its cult roots to become a costume party everyone was invited to.

In 1983, Princess Diana declared Duran Duran her favourite band, though the seal of royal approval was regarded with some ambivalence by the band's vocalist Simon Le Bon. 'With your average general public, it probably made us accessible,' he later reflected. 'For a lot of other people it made us a little uncool. The royal assent is the establishment saying they like you. It's not very rock'n'roll, is it?' It certainly didn't improve the movement's standing with the dedicated music press. According to Dave Wakeling, singer and guitarist with the politically-conscious ska band the Beat, 'We were all destroyed by the new romantics. All of a sudden our utilitarian gear looked plain next to these dandies. People wanted music as escapism again.' While many bands were composing musical polemics against the divisive right-wing prime minister Margaret Thatcher, the new romantics were busy rifling through the dressing-up box, issuing upbeat

history, with a striking number of one-time Blitz regulars now to be found as influential figures in today's London media, fashion and entertainment scene. 'You had to dig around,' observes Rusty Egan of the cult's humble genesis. Looking back, Spandau Ballet guitarist and songwriter Gary Kemp pays tribute to Strange as something of a subcultural pioneer: 'Steve was nineteen when he was running this club. No one had done that before, taken a club and given it its own identity one night a week. This was the beginning of lots of things that changed culture as we know it . . . the Blitz was this petri dish of ideas. Even though we were dressing up in am-dram clothes, we all had this sense of responsibility to the future. All of us thought we are going to place ourselves in this decade that was coming, and drive it.'

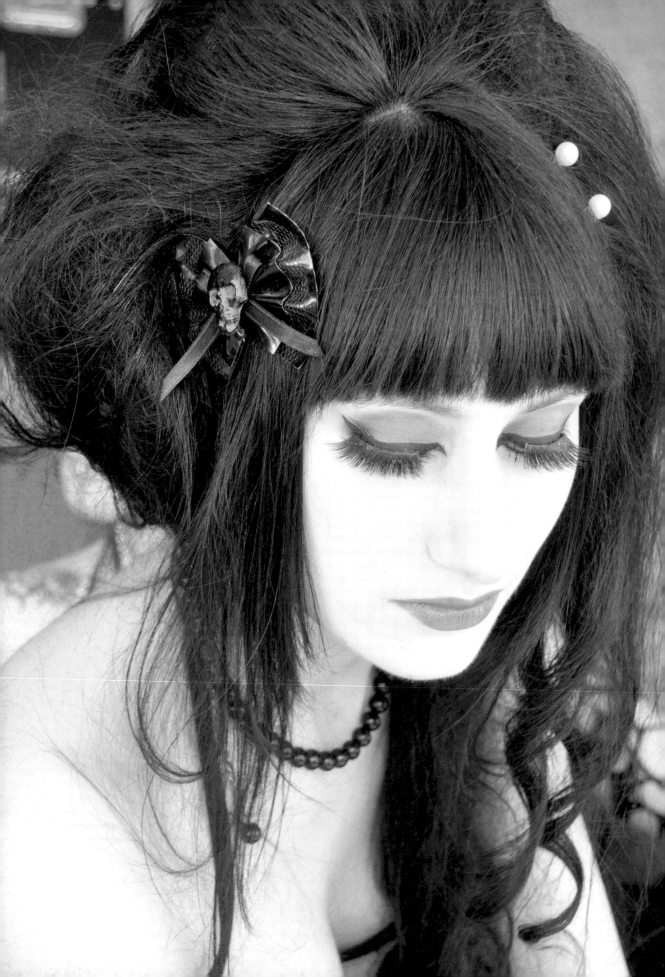

GOTHS
Black Planet

The elusive nature of goth is one of the subculture's strengths, allowing it to adapt and evolve over the years – to embrace new ideas, sounds and imagery.

Goth is arguably the most misunderstood and misrepresented subculture in these pages. 'Goth' is an abbreviation of 'gothic', so many understandably assume that goths are people fascinated by the macabre and ghoulish. To a certain extent this is true, but equally, there are many dedicated goths with little interest in horror movies, who have never picked up a gothic novel in their lives. Indeed, a number of goths reject all association with the dark and dismal, to the extent of starting subculture offshoots like the colourful perkygoth, self-consciously rebelling against the clichéd image of the scene as morbid and gloomy. Part of the motivation for this is confounding accusations from the conservative media and concerned Christians, who associate the subculture with suicidal depression and sinister occultism. It's

Opposite: Goth represented a revival of old-fashioned glamour, with a powerful streak of macabre mischief thrown in for good measure (right).

also a reaction to the tendency among casual observers to lump in other subcultures with dark dress codes – particularly devotees of extreme heavy metal – with goth.

All too often, any teenager garbed in black or emblazoned with macabre motifs is dubbed a 'goth', something that seriously gets under the pale skin of the more sensitive authentic members of the subculture. So, accepting that not every adolescent with bottle-black hair and skulls on their t-shirt is actually a goth, just what defines the authentic animal? Defining goth has become something of a scene in-joke, a tired topic which – when it appears on internet message boards – is met with a virtual chorus of groans and sighs from scene veterans. The elusive nature of goth is one of the subculture's strengths, allowing it to adapt and evolve over the years – to embrace new ideas, sounds and imagery. But it's surely true that without the powerful aesthetic and artistic tradition behind it – clichéd skulls and bats included – goth would never have initially cohered into a subculture capable of surviving for over three decades and counting.

They were looking for a new, more interesting, less crude sound and style – something that could be sexy as well as shocking.

To start our story at the very beginning, the original Goths were a Dark Age Germanic tribe, one of the numerous warlike European peoples long dismissed as barbarians (though more recent historians have adopted a more liberal perspective). They have little to do with the folk wearing fishnet stockings and eyeliner at modern goth festivals, but a lot to do with the origins of the term 'gothic'. During the Enlightenment era of the 1700s, European intellectuals idealised classical culture, while condemning the continent's medieval legacy as an age of ignorance and ugliness. As one of the forces held chiefly responsible for the downfall of Ancient Rome, the Goths became synonymous with barbarity and superstition.

Medieval architecture and culture was damned as 'gothic' – vulgar and backward in comparison to the Ancient Greek and Roman forms it superseded, which were regarded as archetypes of good taste and civilised attitudes.

Yet, in an early example of counterculture, some influential 18th century aristocrats, architects and artists rebelled against this idea. Even if classical culture represented the virtues of order and reason, contrary values – creativity and passion – were also important. This idea manifested itself in an unfashionable fascination with the culture and architecture of the Middle Ages, driving a desire to recreate it in stone and on the written page – not just as an expression of a growing interest in history, but as a way of recapturing the dark mystery and gloomy atmosphere of the troubled era. By the early 19th century a fad was emerging, as the wealthy commissioned spooky gothic edifices on their estates, while less moneyed Europeans thrilled to gothic novels, their creepy pages filled with wicked monks and demonic seductresses. This morbid medievalism – with its craving for eerie atmospheres and illicit sensations – was an important aspect of the Romantic literary movement, particularly in the case of English poets like the wicked Lord Byron and his equally scandalous friend, Percy Shelley.

A century later, the literary products of the gothic movement would inspire the horror genre on the big screen: beginning in twenties Berlin with nightmarish silent films like *Nosferatu*, taking shape at Hollywood's Universal Pictures, which created the black and white classics of the thirties starring Boris Karloff and Bela Lugosi, and climaxing with the garish period Technicolor chillers produced by England's Hammer Studios. While these films look tame and camp to modern eyes, jaded by 21st-century 'torture-

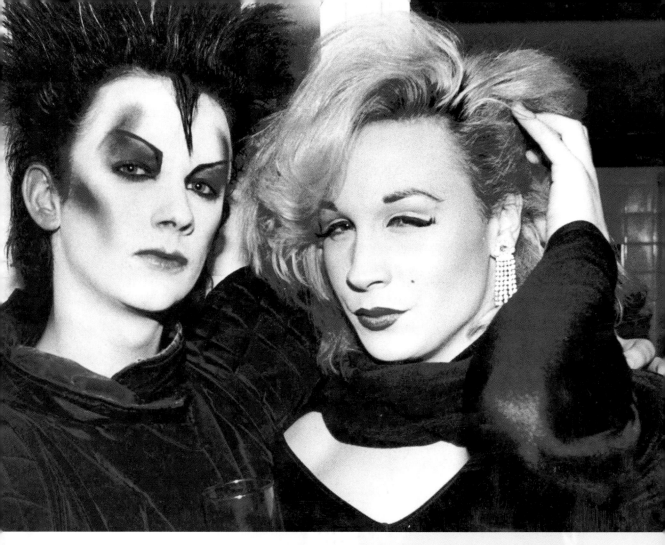

Above: Boy George, always eager to be on-trend, suggests the drift towards the gothic look among London clubbers in this 1979 shot.

porn' shockers like *Hostel*, at the time they were regarded as authentically disturbing, even disgusting, by contemporary newspaper critics.

All of this history is pretty academic to those goths for whom the scene was largely an excuse to dress outrageously, pose and dance to cult sounds in an atmosphere that welcomed eccentrics and misfits. Yet goth is unusually bookish and sophisticated in outlook compared to most equivalent subcultures, and so a fascination with the past is a central feature of goth's appeal for many adherents. For all that, the film that encapsulates goth most successfully isn't a classic horror film, but the 1975 musical, *The Rocky Horror Picture Show*. While initially a flop, it slowly became the definitive midnight matinée cult movie, attracting crowds of devotees who dressed as the film's characters and developed routines to interact with the onscreen action.

An affectionate satire of vintage science-fiction B-movies, its cast of eccentrically-dressed, gender-bending anti-heroes, its championing of decadence over normality and blend of kinky fun, with camp references to Hollywood horror clichés, is pure goth. *Rocky Horror*'s tagline – 'Don't dream it! Be it!' – could almost qualify as a goth motto, expressing the sentiment that everyone should ignore convention and indulge their darkest fantasies. Even if it means, like Frank-N-Furter, being 'a sweet transvestite from Transexual, Transylvania . . .'

While the sentiment may be right, the soundtrack pastiches fifties rock'n'roll, right for the film's retro-kitsch aesthetic, but not known for its popularity within the goth subculture. Fashion punks had abandoned the punk scene

en masse once the Sex Pistols had imploded and more thuggish second-wave bands had seized centre stage. They were looking for a new, more interesting, less crude sound and style – something that could be sexy as well as shocking – where spitting and brawling were not *de rigueur*. Post-punk fit the bill. 'Post-punk' was a tag employed to categorise the generation of bands that emerged from punk's ashes, more sophisticated than punk, but more bleak and downbeat than new wave.

The term 'gothic rock' was first employed in a review of a 1967 gig by the Doors, the darkest of the bands to emerge from California's Summer of Love. David Bowie described his dystopian 1974 album *Diamond Dogs* as 'gothic', though while Bowie would prove hugely influential on the early goth scene, the label didn't stick. It was a 1979 interview with the Mancunian post-punk band Joy Division which many regard as a landmark, the journalist describing the band as playing 'dancing music, with gothic overtones'. By the end of the year, some rock writers evidently regarded it as a cliché (though it wasn't in wide usage), reviewer Penny Kiley huffing that '"gothic" has become a somewhat overworked definition of the genre, but the effect of Joy Division is the same as (to take an obvious example) that of the Banshees'. 'We'd actually described *Join Hands* as "gothic" at the time of its release, but journalists hadn't picked up on it,' observed Banshees bassist Steven Severin of his band's second album, which emerged in the autumn of 1979.

Siouxsie and the Banshees can legitimately claim to have been part of punk's first wave, though largely as dedicated Sex Pistols fans. The band's first performance was at the legendary 100 Club Punk Festival in 1976, though there was little indication from the twenty minutes of improvised cacophony that the Banshees had any future – nothing except Siouxsie Sioux's confrontational charisma. By the time the Banshees secured a deal in 1978 they had evolved into an accomplished and original quartet, whose inventive, eclectic sound fit thematically into the post-punk category. There was certainly something gothic about the band, from their name (inspired by a Vincent Price horror film), dark themes and lyrics, to their sound, which borrowed from horror-movie soundtracks such as *Psycho*. The band quickly rebelled against the goth tag as creatively restrictive. 'They were using horror as the basis for stupid rock'n'roll pantomime,' Sioux later snarled of the goth bands that surfaced in their wake.

The outspoken singer took particular exception when her distinctive look began being copied by early goths. Yet, according to seventies and eighties American trash-culture encyclopaedia *Retro Hell*, the look had crossed the Atlantic even before the band's first single was released. The book includes an entry devoted to 'Siouxsie Clones', written by Pleasant Gehman: 'Siouxsie Clone attributes: china-doll wigs, black nails, torn net stockings, lacy black vintage dresses, layered black underwear, tank tops and leotards, small square black purses, kinky footwear, vinyl miniskirts with stockings and garters.' Whether the notoriously prickly singer liked it or not, as the only truly glamorous presence to emerge from punk, Siouxsie proved a style icon for a generation of female fashion punks, many of whom would go on to become fully-fledged goths.

The singers who would go on to provide sartorial inspiration for the male of the species proved equally dismissive of the honour. Robert Smith played guitar with the Banshees on occasion, but is best known as the front-man for gloomily introspective post-punk band the Cure. 'It's so pitiful when "goth" is still tagged onto the name of the Cure,' he later sniffed, but his image proved influential, the white make-up, smear of red lipstick and halo of black hair making the singer resemble a manic-depressive marionette. As singer with the angrily anarchic Australian post-punk outfit the Birthday Party,

Nick Cave was also a significant early influence, with his sinuous frame, skull belt buckle, black clothes and similarly midnight-hued crow's nest of long, unruly hair. Yet the spiky Cave would prove just as ungrateful for the adulation of the embryonic goth crowd, dismissing the subculture in numerous interviews. A cynic might observe that being moody, snooty and contrary, even bitchy, is part of the stereotypical goth persona, and Sioux, Smith and Cave were living up to the cliché in midnight-black spades.

All three were regulars at the Batcave, a club in London's sleazy Soho district that has become a legend in goth lore. The Batcave began when the Bristol post-punk band Specimen relocated to London and couldn't find anywhere to play. So they convinced the owner of the Gargoyle club in Soho to let them host a night on Wednesdays. During the day, the upstairs venue was a strip club. More significantly, perhaps, the basement, known as Billy's, was a gay club that had been the original venue for Egan and Strange's first Bowie nights (though by then Billy's had been renamed Gossips).

The Batcave opened its doors in 1982, and by the following year Specimen had a hit on their hands. London's influential *Time Out* magazine gave a cover to 'Gothic Punk', dedicated to 'Hanging Out with the Undead at the Batcave'. 'To walk into the Batcave is to enter a completely different world, one of which Baron von Frankenstein would have been proud had he channelled his talents into nightclubs rather than surgery,' observed their correspondent. He describes the regulars as the result of a 'three-way pile-up between a trainload of punks, a tanker of eyeliner and an army of Kiss clones, they are the most visually gruesome subcult of all'. The organiser, Specimen's Olli Wisdom, is described as what 'Frank-N-Furter would have looked like if he'd joined the New York Dolls'.

The Batcave's creatures of the night were arguably the first full-blooded goths, though some fashion punks were already starting to

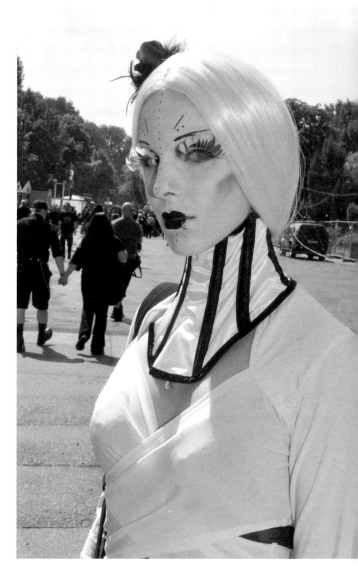

Above: *Self-conscious artifice and a subversive approach to beauty are as important to the goth look as more obviously gothic influences.*

look ghoulishly glamorous, and by no means all of the clientele fit the bill. The playlist was bewilderingly eclectic, and very little of it might be described as goth. Yet the Batcave's trio of house bands – Specimen, Sex Gang Children, and Alien Sex Fiend – helped set the tone. Think heavy make-up, torn black lace and fishnets, and big hair, dyed black, and coiffed into flamboyant crests. Andi Sexgang, singer with the Sex Gang Children, has been

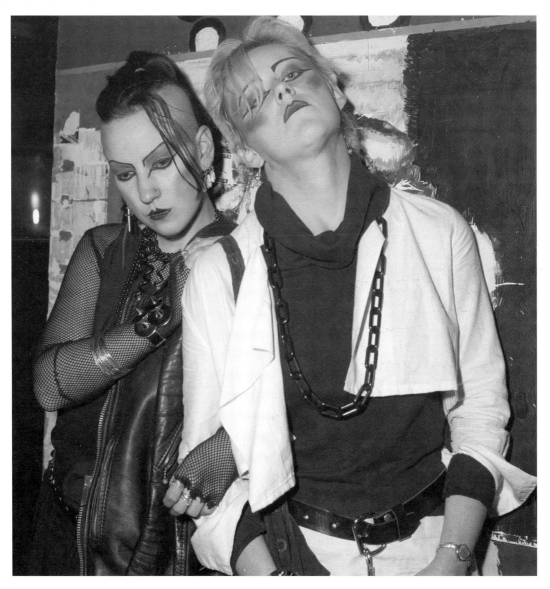

Above: Two archetypal denizens of London's legendary Batcave, brooding for the camera in 1985.

identified as the original goth. 'The goth tag was a bit of a joke,' according to Ian Astbury of the Southern Death Cult, another band of the era with a goth following. 'Andi – he used to dress like a Banshees fan, and I used to call him the gothic goblin because he was a little guy, and he's dark. He used to like Edith Piaf and this macabre music, and he lived in a building in Brixton called Visigoth Towers. So he was the little gothic goblin, and his followers were goths. That's where goth came from.'

The same trendy, glossy eighties style magazines that had helped make Blitz into a launch pad for new romantic bands were notably less enthusiastic about the Batcave. In a 1983 feature on the venue, *The Face* described it as 'the most unsubtle of London's one-night stands, fronted by a Jaggeresque youth in mascara and black lace and without doubt the runaway success of the year'. The clientele were 'a dazzling kaleidoscope of current cults you could describe extremely inadequately as Dracula meets the Muppets'. The knives were out for goth among London's trendsetters as it raised its crimped silhouette over the battlements, and the band that took most of

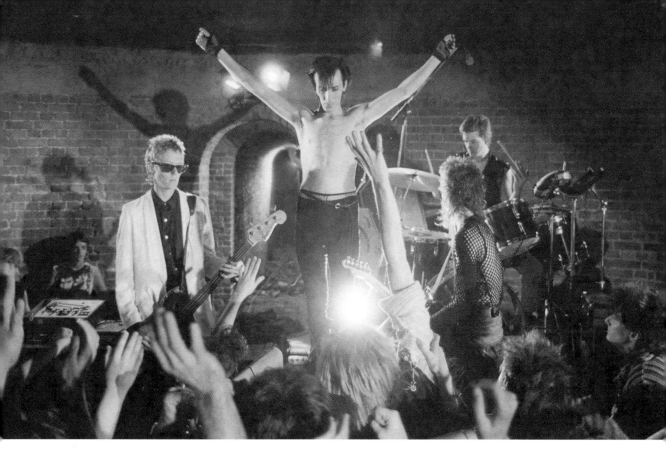

Above: Goth pioneers Bauhaus, captured here live in 1982, filming the promo for their hit cover of David Bowie's 'Ziggy Stardust'.

the flack were Bauhaus. Formed in 1979 in Northampton, they recorded their first single the same year, a nine-minute epic that hit the indie charts, and stayed there for two years. Entitled 'Bela Lugosi's Dead' – its lyrics a macabre tribute to the Hungarian actor best known for playing Dracula in Universal Horror films – it was a curious song, an eerie dirge based on a slowed reggae beat, subsequently identified by many as the first full-blooded goth release.

The single simultaneously made and sunk the band. It became a goth anthem, but being associated with the burgeoning goth subculture had quickly become a guarantee of bad press from UK music hacks, who despised the scene's apolitical theatricality. In the long run, the arbitrary vitriol from established critics helped develop a sense of unity among the band's fans, contributing to goth's tribal identity. Perhaps the most interesting and original element Bauhaus added to their recipe of gloomy, freshly-exhumed glam was an aesthetic borrowed from

Think heavy make-up, torn black lace and fishnets, and big hair, dyed black, and coiffed into flamboyant crests.

the silent horror movies of the twenties, their slender lead singer Pete Murphy taking to the stage in a black body-stocking inspired by the 1920 silent movie *The Cabinet of Dr Caligari* against stark, monochrome lighting.

Even if London's critics and trendsetters hated it, goth appealed to the people who mattered – the punters, happy not just to buy the records, but also to flock to the clubs in suitably dark and decadent finery. What's more, it was spreading. By the early eighties, goth nights, such as the Bone Club, Scream, Sanctuary, the Crypt and the Zombie Zoo were doing good business on America's West Coast.

The USA had been developing its own goth bands, independent of the prissy London scene, typically rather more visceral than their English cousins. 'Back then we called it death rock,'

recalls the punk photographer Edward Colver in Steven Blush's book *American Hardcore*. 'It wasn't called goth yet. TSOL, Christian Death, 45 Grave and even Social Distortion started that whole mess. They all wore lots of pancake make-up and pissed off a lot of the punk rockers in the process.' Most of the American bands were closer – geographically and in spirit – to the low-budget drive-in horror of ghoulish schlock and gory camp than the burgeoning European goth scene, with their more artistic aspirations. The trailblazing death-rock bands were the Cramps and the Misfits, both sufficiently influential to be credited with inspiring new genres: psychobilly and horror punk respectively. Both employed doses of supercharged traditional sounds – the Misfits via the crooned vocals of Glenn Danzig, the Cramps by way of their audible reverence for fifties rock'n'roll – and American death rock generally had a more pronounced rock edge than Europe's post-punk goth bands. The exception that proves the rule is the experimental US outfit Christian Death, who were the definitive cult act, their troubled androgynous vocalist Rozz Williams playing the role of doomed decadent poet with suicidal dedication.

The British band who had the biggest impact on the goth scene in the mid-eighties were the Damned (also the first to export English punk across the Atlantic on their 1977 US tour). From the band's formation in 1976, Damned singer Dave Vanian (his adopted surname an abbreviation of 'Transylvanian') had a gothic image: raven-black hair slicked back, with cadaverous make-up and funereal duds to match. 'Long before there was a recognised gothic look, there were fans turning up at shows dressed like Dave,' recalled Damned guitarist Brian James, 'which was brilliant at the time, because it lifted us right out of the typical punk-rock band thing. Other groups had the spitting and the bondage trousers, but you went to a Damned show, and half the local cemetery would be propped up against the stage.' The band experienced a crisis

It was pretentious and much mocked, but it looked cool, which was what counted.

when the popular member Captain Sensible left in 1984, but subsequently rallied and secured a deal with the major label MCA. *Phantasmagoria*, the album that resulted from the deal the following year, represented a major change in direction for the band.

Vanian's eerie influence had always been apparent – take the spooky epic 'Curtain Call' on 1980's *Black Album* – but starting in 1985, the singer's macabre image was adopted by all members of the Damned. They took the whole gothic aesthetic back to its roots, dressing like undead dandies from the early 1800s, playing live against a backdrop that could have been taken from an original gothic-novel illustration. The new look proved influential in promoting what became known as the 'trad goth' style, which favoured Romantic costumes from the 18th and 19th centuries. Gentlemen carried canes and wore frock coats, riding boots, embroidered waistcoats, top hats or even highwayman-style tricornes. For the ladies it was billowing gowns, corsets, bustles, elaborate hair, veils and even wedding dresses. The style was a step too far into straight-faced Hammer Horror cliché for many of the gothic punks, but it was certainly fun, glamorous and arresting, and a perfect example of the 'Don't dream it! Be it!' ethos of *The Rocky Horror Picture Show*.

By the mid-eighties, the pendulum was swinging away from the nightclub and back to the live venue in terms of what the punters wanted, and a trio of British bands emerged who shifted the focus of the goth scene from the intimate club environment into the stadium-rock arena. In the process goth evolved from gothic punk to gothic rock, a development not everybody welcomed. Scene veterans lamented the emergence of an epic, anthemic guitar sound

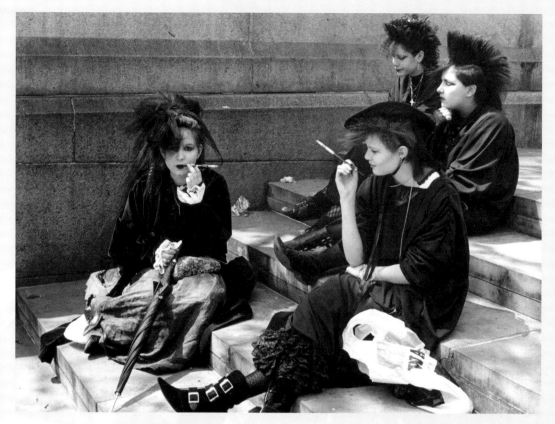

Above: Parasols, boot buckles and cigarette holders – goth can be all about accessorising.

– just the sort of thing punk was supposed to have made redundant – while the bands themselves resisted being pigeonholed as goth, a movement that the music press now routinely ridiculed and ran down. Despite this, the unhappy marriage proved a commercial and popular success, taking goth from a perennial presence in the indie charts to a formidable force in the rock mainstream, with a building new audience who responded to this more bombastic species of goth.

The first of these bands was the Sisters of Mercy, who formed as a post-punk outfit in 1979, receiving enthusiastic reviews for the deadpan, melancholic singles released on their own Merciful Release label. The band's debut album on WEA, *First and Last and Always*, was similarly positively received upon its release in 1985. 'God forbid,' wrote the reviewer for *Melody Maker*, 'but these songs are almost explosive enough to launch a goth revival (the third this year?).' Andrew Eldritch, the

imperious, baritone Sisters singer, took the backhanded compliment to heart, and did everything in his power to disassociate the band from the goth subculture, to little avail. Shortly after the release of the Sisters' debut, Eldritch, who had fallen out with the press and was fast falling out with his fans, also fell out with his band. After an acrimonious public feud, former Sisters Wayne Hussey and Craig Adams formed the Mission, the second of the classic eighties gothic-rock bands. They took the genre even further into the realms of epic rock excess, though still resisted the goth label. 'A large part of why we denied being goths in the early days is because we did want to be pop stars, to perform on *Top of the Pops*,' a contrite Hussey later reflected.

The final band to join the gothic-rock renaissance was the Fields of the Nephilim, formed in 1984, their name taken from deviant Biblical lore, indicative of the band's occultic direction. Goth bands had been referencing voodoo and occult icons like Aleister Crowley

since the subculture's inception, even if the Nephilim appeared to be taking it more seriously than most. What was new was the Spaghetti Western image the band adopted – cowboy hats and long leather coats, dusted with flour to make them appear fresh from the badlands. It was pretentious and much mocked, but it looked cool, which was what counted.

By the late eighties a stylistic overlap with heavy metal was appearing in the goth scene, influenced by these same gothic-rock bands. Considerably more black leather and shades started appearing after dark in nightclubs, while cowboy boots – long a goth fashion faux pas – could be seen on goth dancefloors. The

goth scene – long in touch with its feminine side – was starting to develop a more masculine image. By the nineties, the wave began to break. In 1990 the Sisters of Mercy released their final album, *Vision Thing*, before Eldritch fell out with his label, putting the band into suspended animation. The singer insists they are still going (but *not* a goth band). The following year both the Fields of the Nephilim and the Mission began to unravel amid internal disputes.

Not everybody was unhappy. The Nephilim had been sailing too close to heavy metal for the tastes of many goth veterans, while

As the millennium approached, goth experienced an industrial revolution.

the Mission's style of expansive, sometimes sentimental hard rock was starting to hark back to the sort of self-indulgent seventies music punk had set out to destroy. If goth was to survive into the 21st century, it was time for a rethink, and the answers came from some unexpected directions. A kinship had developed between goth and the industrial music scene in the early days. Pioneering industrial acts like Test Dept had played at the Batcave, while more adventurous goth DJs had been spinning discs from experimental electronic acts for some time, but as the millennium approached, goth experienced an industrial revolution.

Much of this was a backlash against the rise and fall of gothic rock. However, it also reflected the increasing importance of new technology, particularly the internet, which many goths had embraced ahead of the curve. The last factor was the emergence of rave culture, which touched every club scene, goth included. By the late nineties, punters at the more fashionable goth nights – high on the latest designer drugs – began to demand the repetitive dance music that accentuated an ecstasy trip. Initially it was EBM (Electronic Body Music), the most danceable version of the industrial genre, though increasingly goth clubs were pulsing to the mainstream beat of techno and trance. Devotees of this radical new development became known as cybergoths, their outfits a celebration of all things futuristic, with eye-catching riots of Day-Glo PVC, LED t-shirts and luminous plastic dreadlocks. In the most recent development, however, a fad has arisen for Steampunk – a style based upon Victorian science fiction – combining 19th-century fashions with heavily retro-hi-tech. A true case of 'back to the future', and an indication that goth still has numerous surprises up its sleeve.

HARDCORE PUNKS
American Waste

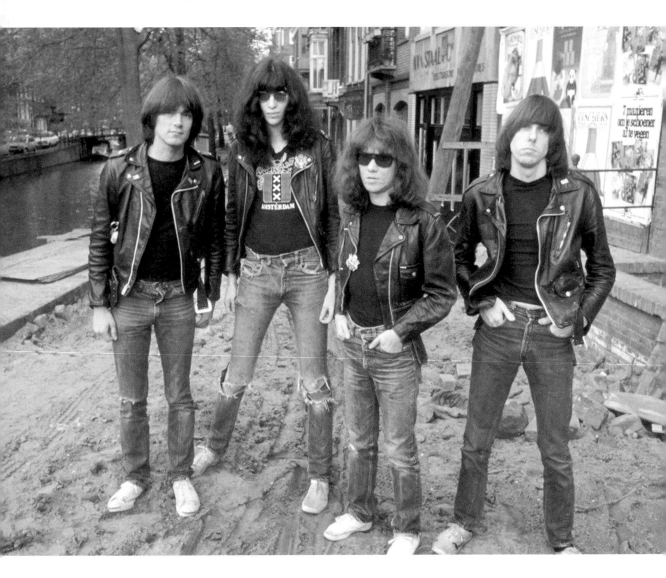

With hardcore punk, the emphasis was on practicality, both in the frenetic environment of the hardcore gig, and for running the gauntlet of violently hostile outsiders.

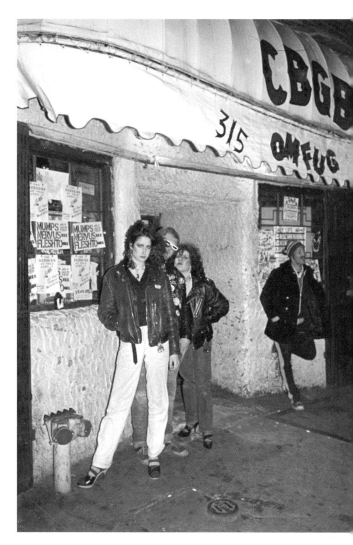

Above: Punks outside the legendary NYC punk venue CBGB's.

Patriotism can manifest in the most unexpected places. The relationship between the UK and the US has always been an ambivalent one. In the sixties, the Brits took American rock'n'roll and successfully sold it back to them courtesy of the British invasion spearheaded by the Beatles, an incursion not universally welcomed. Most American punks – like their British cousins – had nothing but disdain for the nationalist pretensions of the majority of their countrymen. Yet there was a little patriotic pique in the reaction of some US punks to another attempted British invasion in the late seventies. The Americans had, after all, invented punk with bands like the New York Dolls and the Ramones in NYC as early as 1974. But it was Limeys who were dominating the limelight come 1977, most notably the Sex Pistols, who landed on American soil early the following year. Many natives were bemused by the quartet of foul-mouthed Brits, but some were actively hostile.

'I used to like beating up English people; I thought they had real pompous attitudes, I just didn't like 'em,' said Harley Flanagan, who blamed his own attitude problems on being 'a product of my environment', that environment being New York's rough Lower East Side. Flanagan's background, however, wasn't all street brawls and attitude. At age nine, the young Harley penned a book of poetry, with a foreword by the beat poet and hippie

Opposite: They might look like rockers, but the Ramones proved one of the most influential acts in US punk.

spokesman Allen Ginsberg, a family friend and neighbour. By age twelve, however, he was drumming for the punk band the Stimulators, founding the Cro-Mags the following year in 1983. The New Yorkers would become one of the most influential hardcore bands. Flanagan's friend Jimmy Gestapo – singer with another important NYC hardcore act, Murphy's Law – described how the tough situation on the streets helped create the US scene. 'Everybody got beat down so much for being punk rock that they became hardcore,' he told Steven Blush in *American Hardcore*, the definitive text on the

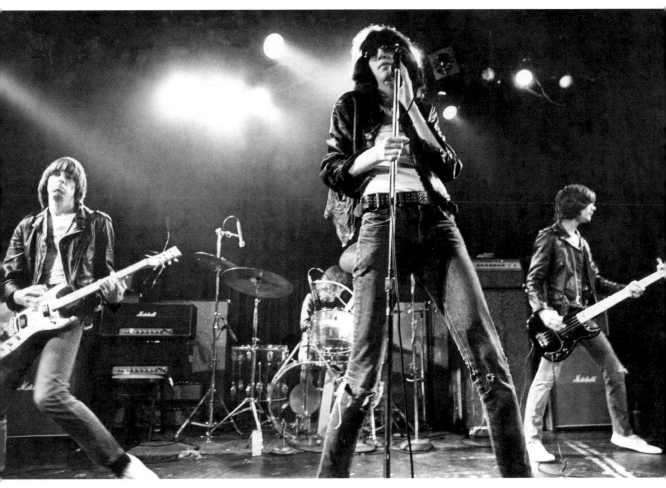

Above: The Ramones cut loose onstage in the early seventies.

scene. 'We got beat into hardcore. It was fun running around with spiked hair and bondage belt, but I got beat into shaving my head, putting boots on, and arming myself with a chain belt. I evolved my fashion statement into a function. That's what everyone around me did.'

Hardcore style was a conscious rejection of the peacock tendencies of classic punk, with its evermore flamboyant Mohican crests and tartan bondage trousers bought from expensive boutiques. The emphasis was on practicality, both in the frenetic environment of the hardcore gig, and for running the gauntlet of violently hostile outsiders – from ethnic street gangs and rednecks to cops and college jocks – who often greeted fans outside the venue. They favoured street clothes – either army surplus or even just a t-shirt and jeans – and often the only thing that separated a hardcore punk from any other street kid was sweat and attitude. Other distinguishing factors included tattoos and band logos painted onto coats and leather jackets. Some wore chains or bandanas on their heavy boots, though others dismissed this as a frivolous betrayal of hardcore's minimalist ethic. One unique hardcore style was the 'butt flap' – a scrap of cloth bearing a band name, hung from the back of your trousers. At a time when long hair was only just going out of fashion, hair was hacked back, or even shaved, and there was a substantial overlap between the hardcore scene and the first wave of skinheads to appear in the US.

Hostility to high-profile 'fashion punks' like the Sex Pistols was common among hardcore kids.

Hostility to high-profile 'fashion punks' like the Sex Pistols was common among hardcore kids. Despite his earlier expression of Anglophobia, Harley Flanagan later confessed that the US scene was developing in parallel to some UK punks, who were also rejecting many of the leading early English bands as middle-class poseurs. By 1980, the second wave or street punk movement was emerging in Britain, with its studded leather jacket, Dr Marten boots and Mohican image now widely accepted as punk uniform, alongside a crude, self-consciously thuggish sing-along style of music influenced by soccer terrace chants. More significantly, it was also at this point that UK punk started cross-pollinating with the skinhead subculture, creating the aggressively working-class Oi! genre. It was this hooligan-friendly version of British punk, played by bands like Sham 69 and Discharge, which would have an influence on early hardcore, alongside US punk bands like the Ramones and the Germs – Harley Flanagan even going so far as to describe hardcore as an American version of Oi!.

The racist element in Oi! inspired most critics to dismiss or condemn the movement in its British birthplace. Stateside, the adoption of skinhead styles by many young punks would lead to the first of many tensions in the hardcore movement, due to the radical right-wing reputation that came with the shaved head (even if this reputation wasn't always warranted). Ironically, in view of this, many consider 'Pay to Cum' to be the first true hardcore recording, a 1980 single by Bad Brains, who were all black musicians. They began as an experimental jazz act named Mind Power, before a building interest in the burgeoning punk sound inspired

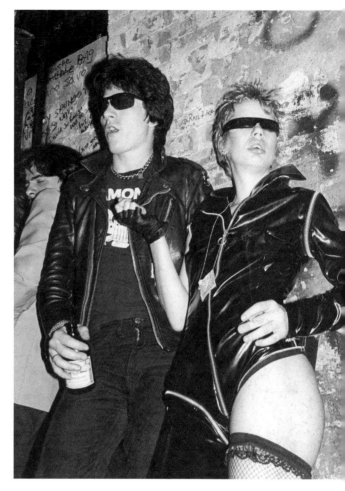

Above: *Punks at CBGB's in 1977 – a new generation of hardcore punks would soon emerge who dismissed such subversive peacocks as fashion punks.*

their change of name and direction in 1977. The band were particularly impressed by the fusion of punk and reggae in the sound of leading UK punk act the Clash, and Bad Brains developed their own inimitable crossbreed of the two apparently incongruous styles. It was the frenetic speed of some of their new material that had the most impact, however, and the equally furious audience response earned Bad Brains a bad reputation in their home city of Washington, inspiring the song 'Banned in DC' and the group's relocation to New York.

They found a new home in the legendary NYC venue CBGB. The acronym stood for 'Country Bluegrass Blues', but since it opened

in 1973, the club had followed a policy of fostering original talent in any genre, and it soon became best known as the breeding ground for America's fledgling punk scene. If, in the seventies, CBGB was the cradle of US punk, by the eighties it had become the spiritual home of hardcore.

However, hardcore had many homes, with regional scenes springing up across the US independently. The term itself is often credited to a Canadian punk band, DOA, who titled their second album *Hardcore '81*. The album's sound was significantly faster and more aggressive than their debut, a key characteristic of the hardcore strain of punk. The Vancouver band also took an ideological stance, directing the rage in their music at political injustice and hypocrisy, an approach also frequently found in the classic hardcore recipe. Indeed, rage was the defining hardcore sentiment, as an audience grew organically across the map of America.

The first indication that hardcore had hit a local scene usually erupted at gigs when slam-dancing – where dancers deliberately collided with each other – replaced punk's comparatively sedate pogoing (jumping up and down, a style that Sex Pistol Sid Vicious claimed to have invented). Slam-dancing was eventually dubbed moshing, a style later adopted by numerous other scenes – as was stage-diving, climbing onto the stage then launching yourself into the audience. While subsequent subcultures emulated these aggressive dance conventions, few matched the savage intensity of an archetypal hardcore gig, where physical aggression in the audience mirrored the intensity of the music and frequently boiled over onto the stage. The spirit of hardcore involved rendering the music down to its purest form – an experience of simultaneous power

If, in the seventies, CBGB was the cradle of US punk, by the eighties it had become the spiritual home of hardcore.

and frustration only ever really perfected live, its impact on the dancefloor frequently leaving a swathe of bruises and the odd broken bone. This intoxicating recipe of blood, sweat and fear gave hardcore punk its power, but also embodied the self-destructive tendency that haunted the movement.

Few hardcore scenes were more notorious for violence than Los Angeles. While the race riots in 1992 made the world aware of the number of rotten apples in the LAPD, local punks had known for some time that the local police were frequently violent and lawless, that their brutality wasn't confined to vicious expressions of racism, just as poverty and desperation weren't confined to LA's black ghettos. 'The police, especially in LA, have always been pretty fascismo,' claimed Dez Cadena. 'The cops thought punk was a rebellion that threatened them, the American family, and society in general – and they wanted to stomp it out.' Cadena was vocalist and later guitarist with the Californian hardcore band Black Flag, and had experienced police methods up close on numerous occasions. The police developed thick surveillance files on hardcore bands, and routinely broke up hardcore gigs as though they were riots, vigorously and indiscriminately employing tear gas and riot sticks on the predominantly teenaged audiences.

Inevitably this brutality spawned militant anti-authority sentiments in the scene, as well as hardening attitudes, particularly in Los Angeles, where police violence was a particular problem. Perhaps the sense of being embattled also contributed to the fierce dedication of bands like Black Flag, who developed a powerful work ethic after forming in 1976, founder Greg Ginn releasing the band's music on his own SST label, collectively and aggressively promoting the band at street level with flyers, posters and

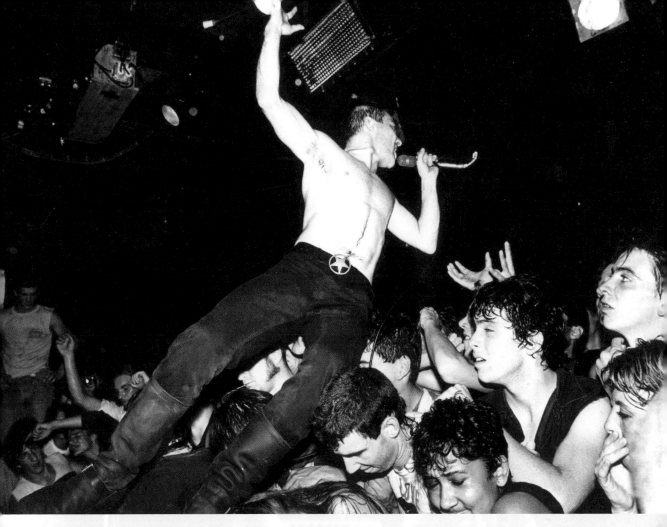

graffiti (which served to further bring them to the attention of the police). Black Flag proved hardcore's most effective early evangelists, touring tirelessly and turning pockets of local punk activity into a national scene. Most members of this building legion were white boys with troubled backgrounds, the music providing an outlet for the frustrations engendered by poverty and neglect.

They frequently found themselves trapped between a rock and a hard place – persecuted by the police and belligerent college jocks as freaks, and targeted by ethnic gangs in the rundown neighbourhoods where many of them lived simply because of the colour of their skin. Banding together, they found safety in numbers, and the opportunity to bite back. The situation led to one of the most controversial lyrics in the hardcore canon, the 1981 song 'Guilty of Being White' by Minor Threat. Minor Threat, formed in 1980, swiftly

became the leading hardcore act in their home city of Washington DC, touring Europe with Black Flag the following year. Minor Threat's vocalist Ian MacKaye, who wrote 'Guilty of Being White', took great exception to those who chose to interpret the song as racist, pointing out that it was clearly a condemnation of those who judged others by the colour of their skin.

Another 1981 Minor Threat song by MacKaye, 'Straight Edge', caused even more controversy within the scene. It triggered the straight-edge movement of hardcore kids who believed that adrenaline was the only intoxicant you needed, condemning drugs, alcohol, cigarettes, caffeine, and in some cases even meat and sex, as poisons that cloud your mind. While straight edge certainly had a positive impact on some lives, inevitably in the febrile hardcore

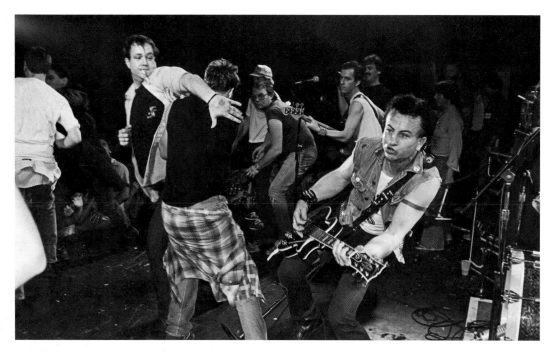

scene a few took it to violently puritan extremes, knocking drinks out of people's hands or even assaulting kids they saw taking drugs. Straight edge was also a powerful tool in bringing younger recruits into the hardcore ranks, too young to drink legally anyway. While venues without bars were unattractive to many potential punters in search of sex, drugs and rock'n'roll, they could welcome the under-twenty-one crowd barred from many gigs.

It was San Francisco band the Dead Kennedys who pioneered all-age afternoon shows to attract younger audiences, which proved instrumental in building hardcore's popularity. Formed in 1976, the band's name, which mocked the sacred status afforded America's most revered political dynasty, was typical of their wittily provocative approach. In 1981 they released a single that rivalled Minor Threat's 'Guilty of Being White' for its divisive effect within the hardcore subculture. While Ian MacKaye's song had a provocative anti-racist subtext, 'Nazi Punks Fuck Off!' by Dead Kennedys vocalist Jello Biafra was less ambivalent.

In 1986 the Kennedys' acutely acerbic

Above: Fans of the influential LA punk band Fear were fearsome even by hardcore standards, famously trashing the studio during the group's 1981 performance on Saturday Night Live.

attempts to provoke the American establishment bore bitter fruit when Californian authorities launched a prosecution against the band, based upon the use of H.R. Giger's 'penis landscape' artwork on the sleeve of their 1985 album *Frankenchrist*. It became a test case for freedom of expression, then under widespread attack during the right-wing presidency of Ronald Reagan (a figure who at least united hardcore punks, as he was universally despised). The Dead Kennedys narrowly won the battle, but the pressure it put them under helped precipitate the collapse of the band, who played their last gig in January of 1986 (controversial recent revivals notwithstanding). Hardcore had already turned a corner by then, or, in the view of many devotees, was on its last legs. In characteristic style Biafra launched a last salvo in the form of the song 'Chickenshit Conformist', in which he accuses most punks of being just as closed-minded and conservative as the parents they were rebelling against.

This intoxicating recipe of blood, sweat and fear gave hardcore punk its power, but also embodied the self-destructive tendency that haunted the movement.

Hardcore contained the seed of its own destruction from the start. Nobody can stay that angry forever, and the violence of the gigs, while exciting, would inevitably alienate everyone but the serious adrenaline junkies. Hardcore's fierce masculine values also ultimately limited its appeal, and while the scene's single-mindedness was its main strength, it was also a fatal weakness. As rigid rules emerged, the better bands became bored. They tired of playing the same few chords as fast as possible, of being attacked by the fans onstage, and many – such as Black Flag or North Carolina's Corrosion of Conformity – began to grow their hair and court an audience who welcomed technical proficiency and showed their dedication in a less bruising fashion. To many hardcore diehards this was an unforgivable betrayal, as metal fans had always been among the scene's many foes. Yet for others, it was a natural evolution, and they were welcomed into metal's broad church with open arms, hailed for helping birth the thrash movement that was finally exorcising air-headed glam rock from the metal temple.

The punk torch was handed on to so-called pop-punk bands – upbeat American acts who took the more melodic aspects of early punks like the Ramones as a base to create a radio-friendly variant. By the mid-nineties, pop-punk bands like Green Day, the Offspring and Blink-182 were enjoying international chart success, though many purist veterans questioned whether the 'punk' part of the label

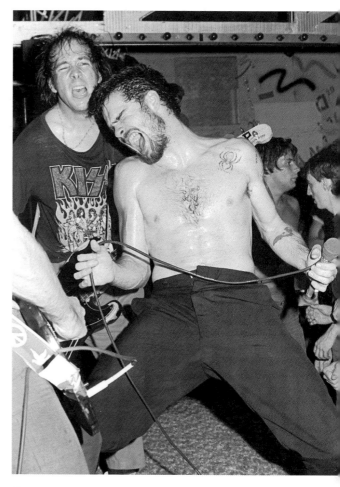

Above: *Black Flag performing in 1982 – the physical intensity of their live performances defined true hardcore punk.*

was justified for these bands, who conspicuously lacked the fire and fury of their forebears. 'I think it's your own choice if you turn from an angry young man to a bitter, old bastard, or if you stay hungry in a good way,' observed Green Day's Billie Joe Armstrong. Even if hardcore expired in the mid-eighties – something many devotees still deny – the movement remains one of the most important milestones in subculture history. Though hardcore bands never enjoyed the multi-platinum album success of their pop-punk successors, hardcore was an authentic grassroots movement that prevailed against insurmountable odds, fuelled only by blood, sweat and dogged self-belief.

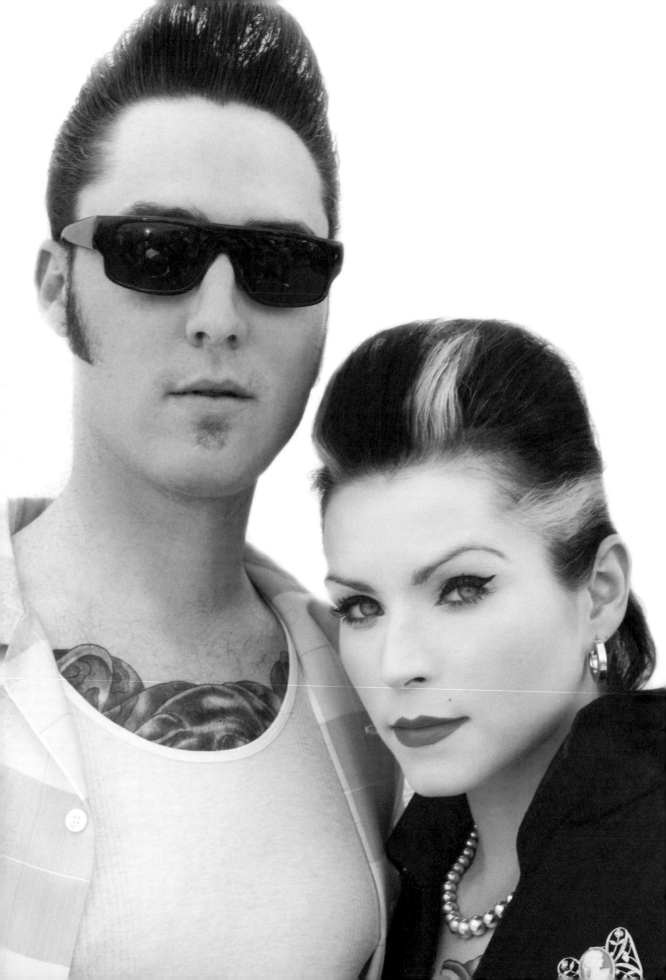

PSYCHOBILLIES
Rockabilly Psychosis

By the seventies there was a mass revival of interest in fifties rock'n'roll rebellion.

The seventies were lean times for devotees of classic, high-energy rock'n'roll. Eddie Cochran had died in road accident while touring the UK as far back as 1960, and Gene Vincent (who'd been in the same car but survived) succumbed to a ruptured stomach ulcer in 1971 at age thirty-six. Elvis limped on until 1977 – a bloated caricature of his former self – crippled by the addiction to prescription drugs that finally killed him. In his troubled latter years, the King had helped tame the image of rock'n'roll – even turned it into something of a joke, devoid of any of the rampaging hormones and delinquent sneer of its heyday. By the seventies there was a mass revival of interest in fifties rock'n'roll rebellion. But it was dominated by a building feeling of conservative nostalgia towards the era as a golden age of conformism and innocence. Many had conveniently forgotten the hostility and hysteria directed towards the original teen rebels of the 1950s.

A barometer of changing attitudes was the popular US TV series *Happy Days* – a teen-

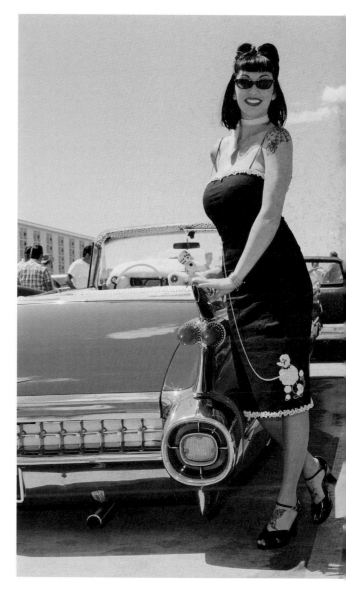

Opposite and right: A recent revival of interest in the fifties roots of cool has given 21st-century subculture a chic new edge.

focused sitcom set in the fifties that ran from 1974-84, its banal title an indication of the show's nostalgic tone. The show's token rebel rocker was a cool character called the Fonz, complete with quiff and Triumph motorbike, played by Henry Winkler. He became the show's most popular character, and a seventies icon was born. Yet the Fonz was a hoodlum with a heart of gold, a wild spirit repeatedly tamed by the love of a good family.

The Fonz wasn't born in a vacuum. Before taking on the role, Winkler appeared in *The Lords of Flatbush*, a 1974 film about four leather-clad Brooklyn greasers, one of a spate of movies that used retro rock'n'roll rebellion as a backdrop. By far the most influential was

Above: A London rockabilly couple pose in front of their vintage American auto.

1978's *Grease*, which features all of the clichés of fifties rebellion – rock'n'roll, rumbles and hot-rod racing (though no bikes) – but is another unabashed exercise in warm nostalgia. If anything proved that the adolescent rebel spirit of the original rockers had lost its power to shock, it was the success of *Grease*, which broke box-office records by appealing to moviegoers of all generations, with its feel-good love story and quaintly retro setting. Yet some were trying to keep the rock'n'roll flame burning.

Among the most commercially successful was a Welsh singer with the stage name Shakin' Stevens. His big break came when he took the

The rockabilly look diverged from that of many British rock'n'roll traditionalists, who either clung to teddy boy drapes or the leather-clad image of the sixties rockers.

title role in *Elvis the Musical*, and he went on to become one of the most successful European recording artists of the eighties, with a series of hit fifties-style rock'n'roll releases. Yet each one was another nail in the coffin for the rebellious spirit of the era – every family-friendly, chart-topping single making it look increasingly redundant. Rock subculture has always had a healthy respect for tradition, and the grassroots fight to reinstate some rebellion in the scene centred on a largely forgotten term from its nativity, in the form of rockabilly.

Rockabilly is an elusive and occasionally incendiary tag. In the fifties it was sometimes used interchangeably with rock'n'roll, because it described the interplay between black urban guitar music (rock'n'roll) and its rural white southern equivalent (hillbilly). Before he became the King of Rock'n'Roll, Elvis was billed as the Hillbilly Cat. Presley's debut single, released in 1954, has been hailed by *Rolling Stone* magazine as the first rock'n'roll record, though at the time it was described in numerous ways, not least as 'rockabilly'. The A-side was 'That's All Right', a rhythm-and-blues number first recorded by the black Mississippi bluesman Arthur Crudup, while the B-side was 'The Blue Moon of Kentucky', originally by the white Kentucky bluegrass pioneer Bill Monroe.

Sam Phillips, the record producer who discovered Elvis, was dismissive of the rockabilly tag. 'I've always thought "rock'n'roll" was the best term, because it became all-inclusive of white, black and the whole thing, whereas "rockabilly" tended to just want to lend itself so specifically to white,' he said. 'It also promoted the feeling that maybe we were stealing something from the blacks and wanted to put it in a white form, so I never did like "rockabilly".' Significantly,

perhaps, Phillips was reflecting in the nineties, by which time he had weathered numerous charges that rock'n'roll was a textbook example of American black culture being appropriated and exploited by white businessmen. It's certainly true that numerous early rock'n'roll classics were originally recorded by black artists, but only became hits when covered by white bands. You could equally argue that this didn't end in the fifties.

The song 'Tainted Love' was a huge hit for the pasty-white UK synth-pop duo Soft Cell in 1981, yet few of those who bought it were aware that it was a cover of a 1965 number by the black American singer Gloria Jones. On the other hand, Jones didn't write 'Tainted Love', it was the B-side to a flop single that would have likely sunk into obscurity had it not been resurrected by Soft Cell's Marc Almond, who discovered it as a consequence of the – predominantly white – British northern soul scene, which fetishised black American soul music. Music can be used as a way of breaking down racial barriers, or as a way of scoring ideological points. Those who endeavoured to revive the term rockabilly in the seventies weren't trying to deny the vital role American black culture played in the development of rock'n'roll. Rather it was an attempt to redress the way in which the contribution of poor, young white Americans from the nation's southern states were being airbrushed out of the picture by well-meaning liberal commentators.

In his provocative 1998 book *The Redneck Manifesto*, arch-controversialist Jim Goad argues that the USA's 'white trash' have replaced the nation's black population as the chief targets of acceptable bigotry. Subtitled *How Hillbillies, Hicks, and White Trash Became*

America's Scapegoats, Goad's incendiary tract suggests that those in power now deride the white underclass in a conscious policy of divide-and-rule: 'A whole vein of human experience, of potential literature, is dismissed as a joke, much as America's popular notions of black culture were relegated to lawn jockeys and sambo caricatures a generation or two ago. The redneck is the only cardboard figure left standing in our ethnic shooting gallery.'

For most fans of rockabilly in the eighties, however, such cultural and ideological controversies were largely irrelevant. They simply wanted to recapture the rebellious spirit of the guitar music they loved, rescue it from toothless retirement as retro nostalgia, and get it breathing fire again. In his excellent book on rockabilly, *A Rocket in My Pocket*, music journalist and rockabilly devotee Max Décharné defines that spirit: 'Youthful enthusiasm, urgent rhythms and stripped-down arrangements driven along by a slapping upright double bass; these were songs sung mostly by teenagers which dealt with all the essentials of the hepcat lifestyle: girls, cars, booze, dancing.'

Curiously, this return to rock'n'roll's pulsing roots required a transatlantic journey. One of the most influential figures in the rockabilly revival was Brian Setzer, who formed the rockabilly band the Stray Cats in New York State in 1980. Later describing what drew him to a style most regarded as ancient subcultural history, Setzer said it was 'a whole look, and a whole lifestyle as well, that impressed me. So, I was definitely enamoured of that whole period. I love fifties cars. I love the music. I love the clothes. I just thought it was the greatest time

Guys in flat-top haircuts, baseball jackets, frayed denim and retro work-shirts, girls with elaborate fifties hairdos and skirts or pedal-pusher pants, plus a passion for polka dots and vintage lingerie.

in American history.' He wasn't alone, but much of the enthusiasm for full-blooded fifties revivalism seemed to be in the UK. British bands like the Polecats, Crazy Cavan and the Rhythm Rockers, and Matchbox were starting to enjoy some success, with Matchbox even hitting the UK Top Twenty with their single 'Rockabilly Rebel' in 1979. The following year, the Stray Cats decided to abandon rock'n'roll's American birthplace and take a chance on the burgeoning British rockabilly revival.

'I just remember reading an English newspaper, that was probably in a little magazine stand with a picture of some guy who had like a pompadour, an earring, a tattoo,' said Setzer. 'At the time, it was pre-punk. It was so out of the ordinary. Nowadays, everybody's got that [. . .] It just became a thing in the back of our minds, we should go to England, because we weren't getting anywhere on the East Coast. Then one day we finally met an English teddy boy sort of character, you know the English equivalent to the American greaser, from the fifties. He just said, "Brian, if I ever took you guys to England, you would be stars. They would love you there, 'cause you're authentic. You're Americans." And . . . he was right.'

Upon hitting London, the Stray Cats were almost literally an overnight success. The band's gigs became the hottest tickets in town, while labels began a bidding war to secure the band, whose self-titled debut album came out in 1981. It was the start of a brief, but highly successful career that established rockabilly as a vibrant force once more, not just in the UK, but also Europe, and even the USA. The rockabilly look diverged from that of many British

rock'n'roll traditionalists, who either clung to teddy boy drapes or the leather-clad image of the sixties rockers. Rockabillies went back to source, with styles inspired by fifties movies and vintage rock'n'roll album covers. Guys in flat-top haircuts, baseball jackets, frayed denim and retro work-shirts, girls with elaborate fifties hairdos and skirts or pedal-pusher pants, plus a passion for polka dots and vintage lingerie. Most controversially, the Confederate Flag from the American Civil War became iconic – a universal symbol of rebellion as far as most rockabillies are concerned, but still associated with the iniquities of slavery in other eyes.

Within the tribal environment of eighties UK street culture, friction was perhaps inevitable, and not all of the nation's rock'n'roll veterans welcomed this new injection of energy. The teddy boys had hit the headlines a few years earlier courtesy of mass brawls with the fledgling punk movement, and in subcultural terms the marriage between rockabilly and punk certainly bore metaphorical fruit, though it was a troubled delivery. According to Mark Robertson – self-described 'drum banger' with the Meteors – his first tour with his new band in 1981 was a baptism by fire, culminating in a night when the venue's management brought a contingent of teddy boys to the dressing room to tell him that they hated his band, motivated, he suspects, by his luridly-dyed hair. The evening's event degenerated into violence. 'The good thing about that night was because the rockabillies were on one side with us, fighting with the teds and bikers,' enthused Robertson. 'Things have just developed from there. When we started picking up attention in the music press and stuff we started being lumped together as just another rockabilly revival band, but now they slag us off for being a punk band.'

The Meteors are now widely regarded as the definitive psychobilly act. 'Basically, the songs are just a cross between rockabilly and early

Above: *Psychobilly evolved into a hip synthesis of rockabilly, goth and punk.*

punk,' explained vocalist Paul Fenech. 'It's the feeling that the early punk stuff generated before it got commercial, and the excitement that we tried to carry over into the sort of stuff we sing about, and the sort of stuff we write about is the stuff we know about which is mainly horror and science fiction, because that's all the stuff we are really into.' Psychobilly took eighties rockabilly revivalism and added a substantial dash of punk-inspired insanity – invoking a sort of undead Elvis, hungry for human flesh. Quiffs took on improbable proportions while fans became increasingly volatile and frenzied to the over-heated sounds of fifties rock'n'roll taken to its most frenetic –

Above: The fetish model Bettie Page became one of the most popular alternative icons of the fifties, evoked here by a trio of stern femmes.

and frequently bloody – extremes. Dedicated Meteors fans designated themselves as the Wrecking Crew, and psychobilly dancefloors often looked perilously close to brawls set to music. If the rockabilly revival's mission had been to dismiss rock'n'roll's image as anodyne nostalgia, psychobilly was its ultimate success, generating an international subculture that has earned a fearsome reputation for high-octane hell-raising.

The Cramps, an American punk band formed in 1976, who took both their classic rock'n'roll

and trashy horror movies notably seriously, are often identified as the forefathers of psychobilly. They embodied 'juvenile delinquency' – the fifties media buzzwords for a supposed plague of teen criminality – and horror played a significant role in the demonisation of youth by the American establishment of the era. The musical world the Cramps created was equal parts cheap drive-in exploitation movies and camp evocations of other forbidden elements of

fifties youth culture, such as the era's infamous horror comics. In 1954 the US psychiatrist Fredric Wertham published his book *Seduction of the Innocent*, an influential text highlighting the humble comic as responsible for promoting youth rebellion and teen deviance. In particular, Wertham singled out horror comics, which in the fifties contained far more graphic gore than you could ever hope to see on the cinema screen; a lurid, three-colour world of vengeful zombies and cheerful sadism that encapsulates the psychobilly vibe.

While the Cramps claim to have dreamed up the term, they were always insistent that they were never actually a psychobilly rock'n'roll's raw roots, much of it revolving around other aspects of vintage fifties outlaw culture, aside from the music. 'It's just about the kind of people who like to kind of go against the grain,' explained ex-Stray Cat Brian Setzer in 1996. 'It's definitely about old cars, but it's about fixing them up in your own style, making them custom or hot-rodding them. It's also about style in the way you dress, whether it be rockabilly style or swing style. It's about thought going into your daily life. Like I would never go out in a pair of sneakers and jeans with my hair not combed – it's never been done! It's about care and thought that goes into your daily regime. There's a lot of people who

> In subsequent decades, the underground has reclaimed the fifties as a golden age of stylish rebellion and a swinging celebration of glamorous self-indulgence.

band. 'The Cramps weren't thinking of this weird subgenre when we coined the term "psychobilly" in 1976 to describe what we were doing,' bassist Poison Ivy told Marc Spitz and Brendan Mullen in *We Got the Neutron Bomb*. 'To us all the fifties rockabillies were psycho to begin with; it just came with the turf as a given, like a crazed, sped-up hillbilly boogie version of country. We hadn't meant playing everything superloud at superheavy hardcore punk tempos with a whole style and look, which is what "psychobilly" came to mean later in the eighties. We also used the term "rockabilly voodoo" on our early flyers.' The prevalence of camp horror imagery in the Cramps' material has inspired some critics to style them as the forebears of another subgenre – gothabilly – which also combines gothic imagery with fifties-style rock'n'roll, but is distinguished from psychobilly by being more theatrical and less testosterone-fuelled and aggressive.

There are several other supposed subgenres and movements that owe something to do that, in their look and in your daily life and the way you live.'

Other examples include the retro-striptease style known as burlesque dancing, as well as the curvaceous pin-ups of the era (particularly the legendary bondage model Bettie Page), chintzy cocktail bars (think Hawaiian themes like Tikis and hula dancers), alongside the colourful pop-art imagery of dapper devils and sinful gambling motifs (originally associated with customised hot-rod cars). Most obviously, it's about the clothes, and 21st-century counterculture has seen a huge revival of interest in fifties-style retro glamour that's spread far beyond the realms of rock'n'roll, to be embraced by a whole range of disparate scenes, often seen at tattoo conventions and fetish clubs. While, by the seventies, the mainstream had turned the fifties into a period associated with conformity and innocence, in subsequent decades, the underground has reclaimed the era as a golden age of stylish rebellion and a swinging celebration of glamorous self-indulgence.

CRUSTIES
Another Man's Cause

'They want to do their own thing, that's why they use the label "free" – they want to be free of everything.'

The summer of 1985 witnessed the most dramatic and violent confrontations between an alternative subculture and the forces of authority that Britain has ever seen. On 1 June a large contingent of uniformed police intercepted a rusty cavalcade of some hundred vehicles, determined to prevent them from reaching an illegal hippie festival at Stonehenge in Wiltshire. Police roadblocks channelled the convoy into a field, then descended upon their ramshackle quarry, determined to make mass arrests. Nick Davies, an experienced reporter for the *Observer*, described the ensuing chaos: 'There was glass breaking, people screaming, black smoke towering out of burning caravans, and everywhere there seemed to be people being bashed and flattened and pulled by the hair . . . men, women and children were led away, shivering, swearing, crying, bleeding, leaving their homes in pieces . . .'

The Battle of the Beanfield, as it became known, marked a grim landmark in recent British history. Under the right-wing prime minister Margaret Thatcher, many believe the police became worryingly politicised, employed to enforce controversial state policies rather than simply keep the peace. At the Battle of

Opposite: The notorious Battle of the Beanfield in 1985, where riot police waged war on new age travellers.

the Beanfield the police used the same hard-line, bellicose tactics they had employed against striking miners in the preceding months, many since suggesting that they overstepped the line into outright brutality.

While surprisingly little-reported at the time, the Battle of the Beanfield quickly took on symbolic significance. Portrayed by the authorities as the unfortunate aftermath of a wholly legitimate police operation to prevent wholesale illegal trespass, others saw events differently. According to Penny Rimbaud, of the leading anarcho-punk band Crass, 'having struck a decisive blow to the heart of the British working classes by crushing the miners and their union, Thatcher and her cronies turned their interests towards the next "enemy within": alternative Britain'.

The Peace Convoy, who became tabloid villains following the Battle of the Beanfield, represented the hardcore of a loose collective of nomadic hippies that had built up over the preceding decade, collectively known as new age travellers. They, in turn, were members of a larger burgeoning subculture who became known in the late eighties as crusties. This, at least in part, was a less-than-approving reference to the cult's decidedly casual attitude to personal hygiene. It may also have something

Above: Many new age travellers adopted dogs as ideal travelling companions.

to do with the emergence in the mid-eighties of a highly politicised, defiantly unhygienic punk-metal crossbreed that became known as crust punk. Some identify Crass as the prototypical crustie punks, though the British bands most associated with the term are Antisect, Amebix and Hellbastard. Whatever the true story, the crusties were certainly the result of the cross-pollination of supposed subcultural foes – hippies and punks – thrown together by the increasingly bleak and hostile environment developing in Thatcher's Britain. Even if few liked to say it, by 1980 it looked to many rebellious idealists like the punk revolution had failed just as miserably as the hippie experiment a decade earlier.

In the seventies, many hippies attempted to establish hermetic worlds, wholly separate from the 'straight' society they despised, in rural communes and large urban squats. Of particular importance were the free festivals, open-air celebrations of the anti-materialist hippie lifestyle, though some punks played a significant role in the foundation of the

foremost events. Founded in 1972, the Windsor Free Festival became the most prominent free festival in the UK, at its height attracting thousands of revellers, before truncheon-wielding police shut it down in 1974. There was some disquiet over the heavy-handedness of the eviction among liberal commentators, while the focus for festival-goers shifted to Stonehenge, which was growing into an even bigger annual celebration. Both venues signalled a distinct British character emerging in the UK's hippie underground, no longer merely a pale echo of San Franciscan psychedelia. Windsor was held close to Windsor Castle, 'in the Queen's back garden', indicating a degree of anarchic, anti-monarchist mischief.

From 500 in 1975, by 1984 attendance of the Stonehenge Free Festival had risen to some 70,000, a small town coalescing around the ancient stone circle every summer as revellers descended to enjoy the music, drugs and

chaotic carnival atmosphere. Not everybody appreciated the festival's building popularity. According to poet and festival veteran Lucy Lepchani, 'Chaos reigned as townies came out for the solstice, and coachloads of city tourists, alien to our wide-awake eyes with their litter-dropping, alcohol puking, grubby minds and groping paws.' Overall, though, most preferred to highlight hippie events like Stonehenge as successful examples of an alternative way of life.

After the outcry over the 1974 violence in Windsor, the police adopted a far less confrontational attitude to the free festivals, largely maintaining only a token presence – at Stonehenge there were often only two officers,

year following Margaret Thatcher becoming prime minister in 1979. Much of this was due to the harder line being taken against squatters, particularly in London. While many of those evicted were hippies, there were also numerous hardcore political punks, those who'd refused to abandon the cult or its anarchist ideals when more fashionable punks drifted away in search of the next exciting street fad.

This increasing hippie-punk cross-pollination was reflected in the ideology of the burgeoning crustie subculture. Peace survived as an ideal, but love was taking a backseat, while anarchism became a veritable watchword. Elements of the liberal hippie ethos endured

The crusties were the result of the cross-pollination of supposed subcultural foes – hippies and punks – thrown together by the increasingly bleak and hostile environment developing in Thatcher's Britain.

stationed in the car park, who would politely decline when offered spliffs by over-exuberant festival-goers. A building network of free festivals sprang up over the UK, making it possible for the truly dedicated to travel from one to another, even earning a living working on the sites or providing for the demands of fellow festival-goers – both legal and illicit – making ends meet with odd jobs or social security benefits in the lean winter months. 'During the 1970s – the late seventies – more and more people started to live on vehicles,' according to Mo Lodge, one of the travellers arrested after the Battle of the Beanfield, interviewed in the 1991 documentary *Operation Solstice*.

Several factors played a part in the birth of the new age travellers as a movement in the eighties. Spiralling youth unemployment left increasing numbers of young people with little hope of a fulfilling life in conventional society. According to Andy Worthington, author of *Stonehenge: Celebration and Subversion*, the number of people adopting the nomadic lifestyle doubled every

– vegetarianism, animal rights, feminism, anti-racism, anti-capitalism – but now leavened with an increasing punk tendency towards 'direct action' rather than passive resistance. Above all, while punk had snarled 'no future', and the hippie gurus offered garbled oriental mysticism, a new philosophy was evolving that was more streetwise and eclectic, yet firmly grounded in British soil. There was an interest in tribal shamanism and the culture and myth of the nation's ancient Celtic inhabitants. Other influences included American beat literature, particularly the edgy American author William Burroughs, as well as radical politics and the occult, particularly chaos magick, which combined arcane mysticism with the post-modern, anti-dogmatic theories of an incoherent cosmos.

The emerging look also embodied a crossbreed of the hippie and punk subcultures. Defiantly grubby, for the embryonic crustie the dust of the roads and the grime of the streets were badges of honour and symbols of difference from the

well-groomed ranks of the UK's wage slaves. (Unsympathetic voices dubbed crusties 'soap dodgers'.) Alongside colourful hippie influences, such as woollen jumpers, tie-dye and patchwork, army surplus clothing – particularly boots – proved popular, durable and cheap. Hair might be long, in the hippie style, though Mohicans were also common. The trademark crustie style, however, was dreadlocks. In part a tribute to Rastafarian culture (the distinctive red, gold and green Rasta colour scheme was a theme alongside the traditional hippie rainbow equivalent), but also the ultimate tonsorial gesture of rebellion, a rejection of the most basic conventional grooming routine of combing your hair.

Tattoos became popular – particularly Celtic knotwork designs – as did piercing, the crusties pioneering the practice long before it became a high-street fad, though they preferred to emphasise the supposed spiritual significance of body-modification, pointing to its use in tribal cultures. The ultimate street accessory, which became a crustie icon, was a pet dog, typically kept on an improvised lead (lurchers were particularly popular, perhaps because they were associated with poaching). Hence the term 'dog-on-a-string', which became synonymous with the subculture. For the crustie, who was often homeless by misfortune or design, a lurcher represented an ideal companion on the road, its lean, somewhat disreputable pedigree a perfect match for its typically unkempt, underfed owner.

On the Beanfield that fateful day in June, there were few journalists on hand to witness the police action. Shamefully, most had acquiesced to police instructions that they stay away from the trapped convoy. While Nick Davies of the *Observer* was the only print journalist to ignore police demands, a lone crew from ITN defied the prohibition on filming events. 'What we've witnessed in the last half an hour here has been surely some of the most brutal action by police forces in Britain for a long time,' reported ITN correspondent Kim Sabido, visibly shaken. 'Whatever the causes, the end product seemed to be just hitting out wildly by the police with babies in those trucks and in those buses, and young women with those babies in their arms were hit as well . . .'

The impact upon the new age travellers was unsurprisingly heavy. 'People split all over the place,' festival photographer Alan Lodge later told the BBC. 'Large numbers went to Europe.' Among those that stayed put, many were inevitably further radicalised by the violent confrontation. 'It turned all of us and I'm sure that applies to the whole travelling community,' added Lodge. 'There were plenty of people who had got something very positive together who came out of the Beanfield with a world view of "fuck everyone".'

In the ensuing years, the crustie subculture became established on the nation's streets. 'Crustie' was coined in part because many of the new recruits weren't particularly nomadic, making the term 'new age traveller' somewhat redundant. By targeting the new age travellers, the authorities effectively made the lifestyle, or at least the look, into a beacon for rebellious youngsters. Scrawling an anarchy sign on your army surplus jacket and letting your hair clump into uncombable dreads became the most fashionable way of showing two fingers to Margaret Thatcher, hated high priestess of craven corporate conformity. 'It was just building into a huge swell, you know?' musician Jon Sevink told the *Guardian* in a 2011 retrospective piece entitled 'The Return of the Crusties'. 'People dropping out all over the place and trying to join up.'

> Of particular importance were the free festivals, open-air celebrations of the anti-materialist hippie lifestyle.

Sevink was fiddle player with the Levellers, who, alongside New Model Army, became the unofficial standard-bearers for the subculture. Significantly, both bands took their respective monikers from radical movements rooted in English history. They blended traditional folk rhythms with contemporary revolutionary sentiments and rousing rock riffs to create a sound that blended subversive rebellion with a reverential sense of tradition. On the streets many crusties were drawn to a romantic ideal of the movement as a revival of the medieval troubadour tradition, of colourful wandering rogues and minstrels making a living on the road as rebel entertainers. Busking was popular – particularly with unorthodox instruments like the Celtic bodhrán or the Aboriginal didgeridoo. Others mastered skills such as juggling, stilt-walking, or even fire-breathing in the hope of earning a living with street performances. Less appreciated was the growing prevalence of begging, with dreadlocked youngsters – many of them suspiciously well-spoken for vagrants – petulantly demanding 'spare change' becoming a growing nuisance.

Levelling the Land, the Levellers' second album, was a surprise hit, eventually going platinum. It concludes with a song about the Battle of the Beanfield and is considered by some to be the archetypal crustie album. The band's success drove a wedge between them and their core fans, obliging them to abandon the traveller lifestyle. 'We got too famous, we just got too big for the scene, and you know, suddenly everyone knows you,' Jeremy Cunningham, the band's bassist, told the *Guardian*. 'I ended up moving out of a bus just because of that. I was too well known on too small a circuit. There were tall tales going around, and the law was coming down so heavily I decided I'd be more free living in a flat than a truck.'

The building popularity of the Levellers first became apparent at Glastonbury, the festival that took over as the flagship event after

Above: *Fire-breathing was just one of the circus skills many festival veterans studied in order to try and earn a living busking.*

Stonehenge was sunk in 1985. Organisers made special provision for the hardcore travellers of the convoy, allocating them their own field. Yet years of constant skirmishing with the law, combined with a building sense of representing the last true outsiders in British society, had made the convoy increasingly arrogant and prickly and pugnacious towards outsiders, as the 'Peace' prefix became increasingly inappropriate. In 1990 that attitude exploded into violence at Glastonbury in what became known as the Battle of Yeoman's Bridge.

Above: The controversial Castlemorton Festival in 1992, which heralded a crossover between the crustie and rave subcultures.

The Levellers played the Traveller's Field that year, and as the festival was drawing to a close, it was reported that one convoy vehicle had knocked down several fences, while travellers were accused of looting tents. Festival security were sent to intervene, and a fierce pitched battle began. The convoy prevailed by virtue of numbers, but it was a Pyrrhic victory, resulting in the organisers cancelling Glastonbury the following year. When it restarted in 1992, there was no travellers' field, and high fences were erected to discourage undesirables.

It was this year that the Levellers played the main stage for the first time, drawing record crowds, indicating that many were receptive to the crustie message despite the increasing belligerence of the convoy. Of course, not everybody was convinced. The *Daily Mail* can usually be relied upon to print alarmist articles demonising perceived deviants, and in 1992 it published the story of a nice, middle-class girl who dropped out of sixth-form college and entered 'a dark tunnel of rebellion', becoming preoccupied with the environment after falling for a crustie. She developed the 'eccentric syndrome which finds something "wrong" in living in a centrally-heated, wall-to-wall carpeted house,' shuddered the article. 'Readers were left

The crustie subculture waned significantly in the nineties, partly due to familiarity, its very popularity sapping the scene of its rebel image.

in no doubt that the young woman's subsequent death in a freak car accident was the direct result of her lifestyle choice,' notes Mark Garnett in *From Anger to Apathy*. Yet it was the *Daily Mail* that was out of step with the tide of public opinion. The Levellers were even approached by the high-street clothing chain Topman – hardly a radical brand – as potential models. 'It was weird,' reflected the band's vocalist Mark Chadwick.

Whether the crusties' presence promoted the causes they supported or was, due to the negative light in which they often were perceived, detrimental, many such causes were making progress. They were highly visible in the huge riots triggered by Margaret Thatcher's immensely unpopular Poll Tax in 1990. In the wake of the unrest, Thatcher resigned, and there was a moratorium on the kind of violent police methods that had been employed at the Battle of the Beanfield five years before. Crusties were also at the forefront of the road protests that faced Thatcher's Conservative successor, John Major, when he took up his new position in 1992. While many motorists derided crustie attempts to halt the government's ambitious road-building programme, others were sympathetic, not least because of the dangers campaigners exposed themselves to in their efforts to deter the diggers. Ecological awareness was building in the British public, even making a minor celebrity of the crustie activist Daniel Hooper, affectionately known as Swampy. In 1997, a Labour politician was elected prime minister on a platform sympathetic to many of the green issues dear to

crustie hearts, even if Tony Blair's subsequent record in office was decidedly controversial.

The crustie subculture waned significantly in the nineties, partly due to familiarity, its very popularity sapping the scene of its rebel image. Many were also diverted into the rave scene. Numerous hippies imagined that the flood of dance drugs and building culture of illegal, all-night techno parties could be harnessed to revive the spirit of the sixties. In practice, it often worked the other way, with previously dedicated activists abandoning their idealism in favour of an ethos that simply demanded the right to party. The emergence of electronic music on the free festival scene proved deeply divisive. The incessant, repetitive beats played at deafening volume for hours upon end were incompatible with most other entertainment previously enjoyed by festival-goers, and often soured any good relations previously built up over many years with local communities.

The ultimate fate of crustie culture is perhaps best illustrated with a return to the recent history of the Glastonbury Festival. In 2014, it attracted around 200,000 people willing to pay £210 to watch the chart-friendly likes of M.I.A. and Dolly Parton. Glastonbury is now part of the fashionable social calendar – known among middle-class hipsters as 'Glasters' or 'Glasto'. Few can raise the ticket fee from busking, so most of the audience with dreadlocks are likely 'trustafarians', a derisive term for those who affect ethical values and an alternative style, but rely upon handouts from wealthy relatives. Some, however, maintain that crusties still attend the festival in numbers. Similarly, their presence across the UK, while diminished, can still be felt, even if their activism and protests fail to generate the headlines of years past.

Whatever you might think of their politics or the traveller lifestyle, however, the subculture's endurance in the face of some four decades of frequently violent establishment hostility says something.

HIP-HOP
Fight the Power

Hip-hop is a subculture based around partying, and one that is mired in the volatile realms of the drug trade.

DJ Afrika Bambaataa famously defined hip-hop as a black American subculture consisting of 'four elements' – DJing, MCing, graffiti-artistry and breakdancing. While heavily interconnected, the four spheres are also separate entities. For example, by no means all graffiti artists are rap fans, some breakdancers took exception to rappers referring to themselves as b-boys when they didn't dance, and the DJ techniques employed in hip-hop have roots and influence that stretch far beyond the scene. The relative importance of the elements has also fluctuated, and it's now MCing – better known as rapping – that has become the highest-profile aspect of the hip-hop subculture.

The origins of the term are controversial. 'Hip' is a slang term with roots going back at least a century in black American street culture, meaning 'clued up' or 'with it'. 'Hop' may derive from an old term for a dance, or an abbreviation of 'hophead', meaning 'drug addict'. The different implications of the two meanings also echo a tension within hip-hop –

Opposite: Breakdancing and graffiti are two of the 'four elements' that traditionally make up hip-hop culture.

between a subculture based around partying, and one that is mired in the volatile realms of the drug trade. Some claim it was simply the term's cadence that made it appropriate for the rhythmic character of rap. The DJ Keith 'Cowboy' Wiggins has been credited with coining the term in 1978 while teasing a friend who had just joined the army, using the chant 'hip, hop, hip, hop' to mock the sound of soldiers marching. If true, this also has some potential deeper, if doubtless inadvertent, significance. Black Americans had been shouldering a disproportionate amount of the burden of fighting the unpopular Vietnam War, and were more likely to be posted to frontline service, hence suffering a higher percentage of casualties in the conflict than white servicemen.

The Black Panther Party was founded in 1966 as a militant left-wing organisation devoted to fighting for black rights, employing force where necessary. This philosophy increasingly led to armed confrontations, particularly in the wake of civil-rights campaigner Martin Luther King's assassination in 1968, resulting in the deaths of both law-enforcement officers and Panther members.

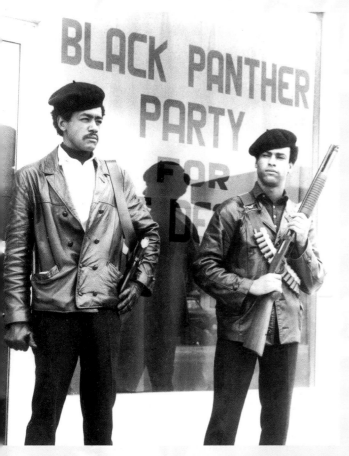

Above: The Black Panther Party fought for Afro-American rights, but were strongly opposed by the FBI.

– in turn fostering militancy and stronger bonds within the fledgling street gangs. New York street-gang turf was confined to a district or just a few blocks, making conflicts between rival groups even more likely. In December of 1971, an attempt was made by leaders of the Ghetto Brothers to broker peace between the district's warring factions, and focus their efforts on improving the neighbourhood. The violent drama and politics of the situation attracted international press interest and was later depicted in the 1979 movie *The Warriors*, which became a cult hit despite claims that it romanticised gang violence.

The truce did not end gang violence, but most experts agree that the most notorious Bronx street gangs went into decline by the mid-seventies. Some members grew up and moved on, some were drafted to fight in Vietnam, some became involved in the drug trade the gangs had previously tried to suppress. Inevitably many died violently, victims of rival gangs or the police, who took an increasingly aggressive approach to what many regarded as the rotten core of the Big Apple.

It was the predominantly Afro-American gang, the Black Spades (originally known as the Savage Seven), who would prove to be the launching pad for hip-hop subculture, under the leadership of an enigmatic figure who called himself Afrika Bambaataa, whose respect for the Zulu warriors' solidarity and dignity inspired both his moniker (borrowed from a Zulu chief) and a revolutionary new attitude. The gang became the core of DJ Bambaataa's new Universal Zulu Nation, a movement designed to channel the rage felt by many young black Americans into positive, productive energy. Bambaataa revived the doomed attempt the Ghetto Brothers had made to unite the gangs in 1971, but this time centred it on ideals of black pride and an acute sense of the vibrant creative culture bubbling beneath the violent surface of the Bronx. 'It almost flipped back to the fifties

By 1969 operations against the Black Panthers, particularly by the FBI, were beginning to take their toll; the movement dwindled from 10,000 members in early 1969, to just twenty-seven in 1980. The decline of black power movements like the Panthers led to a resurgence of street-gang activity, as power vacuums in the ghettos encouraged new groups to band together. There had been violent street gangs in American cities for some 150 years, but those emerging in the late sixties, particularly in New York's notorious Bronx district, appeared better organised and better armed than their predecessors. The ethnic make-up of many of the groups also ensured more heat from the authorities – who were wary of racial radicalism in the wake of battles with the Black Panthers

gangs where they was wearing the nice satin jackets and the nice names,' he later recalled. 'As you got into the graffiti artists, then you had the aerosol paintings on the jackets. People was getting more cool. It just started switching the whole culture into this whole "party and get down" atmosphere.'

One of the most influential figures spreading this party message was Clive Campbell, who became a legend under the name Kool Herc. The latter part of the DJ's nickname was an abbreviation of 'Hercules', in recognition of his bullish athleticism on the basketball court. But, like Bambaataa, he was a natural diplomat, who'd earned respect on the unforgiving ghetto streets with charisma and intelligence rather than blunt intimidation. More importantly, Kool Herc was among the leading pioneers of a new sound that was taking the Bronx underground by storm. He worked out that the parts of a track that inspired the most creative dancers were the instrumental breaks, particularly those with heavy percussion. Played through a souped-up system, a little ingenuity combined with developing musical technology allowed DJs to extend these with loops, or even mix tracks together (a discovery also being made by DJs in Detroit and Chicago, leading to techno and house). Just as conductors lead orchestras, the creative DJ was slowly becoming the star of the show. The final factor was the emergence of the Master-of-Ceremonies – or MC – who would use a microphone to shout encouragement to the crowd, building the atmosphere of the event. From its supporting role in the seventies, MCing would evolve into rapping, the essence of modern hip-hop.

The events put on by DJs like Kool Herc were street events – sometimes literally – with sound systems powered by tapping into the national grid via lines plugged into street lamps. The kids who reacted with the most athletic moves during the increasingly lengthy, rhythmic 'instrumental breaks' created by skilled DJs became known as 'breakdancers'. Visionary DJs like Kool Herc and Afrika Bambaataa identified this as a positive outlet for the violent frustrations of black and Puerto Rican street kids who might otherwise be drawn into the omnipresent ghetto vortex of violence and drugs. It's a common myth that competitive breakdancing successfully replaced violence as a means for settling disputes, but this gives too little credit to charismatic community leaders like Herc and Bambaataa, and too much to dancing. B-boy legend Luis Angel Mateo, aka Trac 2, observes that there was 'a lot of motion, a lot of gestures, what one person was going to do to another, what one gang was going to do to another'. Energetic and athletic, but aggressive and sometimes provocative, breakdancing could resolve disputes, but it could also cause them.

By the late seventies, a new figure was rising to prominence in the shape of Barbados-born DJ Joseph Saddler, better known as Grandmaster Flash, who, at the head of his Furious Five crew of rappers, was taking the hip-hop scene by storm. He took the style pioneered by DJs like Kool Herc and added his own innovations, achieving a more technically proficient sound, which included the controversial practice of rhythmically scratching records. Bigger venues started booking DJs like Grandmaster Flash, and it was inevitable that record labels would become interested, particularly as disco had died – practically overnight – in 1979. Flash rebuffed the advances of the fledgling New York label Sugar Hill, doubtful that the organic nature of a hip-hop gig – heavy with improvisation and audience participation – could be captured on vinyl. So the label decided to create its own rap group from scratch: the Sugarhill Gang.

Their debut release, 'Rapper's Delight', came out in August 1979. At nearly fifteen minutes in length, some were sceptical that radio stations would play the record, while hip-hop veterans wondered how you could distil the essence of the rap-DJ performance into

such a short period. Despite such reservations, 'Rapper's Delight' proved a huge international hit, introducing the world to hip-hop.

Seeing that the writing was on the wall, Grandmaster Flash and the Furious Five signed to Sugar Hill Records. They would produce their masterpiece in 1982, though again it was dogged by controversy. 'The Message' abandoned the convention of good-time party lyrics evident in previous hip-hop in favour of addressing the grim existence of life in the ghetto. It proved a turning point in hip-hop's evolution as – contrary to the band's fears – this type of bleak, streetwise honesty would signal the genre's new direction.

In many eyes, 1982 would prove a milestone in hip-hop. That year, an expat Englishwoman who'd fallen in love with hip-hop took over the Roxy NYC, a former roller disco, and opened it as a hip-hop venue deliberately designed to break down boundaries. Ruza Blue, or Kool Lady Blue as she became known, booked

Afrika Bambaataa as headline DJ, and the Rock Steady Crew, one of the Bronx's leading breakdancing collectives. Significantly, the Roxy was in chic Manhattan, and attracted a mixture of traditional hip-hop fans, curious white punks and trendy socialites, as it became the most fashionable place in New York to dance on disco's grave. In November of 1982 Lady Blue even organised a European tour for the show's lead performers. Yet hip-hop suddenly becoming fashionable troubled some traditionalists. In performing for wealthy white liberals, was hip-hop in danger of losing sight of its ghetto roots? Similarly, graffiti was also enjoying a vogue in artistic circles, as influential critics began hailing it as a vibrant new art form – even as the NYC authorities stepped up efforts to stamp it out.

The band that signalled a new wave in the hip-hop movement came not from the Bronx,

Graffiti was embraced by Afrika Bambaataa as one of his 'four elements' of hip-hop culture.

but from the comparatively upmarket New York borough of Queens. Run-DMC adopted a style and a sound that made most of the competition look like seventies throwbacks, blasting away the final gaudy cobwebs of disco. Their debut single 'It's Like That' came out in 1983, followed by the trio's self-titled debut album the following year. The music was stripped back, a lean accompaniment to a more aggressive style of rapping, an approach that saw Run-DMC quickly surge to the front of the hip-hop pack. The album *Run-DMC* is still frequently hailed as the best recording in the genre. They also developed

an image to match this new, edgier approach, including gold chains, black leather and fedoras.

Rap was now developing a new look that, at least initially, combined elements of hard-rock machismo and outlaw street style. Sportswear from brands like Adidas had long been a favourite with b-boys for practical reasons, but it was now becoming a hip-hop staple. It also made an oblique point, as outside of the music industry, sport was the only legitimate path out of the ghetto for many disadvantaged Afro-Americans. Run-DMC also inadvertently opened the door to gangsta rap, the subgenre that would dominate hip-hop in coming years. The authorities didn't just confiscate shoelaces from prisoners, but also belts. Hence low-hung jeans became part of the hip-hop uniform. In time,

Below: *Resplendent in sportswear and bling, Run-DMC changed the course of hip-hop in the eighties.*

those low-hung jeans would expose expensive designer-label underwear. Ostentatious displays of wealth came with the territory for those who'd successfully clawed their way up in the ghetto, and 'bling' – principally gaudy gold jewellery – entered the dictionary courtesy of rap.

In 1986, Run-DMC released their most successful album, *Raising Hell*, establishing hip-hop as a global phenomenon. It also helped establish rap as a growing problem in some eyes, as trouble hit the album's promotional tour. In August the tour reached the Long Beach Arena, and the concert degenerated into a melee, as over 300 black and Hispanic gang members attacked the rest of the audience with knives and clubs improvised from broken furniture, leaving over forty injured before riot police successfully established order three hours later. Some blame the Crips, a notorious street gang who had come to dominate the LA ghettos, though others claim the violence escalated from a clash with the Bloods, the gang's chief rivals. Inevitably, the finger of blame was also levelled at Run-DMC, with their tough image, and hip-hop in general, as rap began attracting criticism from the authorities and the media, who identified it as a catalyst for violence and criminality. It was, ironically, this association between hip-hop and violent crime which would allow West Coast rap to overtake its East Coast competition, just as the notoriety of the Crips and Bloods had long since eclipsed that of New York's street gangs.

Gradually, the scene became more callously ruthless and dangerously violent. The chief trigger was the arrival of crack cocaine, which first began to appear in the US around 1983, spreading across the nation's cities over the following two years. When it combined with LA's already volatile street-gang culture, the results were inevitably explosive. The high potential profits upped the ante in territorial struggles between rivals like the Crips and the Bloods, with the obvious wealth displayed ostentatiously by successful dealers proving a powerful recruiting tool. The drug's effects are also compatible with the gang lifestyle, making the user feel supremely confident, alert and energised, though side effects include paranoia. The effect of crack addiction on the ghettos was devastating, and the American authorities responded with aggression, stepping up their discredited War on Drugs.

Hip-hop's role in all of this became increasingly ambivalent. While DJ Afrika Bambaataa had actively campaigned against PCP (a drug that's also known as angel dust) in New York in the seventies, in the gangsta rap genre that began to emerge during the eighties, the emphasis was on documenting the violent chaos of the ghettos rather than moral judgement. Archetypal of this is New Jersey-born Tracy Marrow, who became better known as LA rapper Ice-T. Previous to his musical career, Ice-T was involved in petty crime, and became a member of the Crips. His nickname derived from his ability to recite passages from the work of Afro-American author Robert Beck, better known as Iceberg Slim, who documented his own experiences surviving in the underbelly of fifties America in harrowingly honest quasi-autobiographical novels, beginning with *Pimp: The Story of My Life* in 1969.

Another, oft-neglected, influence on hip-hop culture was cinema, specifically the 'blaxploitation' films aimed at Afro-American audiences, beginning with *Sweet Sweetback's Baadasssss Song* in 1971. Once it became apparent that there was a lucrative market for films with soul and funk soundtracks featuring kickass black heroes and casts in plots with settings relevant to a black audience, the Hollywood machine swiftly began to pump them out. Some felt that the films exploited black culture to make money for the white faces behind the scenes, but some maverick productions were Afro-American in cast, crew, backing and audience. In particular, the multi-talented Rudy Ray Moore, who began as a

comedian before embarking upon a career as the star of a series of outrageous blaxploitation flicks, the first of which, *Dolemite*, was released in 1975. Dolemite is a super-cool pimp who champions justice in the face of white racist cops who are in league with his corrupt black rivals, triumphing with a combination of kung-fu skills and sexual magnetism. Most significantly, perhaps, he delivers his lines not as taciturn one-liners, but as colourful, rhythmic rhyming patter. According to some, this is the true root of rap. 'Without him there wouldn't be no rap music, he was doing it before we knew what to do with it,' said Snoop Dogg, a legendary LA rapper who, like Ice-T, is reputed to have once been a member of the Crips.

Asked by the ZZZlist website whether he real' – staying grounded, reflecting life on the streets as it really was, however dangerous and harrowing. The band that took it to the next level – the belief that hip-hop shouldn't just document ghetto life but try and change it – hailed from New York. Formed in 1986 from the DJing partnership of Chuck D (Carlton Douglas Ridenhour) and Flavor Flav (William Jonathan Drayton, Jr), the addition of Rapper Professor Griff (Richard Griffin) and DJ Terminator X (Norman Rogers) completed the collective known as Public Enemy.

Professor Griff, the group's 'Minister of Information', was a dedicated member of the Nation of Islam, helping to bring a radical political edge to Public Enemy's material. Starting in 1988, with their second full-length

Run-DMC developed an image to match this new, edgier approach, including gold chains, black leather and fedoras.

might be the first rapper, Rudy Ray Moore replied in the affirmative. In a world where boasting and swagger come as easily as breathing, scepticism is understandable, but many suggest that – alongside funk legends James Brown and Bootsy Collins – Moore was the most sampled artist in hip-hop for some time. Questioned on the background to his talent as an inspired wordsmith, Moore credits his mother, who he says taught him to memorise rhymes. He also gives credit to an influence more conventionally associated with rap, the Caribbean tradition of telling over-the-top tales in a distinctive rhythmic style.

Many of these films may have had authentic roots in the ghettos of seventies Hollywood – representing the black underclass's progressive revenge fantasies against the white elite and its agents – but blaxploitation flicks were still escapist fantasy. In the wake of Ice-T's pioneering gangsta rap recordings, late eighties hip-hop had become about 'keeping it release *It Takes a Nation of Millions to Hold Us Back* – still regarded by many as the greatest hip-hop album ever recorded – they established themselves as giants of the genre. Liberal white critics, previously wary of hip-hop's inward-looking, increasingly aggressive ethos, were electrified by the power of Public Enemy's angry political message, turning them into a band that crossed boundaries. However, there was soon trouble on the horizon. Professor Griff disapproved of Flavor Flav's clowning around, creating tension, while despite the group's stated anti-drugs ethos, Flav developed a serious crack cocaine habit. More damagingly, Professor Griff made a series of incendiary homophobic and anti-Semitic statements, which alienated much of their multi-racial audience, and by 1991, Flav had descended further into drug addiction and served a jail term for assaulting his girlfriend – none of which looked particularly good for members of a band who had set themselves up as hip-

hop's conscience. Even more quickly than they'd arrived, the band were in freefall, no longer regarded as the future of hip-hop, but a moment in its past, dismissed as sell-outs by some purists for touring and even collaborating with white metal bands like Anthrax.

They were also being challenged by gangsta-rap bands, whose tales of the hood were charged by critics as glorifying the horrors of the ghetto. NWA (Niggaz With Attitude) earned instant notoriety with the track 'Fuck tha Police', from their 1988 debut album *Straight Outta Compton*. While the band maintained it was a protest song, aimed at racism in the LAPD, conservative critics – including some police organisations – charged that it condoned or even encouraged violence against serving officers. Inevitably, such controversy proved to be priceless publicity, launching NWA to the forefront of the hip-hop pack.

Ice-T would stir up an even angrier hornet's nest in 1992 with his rap-metal crossover track 'Cop Killer'. The rapper argued that it was a work of fiction, taken from the point-of-view of a protagonist pushed over the edge by police brutality, but hip-hop's critics charged that it had crossed a line, and conservative commentators from President George Bush downwards queued up to condemn the song and its composer. 'Cop Killer' makes reference to Rodney King, a black motorist brutally beaten by police in Los Angeles in March of 1991, as well as the LAPD's chief, Daryl Gates, who had earlier expressed enthusiasm for the summary execution of drug users. The assault was captured on video by a local resident, finally representing proof of the LAPD's brutality and racism, which West Coast rappers had been addressing for years, and the case captured the imagination of the international media. When, to almost universal surprise, all

When crack cocaine combined with LA's already volatile gang culture, the results were inevitably explosive.

five officers were acquitted by a jury, the ghettos of Los Angeles rose up in fury.

It was a sign of the event's significance that even the Bloods and the Crips made a truce, as for four days the city was engulfed by anarchy, until a force of 400 soldiers and marines arrived to restore order on 2 May 1992. By then, countless thousands had been injured, fifty-three had been killed and the city had suffered some $1 billion-worth of property damage. Few – with the exception of those brave residents who, like the Afro-American Bobby Green, risked their lives to help victims of the violence irrespective of race – emerged from the LA Riots looking good.

Many blamed heavy-handed policing and ingrained racism in the LAPD, combined with the crushing poverty in Los Angeles ghettos, for creating a riot waiting to happen. The right-wing response was typified by the much-mocked Vice President Dan Quayle, who blamed the riot on a 'poverty of values'. Inevitably, the hip-hop community – who had been embroiled in the controversy from the start – commented in rap. Dr Dre referenced the riots in 'The Day the Niggaz Took Over' and NWA rapper Ice Cube based most of his 1992 album *The Predator* around the events. Some, like Tupac Shakur, focused on the death of Latasha Harlins, a fifteen-year-old Afro-American girl shot dead by a Korean shopkeeper in a scuffle after he erroneously thought she was trying to steal a carton of orange juice, a tragedy which some suggest inspired the attacks on Koreatown during the riots.

Anybody who imagined that the LA Riots would lead to soul-searching on both sides of the debate, or even a decline in hip-hop's fortunes, was clearly a poor student of American culture, or indeed human nature. For many young people who'd watched the riots unfurl on TV, it was exciting, even exhilarating to witness the

streets of Los Angeles devoured by anarchy, and sales of rap records continued to rise. Rather, it was the genre's soaring popularity – and the money that went with it – that would lead to a crisis in the subculture.

A number of high-profile rivalries sprang up between the East and West Coast, notably between Suge Knight, co-founder of Death Row Records in LA, who was notorious for his Mafiosi-style business approach, and Sean 'Puff Daddy' Combs, who set up Bad Boy Records in 1993. Tupac Shakur was one of Death Row's most profitable signings, the first artist to have a number one album while in jail. Biggie Smalls was one of the most popular artists on the Bad Boy label, and became pivotal in re-energising the New York scene when Californian gangsta rap began to predominate. Business rivalry between the East Coast and West Coast quickly became personal and violent. Shakur was shot dead in 1996, Smalls the following year, and both murders remain unsolved, though most believe they were connected. Turf wars that

Above: Sean 'P. Diddy' Combs, the richest man in rap, exhibiting some of the ostentatious tendencies that critics claim have cheapened hip-hop.

had once been over blocks in the Bronx or LA were now over whole states. Like the LA Riots, the killings just seemed to fuel enthusiasm for gangsta rap among audiences and critics alike. It had become an international industry, selling not just music, but films, fashion, even perfume.

Under the gangsta influence, hip-hop was becoming grimly voyeuristic, a virtual walk on the wild side for many fans – even a modern gladiatorial spectacle, where the world's media could exploit the vicarious thrills of watching hardened criminals fighting over the huge rewards awaiting those who reached the top of the pile. So long as they survived.

The left-wing Black Panthers who died believing they were protecting their community in the sixties were no doubt turning in their graves. The landmark hip-hop track 'The Message' had expressed horror and frustration at the predators plaguing the ghettos in 1982. A decade later, those predators were the ones

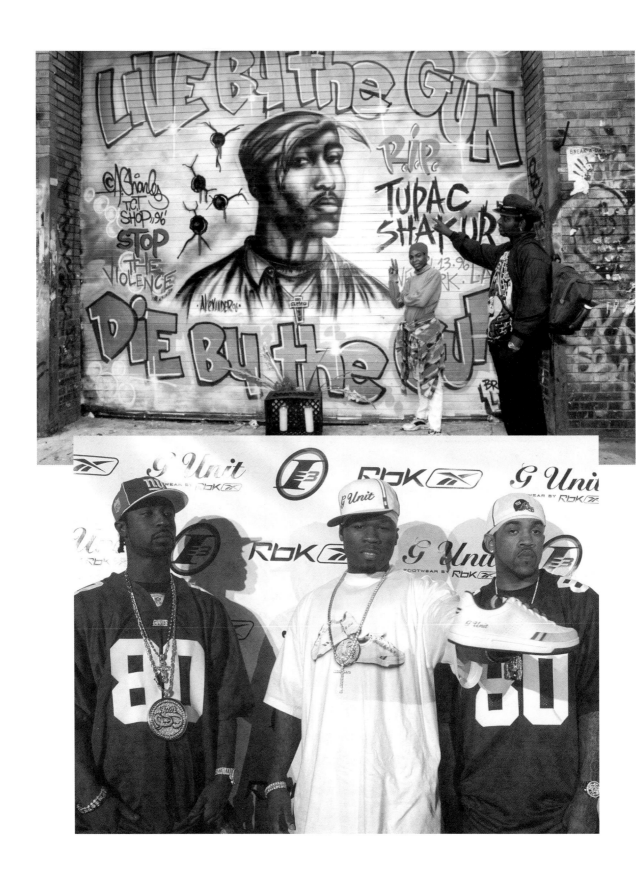

making the music. If the ethos of rap's golden age was expressed in Public Enemy's seditious 1989 song 'Fight the Power', by the 21st century it was encapsulated in the title of 50 Cent's album *Get Rich or Die Tryin'*, which went straight to number one in 2003. Spike Lee, the leading Afro-American filmmaker who directed the video for 'Fight the Power', expressed the view of many sceptics when he suggested that the reason behind 50 Cent's meteoric rise 'is because he's been shot twelve times . . . How more legitimate can you get? He got shot and lived to rap about it. This whole mythology and fascination with gangsta culture . . . look at the title of the CD, *Get Rich or Die Tryin'*. That's crazy. That is the motto of many of these young black kids.'

Lee stirred up quite a hornet's nest when he criticised rap in his 2003 address at an Indiana University – the genre's conservative white critics could easily be written-off as racist or out of touch, but a public figure with a long track record of fighting for black rights was more difficult to dismiss. The Indiana audience applauded the outspoken director, but where it mattered – in the *Billboard* charts, on the streets – it was gangsta rap that was winning hearts and minds. It was not only the music that was proliferating worldwide, but also the look and even the slang. Kids of all ages and races were picking up phrases like 'yo' and 'blood' and repeating them in accents that suggested they had never been anywhere near the USA, let alone Compton or the Bronx.

Gangsta rap's attitude to women, which was degenerating into a caricature of the relationship between a pimp and his 'bitches', was (and continues to be) a source of controversy. Spike Lee focused on it in a talk given in Toronto in 2005, where he once again attacked the influence 'gangsta rap craziness' was having on Afro-American youth: 'These artists talk about "ho this, bitch this, skank this" and all the other stuff. They're talking about all our mothers, all our sisters [. . .] And we're in a time when young black boys and girls want to be pimps and strippers, because that is what they see . . . Something is definitely wrong.'

Spike Lee certainly wouldn't want to be seen as an enemy of hip-hop. Yet the hip-hop championed by idealists like Lee – now known as 'conscious' rap – was losing out to its more aggressive cousin, as fans voted with their wallets.

The indomitable spirit of hip-hop, which had survived decades of institutional racism, the deprivation of grinding poverty, and the ravages of the crack epidemic, seemingly had no answer for the temptations of wealth. By 2008, hip-hop magazine *Vibe* was declaring Marshall Mathers III, aka Eminem, the Best Rapper Alive, one of numerous such critical accolades which were matched by commercial success, with the rapper widely hailed as the most successful of the 21st century. Mathers was a white guy from Missouri, who at once broke down racial barriers, but also arguably severed mainstream rap from its roots in the seventies civil-rights radicalism fostered in the black ghettos of the Bronx. Eminem swiftly settled into the gangsta soap opera of childish – albeit incendiary – feuds and macho posturing. According to Jeff Chang, 'by the turn of the century, to be labelled a "conscious" or "political" rapper by the music industry was to be condemned to preach to a very small choir'.

'Rap has become a sad reality,' concluded Public Enemy's erstwhile Minister of Information, Professor Griff, in 2006. '50 Cent comes out with a movie that's a step-by-step instruction in how to be a thug. And sells it to children?' Yet the mainstreaming of aggressively amoral, apolitical rap might perhaps leave the field open once more for its more progressive, intelligent voices to be heard in the underground, and for hip-hop itself to become a subculture, even a counterculture, once more.

Opposite above: A mural commemorating rapper Tupac Shakur, regarded by many as an inspiration or even a martyr after his violent death in 1996. Opposite below: Rapper 50 Cent (in white) promoting trainers – has hip-hop degenerated into a violent marketing campaign?

RAVERS
What Time Is Love?

The burgeoning British scene forged an indelible link between the electronic post-disco sounds coming from America and the fashionable new drug MDMA, which would spark the rave revolution.

Above: *Two teens in the distinctive cyber gear popular at clubs like the legendary Gatecrasher.*

By the late seventies, hippies were in full retreat under the onslaught of punk, and by 1980 rock had largely routed disco. Yet in the late eighties, the all-night dance and psychedelic drug cultures forged an improbable alliance and struck back with a vengeance. Their secret weapon was methylenedioxy-methamphetamine, better known as MDMA, ecstasy or 'E'. As its chemical name suggests, MDMA is basically a variant of amphetamine, or in other words, speed. Its growing legions of advocates began extolling ecstasy as the ultimate intoxicant – a drug that was erotic but not sexual, one that was trippy without the hazard of vivid waking nightmares, a high that gave you energy without triggering a comedown as draining as those commonly experienced in the aftermath of speed. Above all, MDMA made you want to move to the beat, and by 1990 a mania for epic dance events – or raves – was spreading across Europe and the USA.

If acid helped shape the hippie revolution, rave culture was almost wholly defined by ecstasy. The most significant figure in the popularisation of MDMA was a Californian chemist with an interest in psychoactive intoxicants named Alexander Shulgin. He decided to try the drug in 1976 after discovering some of his students taking it recreationally. Shulgin was so impressed that

Opposite: Rave is a synthesis of light, sound and chemistry.

he began to promote MDMA as a drug with powerful therapeutic potential, and by the late seventies it was in increasing use as an aid to psychotherapy or even relationship counselling. At this stage the drug was usually referred to as 'Adam', an allusion to its supposed ability to return the imbiber to a state of innocence.

Just like LSD, which slowly leaked out from the medical community into their immediate social circles as a recreational drug, thence outwards into the nightclubs and onto the streets, MDMA couldn't remain a secret among psychiatric cliques forever. The first clear indication of it making the jump from medication to club

Its growing legions of advocates began extolling ecstasy as the ultimate intoxicant.

drug occurred in Texas in 1984, at a chic Dallas disco named the Starck Club. Originally catering to a predominantly gay clientele, word soon got out that the disinhibited club not only played the most innovative dance sounds, but sold a new drug they called X-T-C over the bar, and it became the hippest place to hang out in Texas. Inevitably such decadence could not go on forever, and in 1985 the US government banned MDMA. 'The banning, while it degenerated the quality of the drug itself, also did something quite positive – it created a counterculture,' claimed Wade Hampton, a Starck regular. 'It was the very first sign I saw of these pampered kids saying "fuck the system" in a *big* way.' It was, he said, 'a defining aspect of the rave movement: the fight-the-power side, people thinking "I'm doing the right thing, I'm doing it for my own reasons and I will do it by any means necessary".'

At the same time, disco sounds were evolving to cater to the new wave of clubs emerging in the Starck's wake. The rave scene's soundtrack has splintered into countless different categories over the past twenty-five years, as local DJs attempt to establish themselves as innovators in an increasingly crowded and generic market. Yet every subgenre – house, techno, dubstep, jungle, breakbeat, trip-hop, to name a few – remains united by the synthetic, repetitive beat conducive to enjoying an ecstasy trip.

The true pioneers of rave music came from the tough American cities of Chicago and Detroit, though some also credit the New York scene as a significant early influence. The most influential figure in the development of the house sound was a Chicago DJ named Frankie Knuckles, who played at a predominantly gay Latino and black disco named the Warehouse,

before relocating to another club, the Power Plant, in 1983. 'House' initially seems to have referred to records that were categorised in local music stores as the kind of material played by Knuckles at the Warehouse. The DJ led the way by employing new music technology, such as drum machines, sequencers and samplers, to modify the dance tracks he was playing, which became the basis for house music. Others followed suit, eventually recording their own mixes tailored to the new tempo of the dancefloor, paving the way for the DJ as superstar. Chicago's chief competition came from Detroit, and leading Detroit DJ Juan Atkins, aka Model 500, has suggested a less specific origin for the term 'house' – that it came from those venues where DJing was distinctive enough for it qualify as a house style, just as restaurants have signature dishes.

Techno and house music enjoyed a particularly warm welcome in England, though a significant catalyst was its adoption on the Mediterranean island of Ibiza, a Spanish resort favoured by British holidaymakers with a significant hippie community and clubs playing Chicago-style house music. MDMA was banned in the UK in 1977 as a variant of speed, and as early as 1985 British tabloids were printing scare stories about ecstasy, labelling it a 'sex drug', the first of a series of panics over 'designer drugs'. Yet while MDMA certainly stimulates indiscriminate intimacy, few users regard it as an aphrodisiac. The UK's role in rave culture started in earnest in 1987, when holidaying UK DJs encountered ecstasy and house in Ibiza clubs, and decided to recreate the atmosphere in a London club. Some have suggested that they misinterpreted the term 'acid house' – mistakenly assuming the sound was inherently linked to LSD when it was actually a reference to the music's origins. (The slang purportedly came from 'acid burn', referring to music sampled from other records – hence 'burned' or stolen.)

Above: *Once a haven for hippies, the island of Ibiza became an international rave Mecca in the nineties.*

Whether based on a misconception or not, the burgeoning British scene forged an indelible link between the electronic post-disco sounds coming from America and the fashionable new drug MDMA, which would spark the rave revolution. The revolutionary qualities of the scene were quickly brought to the surface, against the backdrop of a confrontation between the Conservative British government and the drug-fuelled all-night dance parties people were starting to call raves. One symbol inevitably associated with ravers is the yellow 'smiley face', indicative of the scene's upbeat outlook, according to devotees (and its beaming mindlessness according to critics). Unlike most subcultures covered in this book, the vast majority of ravers confine their alternate identity to the weekend, and even at hardcore raves most dancers will simply be wearing something fashionable and easy to dance in.

As with the music, many fashion statements particular to ravers are designed to complement the ecstasy experience. UV-reactive and luminous fabrics are common, favoured for their psychedelic appearance under venue lights, as are accessories like glow-sticks, which ravers employ as props while dancing. Whistles or horns are sometimes in evidence among clubbers who like to express their appreciation for the music with sounds of their own. Other more outlandish outfits sometimes seen at raves include white boiler suits, gloves and fluffy legwarmers, while outrageously coloured hair has also enjoyed popularity at some venues. One peculiar fashion associated with the scene is babies' dummies, a practical remedy for teeth-grinding, which is often an unpleasant side effect of dance drugs, though most ravers prefer chewing gum. Some venues provide sugary snacks to help boost their clientele's energy levels for all-night dancing sessions, while sweet energy drinks such as Lucozade are

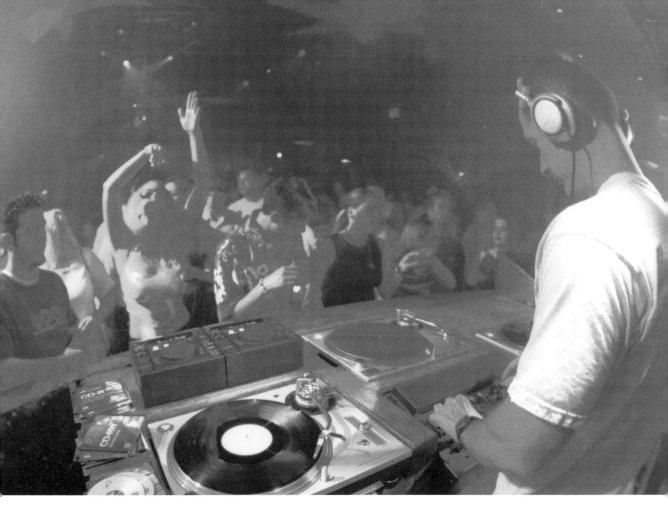

offered as an alternative to alcohol, which often reacts badly with substances like ecstasy.

Illegal parties held in warehouses or fields become a phenomenon by 1989 – impressive examples of guerrilla entrepreneurship. These illicit events featured state-of-the-art sound systems, light shows and even fairground rides – meticulously planned parties that attracted thousands of paying ravers, earning organisers a small fortune into the bargain. The mobility of events, where locations were kept secret until the last minute, then disseminated by the burgeoning technology of mobile phones, gave the police a headache, as did the sheer numbers of attendees. In the summer of 1990 the government passed hurried new legislation deliberately designed to crack down on illegal raves. Within a week the police employed it at a rave near Leeds in the north of England, where 836 people were arrested, the largest mass-arrest in the UK since 1819.

Above: Ecstasy-taking partygoers worship at a DJ booth – the raver's altar.

Some warned that driving the scene further underground would only create greater problems, but the government persisted in its hard-line approach to the issue, even after the divisive Mrs Thatcher was deposed in November of 1990. A showdown was inevitable, and it happened at the Castlemorton Common Free Festival, a week-long rave held in rural Worcestershire in May of 1992 that attracted vast crowds. This time the police targeted organisers, arresting thirteen members of the Spiral Tribe, a loose conglomerate of rave DJs. The trial proved costly and inconclusive, but the police had made their point, and many serious ravers fled abroad to avoid the increasingly hostile environment. The final blow came in 1994, with the enactment of the repressive Criminal Justice and Public Order Act, which incorporated sections specifically aimed at

The pills in circulation were increasingly cut with all manner of impurities, if they contained any MDMA at all.

ravers, including toughened legislation on trespass and, controversially, against events playing music 'wholly or predominantly characterised by the emission of a succession of repetitive beats'.

The act also toughened the laws police employed against the UK's new-age hippie travellers, or crusties, and some suggest it laid the groundwork for an alliance between the two subcultures. Yet the scenes had already been crossbreeding for some time, and by 1990, many crusties had already embraced rave. The Spiral Tribe had roots in the squatting scene, and Castlemorton had been a small hippie festival before the hordes of ravers arrived, lured by some of the nation's most popular sound systems.

Many hippies quietly objected to having their festivals hijacked by maximum-volume sound systems that blasted out repetitive beats twenty-four hours a day, dominating proceedings and enraging neighbours who had previously tolerated gentler events. In a sense, rave proved to be another symptom of the selfishness of the eighties, the idea encapsulated by Thatcher's infamous dictum that 'there is no such thing as society'.

For many purists, rave in the UK died in 1992, when government pressure really began to tell on the movement. As many of the original players fled abroad, criminal gangs moved in to fill the vacuum. 'It's a bit like cannabis,' observed Kenny, an early ecstasy dealer interviewed by Tony Thompson in his book *Gangs*. 'At first the whole trade was run by university students and toffs like Howard Marks and it was all some jolly boys' adventure. Then mobs from London and Essex moved in, and before you knew it, people in Range Rovers are getting their heads blown off.' Raves, now prone to a building underworld

presence, became unhealthy places to be, where armed organisers patrolled the events, turning off water supplies to sell more drinks to thirsty clubbers. The pills in circulation were increasingly cut with all manner of impurities, if they contained any MDMA at all.

Which isn't to say that rave died out. Far from it. The pounding rhythmic dance music inspired by 'designer drugs' became a familiar presence in the nineties charts, created by both dedicated DJs and pop opportunists, all keen to cash in on the vogue for repetitive, inorganic sounds with plenty of samples. The trend also impacted upon a number of alternative subcultures to frequently incongruous effect. The goth subculture, known for its black funereal glamour, embraced the movement in the nineties, creating the cybergoth splinter movement, adherents dancing to techno beats in outlandish UV PVC fetish gear. A higher-profile cross-pollination occurred between rave and the more laddish end of the northern English indie scene. The movement became known as 'Madchester' due to its Mecca in Manchester's Hacienda club, developing its own distinctive slang and sound. Bands like the Happy Mondays, Stone Roses and Inspiral Carpets blended sixties-style rock guitar with rave-influenced beats.

According to a 1990 feature in *i-D*, the scene was centred around 'acid (tabs, dance and rock), lank, page-boy "Baldrick" haircuts and flares'. Devotees became known as 'baggies' in reference to their baggy clothing, which was a curious blend of sixties style and oddball contemporary garments like hoodies, baseball caps, fishing hats, trainers and colourful cagoules, partially as a deliberate rejection of the slick designer-label clothes worn by southern casuals. Whilst Madchester paid lip-

Above: Hot house: the Hacienda nightclub was at the heart of Manchester's infamous Madchester scene, 1989.

service to the Second Summer of Love ethos, it wasn't something that overrode the more anti-social tendencies among many Hacienda regulars. The club was plagued by violence in the early nineties, including a number of gun crimes, triggered by the increasing gangland presence lured by the prospect of drug profits.

The Hacienda was also the site of the UK's first fatal ecstasy overdose, when a sixteen-year-old girl died of internal bleeding after a serious allergic reaction to a pill she took at the club in 1989. It provided the first substantial piece of ammunition for the building tabloid campaign against MDMA and the British rave scene. On a less serious note, the Second Summer of Love found its own Merry Pranksters in the shape of Bill Drummond and Jimmy Cauty. In 1987, recording as the Justified Ancients of Mu Mu, the duo began releasing sample-heavy house music to ecstatic reviews from the

music press. The following year, they changed direction and released 'Doctorin' the Tardis', a pop single, under the moniker the Timelords. Stitched together the *Doctor Who* theme tune and music from glam-rockers the Sweet and Gary Glitter, it was critically reviled but sold over a million copies. They followed it up with a 1988 book entitled *The Manual (How to Have a Number One the Easy Way)*, which offered instructions on achieving chart success without musical talent. The text was both wholly serious and deeply sarcastic, a practical guide and a biting satire on the stupidity of the music business.

Recording as the KLF, Drummond and Cauty subsequently released a series of bestselling house records, becoming the most successful singles artists in the world by 1991 with a succession of original house tracks and remixes of established hits. By 1992, they'd tired of mocking the music business and signalled the retirement of KLF with an appearance at the notoriously hype-heavy Brit Awards. Duetting with the caustic crust-punk band Extreme Noise Terror, Drummond fired blanks from an automatic weapon over the heads of terrified industry executives, leaving a dead sheep behind as a calling card. The pair then established the K Foundation to satirise the art establishment, employing the large sums of cash earned in their recording career to set up a rival to the avant-garde Turner Prize, entitled the Worst Artist of the Year, whose shortlist and winners mirrored the Turner's.

They famously capped the campaign in 1994 by burning the remainder of the money they'd earned as musicians – reportedly a million pounds – in a stunt that mystified, delighted and horrified commentators in equal measure. While the duo succeeded in outraging and parodying the art world and pop industry, their antics largely went over the heads of the record-buying public, whose enthusiasm for KLF hits like 'What Time Is Love?' financed their antics.

While in a newly-unified Germany, the rave scene was just taking off, centred around the Berlin Love Parade (still the biggest techno festival in the world) and fuelled by post-unification euphoria, in Britain the party was coming to an end. By the mid-nineties, most house and techno was thoroughly mainstream, and the country's outlaw rave scene a fast dwindling memory. Ibiza had become the trendiest destination for the UK's rowdiest young holidaymakers – alcohol very much in evidence – to the dismay of the local population.

> The pounding rhythmic dance music inspired by 'designer drugs' became a familiar presence in the nineties charts.

While government rhetoric continued to brand ecstasy as evil, police officers on the street often had a more ambivalent attitude when the nation's hooligan element briefly joined the Second Summer of Love. Thugs tripping on ecstasy proved a far more manageable proposition than when tanked up on strong lager. 'There was a lull because most of the top boys throughout the country were getting loved up on ecstasy pills and going to acid-house clubs,' recalled Jed, on the 2002 BBC documentary *Hooligans*, who'd run with a notoriously violent mob of soccer fans in the preceding decade. 'Then the ecstasy went poor, they got bored of it and went back to football violence.'

Ecstasy both defined the rave scene and motivated the backlash against it, and so it seems appropriate to give the final words on rave to Doctor Alexander Shulgin, the chemist who popularised MDMA. 'Psychedelics are meant for adults to gain an insight into themselves,' he observed in 1990. 'They're research tools. Using them only in the context of music and dance means that the whole element of the experience is being completely wasted.'

GRUNGE
Smells Like Teen Spirit

They dressed in clothes bought from charity shops, artfully combined to express an image that was neither really rebellious nor conformist.

Indie is an elusive musical genre, and while the indie kid was certainly a subcultural phenomenon in the eighties and nineties – particularly in the UK – they remain difficult to pin down. Part of the problem is the term itself. It's an abbreviation of 'independent', referring to the fact that the relevant bands were on small independent labels – in theory those taking more creative risks and fostering new talent. Yet indie's success soon encouraged major labels to get involved, and many of the best-known bands were on either mainstream labels, or subsidiaries launched by industry giants to cater for the market. The majority of the truly independent talents were on labels established by fans or artists themselves, which typically catered to more extreme or esoteric genres – psychobilly, goth, Oi! and such – that

Opposite: Kurt Cobain's earnest sensitivity and painful vulnerability resonated with fans worldwide.

never caught the eye of the commercially-minded industry executives.

Though many of the classic indie bands weren't technically independent, and seldom pushed the envelope or rocked the boat in musical or cultural terms, the scene played a vital role in the wider development of subculture. The best indie music occupies a no-man's-land between chart music and the underground – too accessible to qualify as alternative, yet too quirky, original or thoughtful to dismiss as disposable pop.

One thing the punk revolution had underlined was how vulnerable the mainstream charts were to manipulation by the music industry (most notably via the controversy over the Sex Pistols' single 'God Save the Queen' suspiciously failing to reach number one). Even discounting corruption, dedicated music fans were buying their records from different shops to fickle pop fans, yet the UK charts as they stood only reflected sales in big high-street retailers. The idea of an independent chart reflecting sales from dedicated music shops swiftly caught on among *Record Week*'s competitors, and in 1981 *New Musical Express* – the music paper that became most associated with indie – issued a free cassette in conjunction with leading indie label Rough Trade. The *C81* cassette featured

Grunge is a curious term to pick to describe yourself, but it does capture some of the characteristics of the sound – dirty, gritty, sludgy.

a diverse selection of artists – purveyors of ska, punk, jazz, folk, even poetry – supposedly saluting the fifth anniversary of independent music, though it also marked the first stirrings of indie as a genre. The experiment proved sufficiently successful for it to be repeated each year, with the most momentous release being the 1986 edition, *C86*.

Bob Stanley, a music journalist at the time, who later founded the indie band Saint Etienne, described *C86* as the 'beginning of indie music', but bemoaned the way in which the birth of indie squeezed out many of the interesting and bizarre singles in favour of a more generic sound: 'And so a genre was born,' he sighed in a 2009 retrospective on the independent chart in the *Guardian*, 'one that excluded the variety of the independent chart at the expense of one style, consisting of clanging guitars and carefree tuning . . . A generic "indie" record in 2009 sounds much as it did in 1986.'

The archetypal indie kid was a student moping in a bedsit who regarded the *NME* or its sister paper *Melody Maker* as gospel. The music that spoke to them was quirky guitar pop, while they dressed in clothes bought from charity shops, artfully combined to express an image that was neither really rebellious nor conformist – chiefly big coats and baggy jumpers crowned with tousled hair. Of course, such stereotypes are a caricature of what was a diverse movement that rejected the confrontational displays of many eighties street tribes, while refusing to accept the plastic conformity of the mainstream. If UK indie had a patron saint, then it was the BBC Radio One DJ John Peel, who played a bewilderingly eclectic selection of music, from death metal and reggae to hip-hop. Peel championed the

Smiths, a downbeat Mancunian band, before their self-titled 1984 album finally saw the Rough Trade quartet enjoy success in the UK charts. Self-pitying and self-righteous, clever and camp – the Smiths became the archetypal eighties indie band.

Stateside, radio also proved to be a powerful medium for breaking bands that fell between the two stools of mainstream appeal and obvious genre, specifically college radio stations, which largely freed DJs from the commercial pressure to play undemanding pop. Bands that broke through via this method – such as the Smiths from the UK and domestic acts like REM – were often dubbed 'college rock' in the US, though the British term 'indie' slowly gained popularity, before the vague 'alternative rock' was established as favoured terminology in the nineties. One such college radio station was KCMU, affiliated with Washington University in Seattle, and it was two DJs from the station, Jonathan Poneman and Bruce Pavitt, who founded the label Sub Pop in 1986. Pavitt had previously published a fanzine under the title *Subterranean Pop*, alongside a series of compilation cassettes. Together, the duo decided to try and put Seattle on the musical map. It was a bold ambition.

Most of the bands on the Seattle circuit were blending a traditional seventies metal guitar sound with hardcore's more aggressive attitude and streetwise lyrics. If anything separated the Seattle scene from those found in other major American cities, it was that it was more laidback, and smaller – hence friendlier – and, some say, more incestuous. It was perhaps this communal spirit that allowed a largely happy marriage between punk and metal – still adversaries in many cities – though it did create tensions, with

many underground purists remaining suspicious of anything that sounded too much like the screaming guitars still emanating from LA.

Nobody's quite sure where the term 'grunge' came in, though most credit vocalist Mark Arm, then of Green River. His next band, Mudhoney, became Sub Pop's first flagship band, and Bruce Pavitt used the word in press material to promote the band. It's a curious term to pick to describe yourself, but does capture some of the characteristics of the sound – dirty, gritty, sludgy even – and in time it was also being interpreted as representative of a self-consciously dishevelled look. More importantly, the word also captures an aspect of the attitude behind it – a combination of a disdain for vanity and pretension leavened with a dose of arch, self-deprecating humour. Pavitt was becoming well known for his over-the-top promotional style, and in 1989 he decided that the UK market was ready for Sub Pop, and that London's music papers, with their passion for making and breaking bands in overwrought style, might provide the perfect vehicle. 'I felt that the British audience was really hungry for music that was decidedly more American, more physical, and more rocking than was going on in England,' recalls Pavitt in Greg Prato's *Grunge is Dead*.

John Leighton Beezer was bassist with the Thrown Ups, a madcap Seattle band occasionally cited as a precursor to grunge, which also featured Mark Arm on drums. Beezer recalls how Pavitt convinced a British journalist to come to Seattle to cover the scene, even though Sub Pop didn't have the budget for a hotel: 'So what he did was he found kindred souls – drank with all these crazy people and slept on floors. Went back and wrote what turned out to be a cover article in *NME*, that said, "Holy shit, amazing things are happening in Seattle!" And the British public bought it,' laughs Beezer, though he's wrong on one detail – Everett True, the journalist concerned, had recently been sacked by *NME* and wrote the

Above: Hole frontwoman Courtney Love onstage in Amsterdam in April 1995 – a year after her husband Kurt Cobain's suicide.

feature for *Melody Maker*. 'I think in the movie *Hype* [a 1996 documentary about Sub Pop], Bruce Pavitt says, "Everett basically came out and invented the myth,"' adds the bassist. It certainly created enough buzz for Mudhoney to undertake a successful UK tour, with their debut EP *Superfuzz Bigmuff* entering the British indie charts in 1989.

Yet it was a minor success for the small, over-stretched Seattle label, which was struggling with daily economics, juggling bills, and earning its staff a reputation as bad debtors. Megan Jasper, who became Sub Pop's receptionist in 1989,

recalls that 'in the outside world everybody thought that Sub Pop had more money than the company could handle. And that was because of the way everything was being marketed at the time.' In 1991 they were obliged to start laying off staff, whittling down from twenty-five to just five employees, and the Seattle press began to pen obituaries for the label, while some local musicians were starting to criticise the hype surrounding grunge, increasingly resistant to the idea of a specific Seattle sound. Salvation for Sub Pop would come from an unexpected direction.

Sub Pop signed Nirvana, who hailed from the neighbouring city of Aberdeen, in late 1988, and issued their debut album *Bleach* in the summer of the following year. The band's vocalist Kurt Cobain was unhappy with the result – recorded for around 600 bucks, hastily written and compromised by pressure to adhere to the grunge sound Sub Pop were attempting to establish, according to Cobain. Yet it was well received, with UK critics in particular dubbing it Sub Pop's rawest, most exciting release to date. But sales, while impressive, built upon tireless touring, weren't enough to dig the label out of the financial hole created by their ambition. The solution came via a deal with Geffen Records, who took on Nirvana and saved Sub Pop in the process. Major labels had been sniffing around the Seattle scene for some time – in part thanks to the hype generated by Pavitt's aggressive press campaigns – this new grunge sound was threatening to be the next 'big thing', and astute industry A&R scouts were vying for a slice of the action.

The 1991 single that emerged from Nirvana's new deal, 'Smells Like Teen Spirit', became a nineties anthem, vaulting from college radio play to MTV rotation and international success, much to the surprise of

> Unlike glam, where all the energy came from below the belt, grunge had brains and a heart, which Kurt Cobain wore on his sleeve.

all concerned. The ensuing album, *Nevermind*, toppled Michael Jackson from the top of the album charts in January of 1992. Grunge was now officially an international phenomenon. 'A lot of kids were looking for something that felt more real and had more passion,' observed Butch Vig, who produced the record. Nirvana's energy seemed honest and natural, particularly in comparison to the LA glam bands, with their make-up and strutting. Unlike glam, where all the energy came from below the belt, grunge had brains and a heart, which Cobain wore on his sleeve. 'I just can't believe anyone would start a band just to make the scene and be cool and have chicks,' he said. 'I just can't believe it.'

To the handsome, unkempt singer, his music was art, and Cobain was vocal in his disgust at the sexism, racism and homophobia he perceived as endemic in rock.

Several other bands from the Seattle region were also rising to the top under the grunge banner, even if many disowned the term. While Mudhoney struggled to move beyond cult status, ex-Sub Pop act Soundgarden were already establishing themselves as one of America's hottest acts, taking a basic seventies hard-rock sound in witty, inventive directions. It was this crossover that was generating the scene's popularity among fans who warmed to its blend of drive and intelligence, appealing to both the college-rock and heavy-metal crowds. The Seattle band Alice in Chains began as an LA-style metal act in 1987, before finding their own distinctive, harrowingly heartfelt sound – and chart success – in the nineties.

The last of the classic grunge bands were Pearl Jam, late arrivals formed in 1990, and some accused the band of jumping on the bandwagon, *NME* memorably dismissing them

Opposite: Reluctant grunge figureheads Nirvana.

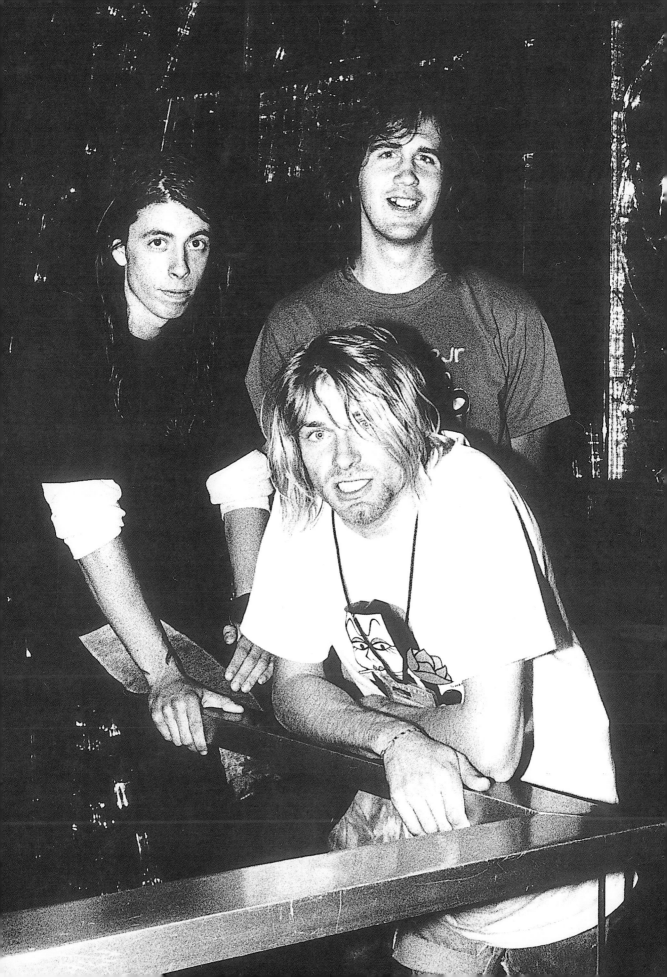

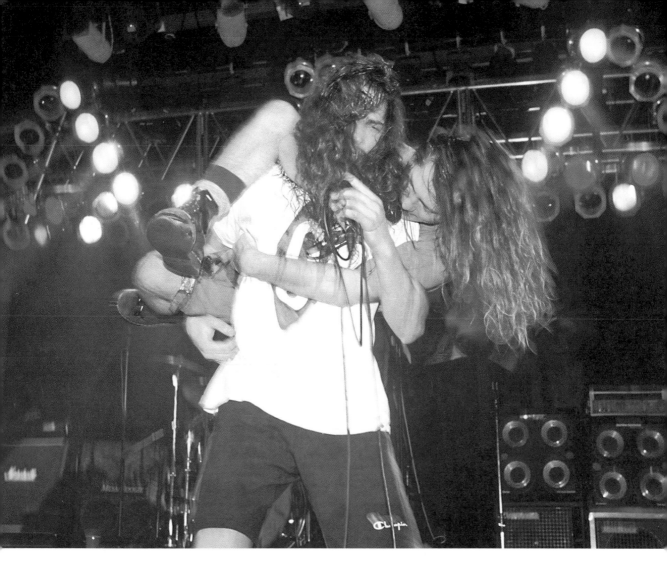

Above: Pearl Jam's Eddie Vedder and Soundgarden's Chris Cornell perform onstage with their band Temple of the Dog in 1991.

as 'trying to steal money from young alternative kids' pockets'. Yet their 1991 album *Ten* proved a slow-burning success, its blend of anthemic guitars and thoughtful, angst-ridden lyrics winning over fans and critics alike, overtaking sales of *Nevermind* the following year. While Pearl Jam was a new project, its members had a strong Seattle pedigree. Guitarist Stone Gossard and bassist Jeff Ament had both been members of the influential Seattle band Green River, before founding Mother Love Bone in 1988. Mother Love Bone are often cited as the greatest grunge band that never happened – their charismatic vocalist Andrew Wood died of a heroin overdose just days before their debut album was due to be released. A much-loved, talented performer, Wood's death was an ominous foretaste of the tragedies that were to engulf grunge.

Meanwhile, a media circus was descending on Seattle, anxious not to miss out on the latest thing. 'It's almost like a cruel joke – Seattle wasn't *supposed* to be successful,' Jeff Gilbert, an ex-Sub Pop employee, told Greg Prato. 'We were really just supposed to have this cool, regionalised music scene, and that was it.' Yet there wasn't just a grunge sound now, but also a grunge look – flannel shirts, threadbare jeans, long ruffled hair and boots. Jonathan Poneman shrugged that it was 'cheap, durable, and kind of timeless. It also runs against the grain of the whole flashy aesthetic that existed in the eighties.'

'It seemed dumb when there were runway shows of "grunge wear",' observed Seattle concert promoter David Meinert. 'I would

buy $0.99 seven-layer burritos and thrift-store clothes – not for a style thing, but because I had no *money*.' There was perhaps an ethos behind grunge's thrift-store chic – an implicit rejection of trivial fashion, the implication that you had more important things to think about – but once it became a *haute couture* trend, the entire concept was teetering into the realms of parody.

Yet tragedy was seldom far away, and in April of 1994 Kurt Cobain took his own life with a shotgun. The autopsy discovered large amounts of heroin in his bloodstream. Cobain's death was greeted with disbelief and despair by friends and fans. His deeply personal music had touched many, and his shocking demise underlined the authenticity of the raw emotion the troubled musician had poured into Nirvana. As the death of Andrew Wood four years previously had already suggested, heroin had seeped into the Seattle scene, and was taking a fatal toll. In 1992 Alice in Chains' hit album, *Dirt*, depicted the tortured psyche of the addict with chilling power. It drew heavily on the personal experience of vocalist Layne Staley, who had struggled with substance abuse throughout the band's career. In 1996, his partner died of drug-related complications, and depression and addiction overcame the singer, effectively ending his musical career. Staley died of an overdose in 2002. His body lay undiscovered for around a fortnight.

In many eyes, grunge had died long before. Just as the Seattle scene was embraced as an antidote to the gaudy excesses of LA glam, so by the mid-nineties the pendulum was beginning to swing back. Tired of worthy 'unplugged' sets and dowdy performers who looked like the fans, audiences welcomed a new generation of showmen, like Marilyn Manson, who took the glam recipe and supercharged and subverted it with a toxic cocktail of sly provocation and shock tactics. In the UK, the tide had also turned. Magazines like *NME* specialised in toppling performers they had previously put

Once it became a haute couture trend, the entire concept was teetering into the realms of parody.

on pedestals, and in the wake of Kurt Cobain's death they actively sought a new trend to dance upon grunge's grave. In a 1993 interview, an *NME* journalist suggested to singer Damon Albarn that his band, Blur, might be an anti-grunge act. 'Well, that's good,' responded Albarn. 'If punk was about getting rid of hippies, then I'm getting rid of grunge.' They had their new trend, and dubbed it Britpop.

The UK music press had never been very comfortable with the hard-rock aspects of grunge, or indeed its American roots, and an indie scene that embraced sixties British guitar pop had an obvious appeal. But Britpop proved to be a damp squib outside of its birthplace, further evidence of the UK's declining influence as a musical superpower in the nineties.

British indie music was becoming increasingly insular and unimaginative, encouraged by a myopic music industry and egoistical hacks. Bizarrely, for a scene long associated with shy students, it was also becoming pathetically thuggish. (Liam Gallagher of Oasis dismissed Kurt Cobain as 'a sad man who couldn't handle the fame. We're stronger than that. And you can fuck your fucking Pearl Jam.') While the UK music press continued to try and generate indie movements, none enjoyed the impact of grunge, the movement they had inadvertently manipulated into launching via Sub Pop. Ultimately, just as the significance of the UK term 'indie' became devalued in the eighties, so staples of the US scene – like college radio – have lost significance in the 21st-century musical marketplace, where vinyl and radio signals are quaint anachronisms for the internet generation.

EMO
The Black Parade

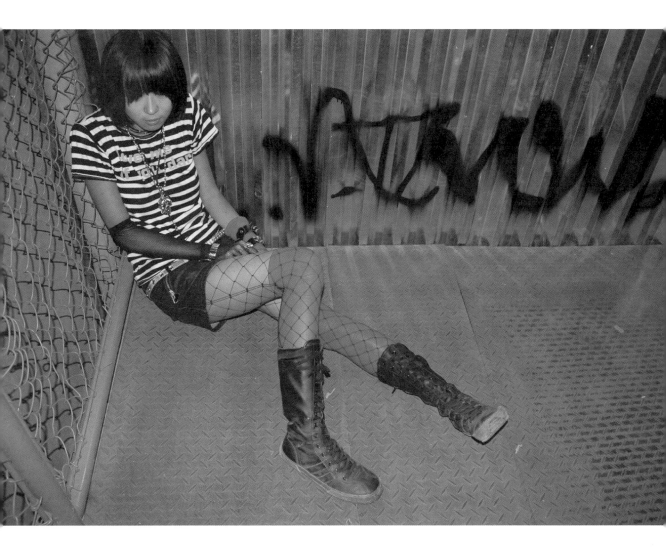

Emo didn't drive teens into suicidal despair, so much as provide a subcultural escape for those who were already troubled.

Just as goth emerged as punk's sulky younger sister in the UK sometime around 1980, a few years later emo, hardcore's sensitive junior sibling, surfaced in the USA. In both cases, the new subgenres clung to their forebears in the hope of protection and a little reflected credibility, before striking out on their own. While gothic punk simply became goth within a few years, emo waited in the wings for quite a lot longer. 'Emo' is generally accepted as an abbreviation of 'emotional hardcore' – though the tag was resisted by adherents pretty much from the start. While there was plenty of emotion in hardcore punk, it was almost exclusively anger, tempered with a little outrage and occasional sarcasm. The concept of 'emotional hardcore' – a variant on the form, which embraced sensitivity and rejected violence – is so at odds with its inspiration as to qualify as a radical backlash from within the subculture.

The leading figure in emo's pre-history is Ian MacKaye of the Washington DC punk band Minor Threat. During their brief career (1980-83), Minor Threat became one of hardcore's most influential acts. They popularised 'straight edge' – puritan punks who rejected drugs and alcohol – though MacKaye later reflected that he'd never intended to start a movement. He was even less enthusiastic about being labelled the forefather of a bigger subcultural phenomenon, the birth of emo, which MacKaye dismissed as 'the stupidest fucking thing I've ever heard in my entire life'. He wasn't referring to the music, much of which appeared on his Dischord label, so much as the media's tendency to invent

Opposite: Teenage wasteland: The emo look typically involved tight clothes, black hair-dye and plentiful eyeliner.

genres in the hope of creating trends. Arguably the most influential signing to Dischord were the Rites of Spring, a Washington DC quartet who contrasted hardcore energy with a quieter, more reflective edge.

That contrast – between musical fury and more maudlin melodic moments – became emo's signature sound. Few could have predicted that the DC post-hardcore scene would generate a movement (the Rites of Spring broke up in 1986 leaving a legacy of just one album and one EP), and many argue that it didn't. At least not organically, and emo, or emocore as it was sometimes known, was just one of a number of new terms being bandied about in the late eighties, such as skate punk and ska punk. It wasn't until the nineties that emo started to look like a coherent subculture. Significantly, *NME* – always eager to coin new genres – is often cited as the first publication to employ the term in print. However, it wasn't just British journalists looking to identify a new movement, but major US record labels, whose future profits relied upon successfully riding the next wave to emerge from the musical underground.

Emo had roots in hardcore, but was made more palatable to a larger audience by possessing greater intellectual and emotional range than its irate inspiration. The sense that the emo label was, at least in part, a media and industry construct has haunted the movement throughout its existence. Yet for fans, particularly younger fans – and emo (like hardcore) was defiantly adolescent – the prospect of banding together under a banner for mutual support had powerful appeal. Despite the reservations of musicians and more cynical scenesters, by the late nineties, emo had become a movement.

Emo was punk for kids not ashamed of being smart or showing their feelings – which meant it wasn't punk in some eyes. The look was a blend of preppy punk and geek chic – the attitude one of angst, unabashed awkwardness and frustration, making it a powerful draw

for smart teenaged misfits. Bands like Weezer and the Promise Ring sold well in the building emo scene, even if most older, established rock critics just didn't get it. As self-confessed geeks, the emo crowds were tech-savvy – employing the fledgling internet to powerful effect – and band tours attracted sponsorship from firms like Microsoft and Coca Cola, eager to tap into the teen demographic that emo was attracting. The breakthrough recording was the 2001 album *Bleed American*, by Jimmy Eat World, which finally transformed emo from a subculture into an international phenomenon.

Several other bands – such as New Found Glory and Dashboard Confessional – followed Jimmy Eat World into the charts on the back of the media's new fascination with emo. While many bands remained suspicious of the term, for journalists it was a convenient tag for any brooding or introspective but aggressive rock music with a teenage audience. 'The media business, so desperate for its self-obsessed, post-9/11 predictions of a return to austerity and the death of irony to come true, had found its next big thing,' writes Andy Greenwald in *Nothing Feels Good: Punk Rock, Teenagers and Emo*. 'But it was barely a "thing", because no one had heard of it, and those who had couldn't define it.'

Emo fashion also included tight black jeans and skinny-fit band t-shirts, sneakers (typically Converse), piercings and tattoos (star designs became an archetypal emo motif). There was also plenty of black hair-dye and eyeliner – leading to further comparisons with goth, though the classic emo hairstyle wasn't long and backcombed but straightened or sculpted, on boys typically into a lopsided fringe. While goth had long been subculture's favourite whipping boy – particularly when the cult's pacifist ethos became widely known amongst belligerent cowards – by the 21st century emo had begun to take its place. Emos were derided as vain, pretentious, self-obsessed whiners by both conformist thugs and judgemental bullies from

rival subcultures. In a scene that appealed to those who already felt victimised and misunderstood, this often strengthened the conviction of devotees, but hostility to the harmless subculture was intensifying to an alarming degree.

Confirming Andy Greenwald's assertion of the significance of the September 11th tragedies, and resultant feelings of gloom and self-doubt in American culture, My Chemical Romance formed in 2001 as a direct response to the atrocity. The New Jersey band's 2004 major-label debut was entitled *Three Cheers for Sweet Revenge*, indicating that the quartet had sharper teeth than the archetypal emo outfit. Indeed, in familiar style, the group's singer Gerard Way vehemently rejected the tag, dismissing emo as 'fucking garbage'. Yet My Chemical Romance's fast-building following clearly fit the category, something that became increasingly obvious in the wake of their 2006 album *The Black Parade*, a critically and commercially successful concept album themed around death and grieving. It made My Chemical Romance the focus of an anti-emo crusade in the UK's reactionary right-wing press, triggered by the 2008 suicide of a thirteen-year-old fan of the band named Hannah Bond, from Kent in England.

The *Sun* newspaper picked up on a dubious speculation by the coroner that her taste in music might be responsible, inspiring the tabloid to print an article entitled 'Suicide of Hannah, the Secret "Emo"'. The *Daily Mail*, a British paper with a justified reputation for reactionary sensationalism, soon joined the witch-hunt, absurdly depicting emo as a sinister, quasi-religious teenage sect dedicated to suicide and self-harm. The paper's piece, headed 'Why No Child is Safe From the Sinister Cult of Emo', is cynically designed to stoke paranoia in the minds of parents across the land whose kids dyed their hair black or listened to morbid music.

Misery loves company, and for every depression-plagued listener pushed further into despair by maudlin melodies, there are surely

countless others for whom the experience is cathartic. While the link between tearful art and suicidal impulses is highly contentious, surely damaging relations between vulnerable teenagers and their parents with reactionary sensationalism is far more likely to create a dangerously volatile situation. Emo didn't drive teens into suicidal despair, so much as provide a subcultural escape for those who were already troubled, just as Tchaikovsky's Symphony Number 6, *Pathétique*, offers a similar cathartic experience for fans of classical music who might be feeling down. Dr Dan Laughey, a media and popular culture lecturer, was highly sceptical of the hysteria over the scene whipped up by the popular press. 'Emo fans are mostly middle-class, often going through puberty,' he told the BBC. 'For the majority of fans, emo music acts like a release valve, driving away all the negative energy and emotion inside them.'

To their credit, Britain's emos didn't take the ignorance of the popular press lying down. My Chemical Romance fans staged a protest in London in May 2008 to object to the assault on the subculture. The *Guardian* interviewed Vikki Bourne, who attended the protest with her daughter Kayleigh, fifteen. Both were huge fans of My Chemical Romance and told how they had developed a closer relationship as a result. 'Emos are being portrayed as self-harming and suicidal and miserable and they're not,' said Vikki. 'Since my daughter met the friends she's got, she's happy, she's got a social life, she's not suicidal, she's got confidence.' Yet that same year, emos faced even more troubling attacks in other nations. Most notably Mexico, where they were subjected to mob violence by baying packs of youths chanting 'kill the emos'. 'At the core of this is the homophobic issue. The other arguments are just window dressing for that,' Victor Mendoza, a Mexico City youth worker, told *Time*. 'This is not a battle between music styles at all. It is the conservative side of Mexican society fighting against something different.'

Above: *My Chemical Romance became emo figureheads, though singer Gerard Way dismissed the tag as 'fucking garbage'.*

Similarly troubling anti-emo sentiment echoed across the globe. In 2008 Russian officials passed laws targeting the subculture. 'Last month the State Duma held a hearing on "Government Strategy in the Sphere of Spiritual and Ethical Education", a piece of legislation aimed at curbing "dangerous teen trends",' reported the *Guardian*. 'There, without a clue in the world, social conservatives lumped "emos" together with skinheads, pushing for heavy regulation of emo websites and the banning of emo and goth fashion from schools and government buildings.' In 2010, Saudi Arabia's infamous religious police arrested ten girls, accused of causing offence in a coffee shop with their emo style. As a peaceful subculture dedicated to emotive music – only ever accused of harming themselves – even emo's most dismissive critics must admit that the movement's plight has proven a reliable barometer of oppression and intolerance in 21st-century societies.

CONCLUSION

In recent years, some experts have been announcing an end to the kind of countercultural tribalism documented in this book. In 1994 the V&A, London's prestigious decorative arts and design museum, hosted an exhibition, *Streetstyle: From Sidewalk to Catwalk*, dedicated to the history of counterculture dress, from teds to cyberpunks. It proved a big success, with queues trailing around the block, and plentiful interest from the international media. However, some of the journalists in attendance observed that the very presence of these clothes in a museum signalled the end of subculture. Ted Polhemus and Amy de la Haye, the exhibition's curators, reluctantly agreed in the colourful book issued to accompany the show, observing tentatively that in the modern world 'we become less and less inclined to subjugate ourselves either to the conformity of the "direction" of fashion or to the conformity and commitment required of those who would become members of a subculture'.

Ultimately, Polhemus suggested, street style had largely won its war with high fashion, which no longer dictated trends unchallenged. But in the process, easily delineated subculture tribes had disappeared, to be replaced by 'the unique individualist'. In his 2010 update of *Streetstyle*, Polhemus writes that he originally believed that the new subcultures suggested to him by colleagues and friends, most notably emo, didn't really exist. None of the kids he spoke to would admit to being emos. Yet, confessed the writer, he was given pause for thought when newspaper articles appeared reporting attacks on emos in places like Mexico, where the victims clearly did see themselves in that light. Part of Polhemus's problem was that many

emos – like goths – saw denying the label as a key part of the subculture identity. It was also a wise survival strategy when rival cults derided emos as self-obsessed wimps, the right-wing press decried them as members of a suicide cult, and insecure thugs saw them as easy prey. Emo most definitely exists, even if it's not necessarily easy for a middle-aged ex-hippie researcher to convince teenagers to admit to being members.

In the nineties, some goths tried to distance themselves from the scene's reputation as an outdated clique defined by gloomy morbidity by creating new, more colourful and upbeat mutations such as cybergoth. Similarly, a few years later, many emos began to rebrand themselves as 'scene kids', a less downbeat and serious, more fashion-conscious spin on the theme. As with emo (and goth), refusing to confess to being a scene kid is often part of the pose, making them similarly elusive to outsiders. The look is also similar, but with more bright shades and less black, though involving the familiar tight jeans, skater shoes and carefully coiffed dyed hair. Scene-kid music is drawn from a rather broader spectrum of styles than emo's introspective post-hardcore soundtrack, with listeners keeping abreast of trends via an eclectic roster of genres – from techno to indie rock to hip-hop – whilst avoiding obvious commercial pop. One oft-cited characteristic of the archetypal scene kid is an enthusiasm for social-networking sites, though this hardly separates them from most of their peers. Overall, there is something nebulous and vague about the movement – if such it is – even down to the name itself, suggestive of a 'scene' but unhelpful as to what might be involved.

Many of the subcultures described in this

Above: *Hipsters were typically white, middle-class twentysomethings whose fashion choices – such as the flip-flops above – were worn 'ironically'.*

book have a history of regarding 'selling out' – of compromising your ideals for popular acceptance – as a cardinal sin. And with some justification: nothing dissolves the glue holding a subcultural tribe together quite as quickly as being quantified and commodified by outsiders. Anybody who suggested marketing the Hells Angels to a mainstream clientele in the sixties would have been regarded as insane. In the 21st century, the Hells Angels are defending their copyright in the law courts. With punk pioneer Iggy Pop pimping luxury cars and insurance, and hard-rock legend Lemmy advertising everything from Walkers Crisps to Kit Kat chocolate bars, the idea that subcultures provide vital proof that you can't buy cool appears to be under sustained and successful attack.

Free festivals were long regarded as archetypal counterculture events, battles between festival-goers and the police emblematic of conflict between two different visions of 20th-century Britain – a clash between advocates of property rights and champions of free expression. When heavy-handed policing closed down first Windsor and then Stonehenge, Glastonbury became the highlight of the UK festival season. The 1990 event was a turning point, when new age travellers, radicalised by battles with the police, clashed violently with festival security, resulting in the end of cordial relations between the nomadic hardcore of self-righteous crusties and Glastonbury's organisers. While it's easy

to sympathise with the festival's management, dismayed by the thuggish behaviour of its dreadlocked guests, the resultant increase in security, rising ticket prices and sponsorship deals with high-profile brands like Orange phones and NatWest bank suggest an event that has largely lost touch with its underground roots, for good or ill.

Determining the year when Glastonbury stopped being cool has become a perennial topic of conversation among dedicated festival-goers. Glastonbury is now part of the fashionable social circuit, with fashion journalists offering tips on 'glamping' (a ghastly compound of 'glamorous camping'). The bands performing are high-profile charts acts, expecting large fees that help put Glastonbury tickets beyond the reach of the kind of ordinary youngsters and footloose free spirits who once made up festival audiences. In 2011, despite tickets reliably rapidly selling out, Glastonbury's founder Michael Eavis suggested that festivals were finally on their way out. 'Partly it's economics,' he said of the audience becoming older and wealthier, 'but there is a feeling that that people have seen it all before.'

There appears to be a more diverse, less overtly tribal quality to 21st-century subculture than was reflected in my experience as a teenager in the eighties. It's increasingly difficult to spot metal fans, for example, and at many gigs leather jackets and long hair are in the minority. Increasingly, alternative kids seem to be wearing a bewildering mismatch of counterculture styles, combining elements of skater, hip-hop, metal and goth – an eclectic blend reflected in the playlists at many contemporary alternative clubs.

Yet look at many photos of seminal seventies punk gigs and few punters look particularly punk. Most of the subcultures described in these pages borrowed from earlier tribes to create their own unique stylistic cocktail. Pioneers often only look clearly defined in retrospect.

Many of the originals only realised they were 'rockers' after reading about themselves in the press. Might we inadvertently be rewriting subculture history in retrospect, using hindsight to create movements that then become self-fulfilling prophecies? (There's a strong argument that all history involves inventing plots to make sense of diverse events that explain the present situation and justify future ambitions.) There can be little doubt that the mainstream media plays a central – if often inadvertent – role in creating subcultures. I've already emphasised the importance of negative reactionary press reports in turning local incidents into catalysts for tribal movements. If the basic nature of media has radically changed in recent years, it seems logical that this dynamic may also have changed.

To get to the root of the issue, it's probably worth looking at the bigger picture. The heyday of tribalism in British youth culture was almost certainly the eighties. Adverts in music papers offered off-the-peg outfits for aspirant members. One such in the *NME* in 1981 listed sets of clothes billed as mod, ska, skinhead, punk, ted, rockabilly, and no less than three Bowie looks. 'Today youngsters divide very clearly into cults – punk, skinhead, heavy-metallers, mod or ted,' claimed the *Birmingham Post* that same year. A 1981 feature in tabloid paper, the *Sun*, also detailed 'The Seven Tribes of Britain' (this time rockabillies, heavy metal, new psychedelics, punks, new romantics, skins and mods), indicating how visible the rival groups had become. There's debate over whether this was a symptom of the vibrancy of street counterculture, or evidence of its weakness, splintering into feuding factions under the pressure of Margaret Thatcher's right-wing government, which aggressively suppressed any perceived deviance. Golden Age or Dark Age? Most likely a complex combination of the two.

Paul Rambali, ex-editor of *The Face*, claimed that the intent of his magazine's staff was 'to cover the doings of our contemporaries in their

search for identity'. During the eighties both Rambali's publication and *i-D* – founded by art director Terry Jones – became influential barometers of the trends emerging from beacons such as London's Blitz Club, and illustrated the divisions that separated most UK street tribes. 'The studio was the street, the models were real teenagers and the clothes were the ones they wore or created themselves,' wrote Rambali. 'It was anti-consumerist, anti-establishment, and cute: anybody could be fashionable for fifteen minutes [. . .] They all expressed their dissatisfaction through clothing; sometimes above all through clothing, and rightly so, for in Britain, the social is sartorial.'

Communication technology in general had been advancing over the decades, and local scenes that emerged based upon tantalising fragments of information gleaned from album covers, traded fanzines or lazy, inaccurate mainstream magazine articles increasingly had access to more reliable information about their inspiration at the touch of a button. As with so much information technology, the effect was ambivalent. While the exchange of information was in itself exciting, the excitement of discovery and essential mystery of foreign subcultures palled. Black metal, one of the most vibrant fringe movements to rise to prominence in the nineties, owed much to

By the nineties the term 'alternative' was becoming increasingly common as a catch-all for every subculture outside of the mainstream.

By the nineties the term 'alternative' was becoming increasingly common as a catch-all for every subculture outside of the mainstream. This likely owed something to interested parties such as record executives being keen to identify and access a new demographic (as did the 'invention' of the teenager in the fifties), yet it signified a new, less combative attitude among rival subcultures. Your enemies were less likely to be members of a different counterculture, so much as the 'straights' or 'townies' who took violent exception to anyone refusing to follow current fashion conventions. Battle-lines in the nineties were increasingly being drawn on a new, simpler, us-and-them model, separating self-consciously rebellious subcultures from those groups whose aspirations more easily dovetailed with mainstream values.

Of course, the rise of the internet had a profound impact on the subcultural milieu. Devotees of niche interests that could never have previously coalesced as groups now found kindred spirits, which encouraged further fragmentation within established subcultures.

the cultural 'Chinese whispers' silenced by the internet. Its Norwegian pioneers were inspired by romantic misreadings of British metal culture; the product of this, in turn, fascinating foreign fans with its exotic Scandinavian setting.

The rise of black metal – both within the heavy-metal subculture and ultimately into the more adventurous realms of mainstream media – undoubtedly owed much to the violence associated with the scene in the early nineties, in the same way that gangsta rappers turning chart battles into wars waged with automatic weapons raised the profile of hip-hop. Part of this has to do with the perennial guilty allure of bloodshed, but it's also indicative of a craving for authenticity. The fact that devotees of the subculture were willing to break the law in order to demonstrate loyalty to their ideals appealed to many at a time when, increasingly, nobody seemed to be taking anything very seriously. The nineties saw a prevalent attitude of ironic detachment. Everything was something of a joke. Cool was no longer simply about being aloof, but required an actively

Above: *Nikolai Fraiture and Nick Valensi of the Strokes, whose hit 2001 album* Is This It *helped popularise the hipster aesthetic.*

mocking demeanour; your tastes were defined by affecting to like something as a statement of satire. Having information at your fingertips courtesy of a Google search made everyone an instant expert – for good or ill – alerting some to the depressing possibility that there was nothing new under the sun.

It is now perhaps appropriate to return to the hipster – the most controversial figure in recent subcultural debates for altogether different reasons. The term 'hipster' is nearly a century old, derived from black American slang for someone clued up on the latest street trends. Its appropriation by aspirational, middle-class white twentysomethings in the late nineties provoked almost universal hostility, and few people would now confess to being a hipster. The hipster was a noxious by-product of the attitude of sneering cynicism common during the nineties, who adopted aspects of

authentic subcultures with a sense of blasé condescension. In 2010 Mark Greif wrote an insightful dissection of the movement entitled 'What Was the Hipster?' for *New York* magazine.

He identifies two major strains of the species. The first is the 'white hipster' who knowingly mocked traditional white, blue-collar culture by adopting 'trucker hats; undershirts called "wifebeaters", worn alone; the aesthetic of basement rec-room pornography, flash-lit Polaroids [. . .] "porno" or "paedophile" moustaches; aviator glasses [. . .] the late albums of Johnny Cash; tattoos.' The white hipster was succeeded by the green hipster or hipster primitive, who looked down their collective noses at modern eco fads and back-to-nature idealism with a raised eyebrow: 'Women took up cowboy boots, then dark-green rubber wellingtons, like country squiresses off to visit the stables. Men gave up the porno moustache for the hermit or lumberjack beard. Flannel returned, as did hunting jackets in red-and-black check. Scarves proliferated unnecessarily, conjuring a cold woodland night (if wool) or a desert encampment (if a kaffiyeh).'

Greif quotes a term coined by the cultural commentator Thomas Frank – 'the rebel consumer' – for those members of subcultures successfully targeted by business. 'The rebel consumer is the person who, adopting the rhetoric but not the politics of the counterculture, convinces himself that buying the right mass products individualises him as transgressive,' writes Greif. 'Purchasing the products of authority is thus reimagined as a defiance of authority. Usually this requires a fantasised censor who doesn't want you to have cologne, or booze, or cars. But the censor doesn't exist, of course, and hipster culture is not a counterculture.'

Greif observes that every subculture has its share of hangers-on and phoneys – those who contribute nothing original of any substance artistically or culturally to the subculture – who almost invariably ditch the style in favour of something they see as more 'cutting-edge' overnight. Yet among the hipsters, such individuals are the substance of the movement – there is no core of meaning, authenticity or originality beneath the scene's fickle, idly arrogant façade. If hipsters are the defining subculture of the 21st century, it's a pretty depressing reflection upon the state of modern society. Yet this is far from the complete picture, and even if they don't show up in studies by marketing research firms or conform to the predictions of cool hunters, traditional subcultures are thriving globally today, perhaps more so than ever before.

The increasingly rich heritage of subcultural history offers new style tribes an unprecedented number of resources to employ for inspiration. The results are perhaps inevitably more complex – even confused – than the more clearly delineated veteran groups. But such hybrids are surely forming into coherent movements, even if they aren't so obvious to outsiders. Contrary to what many believe, joining a street tribe isn't primarily about attracting attention to yourself. It's about finding like-minded souls who share your views and tastes – of which clothing and music are just two aspects – about rejecting the pressure to be good consumers, put on a tie and walk the treadmill until it's time to be put out to grass. Often naive, sometimes violent, frequently ridiculous, almost inevitably self-indulgent, subcultures are still the modern world's most colourful monument to free thought and free expression, and are surely worth celebrating as a potent antidote to the conformism and blind obedience that continues to afflict so much of contemporary society.

Acknowledgements

For help with visual material we would like to give special thanks to the late John Stuart's archive of Rockers memorabilia, particularly to Max Scheler and the late Roger Mayne. We would also like to thank Frederike de Jonge for her photographs of Goths; Richard Barnes for his book on *Mods*, as well as Gavin Walsh for material on the Sex Pistols.

We would like to thank the following for supplying pictures: Joseph McKeown/Getty Images; Popperfoto/Getty Images; Maurice Ambler/Getty Images; Juliette Lasserre/Getty Images; National Film Archive; *Motorcycle Magazine*, Emap; Don Cravens/The Life Images Collection/Getty Images; Fox Photos/Getty Images; Jeremy Fletcher/Redferns/Getty Images; *Fabulous* magazine; Rex Features; *Colorific*; Paul Brown/Rex Features; *Fabulous* magazine; Associated Press; Bill Eppridge/The Life Picture Collection/Getty Images; Gene Anthony; Joe Rosenthal; Rolls Press/Popperfoto/Getty Images; Michael Marten/Camera Press; S. Myatt; AP/Wide World Photos; Joseph Scherschel/The Life Picture Collection/Getty Images; Gene J. Puskar; Phillip Jackson/Associated Newspapers/Rex Features; Raybert Productions; *Manchester Daily Express*/SSPL/Getty Images; Roger Bamber/Rex Features; Thorn EMI Classics; News Group/Rex Features; Graham Wood/Stringer/Getty Images; Mick Gold/Redferns/Getty Images; Andy Phillips; Leon Morris/Hulton Archive/Getty Images; Terrence Spencer/The Life Picture Collection/Getty Images; John Downing/Getty Images; Brian Harris/Rex Features; Stefano Archetti/Rex Features; Feri Lukas/Rex Features; Mercury Records; Gavin Walsh; Annette Weatherman; David Dagley/Rex Features; The Hulton Getty Picture Collection Limited; Erica Echenberg; Glitterbest; Barry Plummer; A&M Records; EMI, Virgin Records; CBS Records; IBL/Rex Features; United Artists Records; Chuck Pulin; Michael Ochs Archives/Stringer/Getty Images; Bronze Records; Paul Bergen/Redferns/Getty Images; Pete Cronin/Redferns/Getty Images; Eugene Adebari/Rex Features; Richard Young/Rex Features; Fin Costello/Redferns/Rex Features; Virginia Turbett/Redferns/Getty Images; Kerstin Rodgers/Redferns/Getty Images; Sipa Press/Rex Features; Dave Montgomery/Getty Images; Pieter Mazel/Sunshine/Retna; Ebet Roberts/Redferns/Getty Images; Anne Fishbein/Michael Ochs Archives/Getty Images; George Rose/Getty Images; Frank Mullen/WireImage/Getty Images; Eye Candy/Rex Features; Iain McKell/Photolibrary/Getty Images; Max Brouwers/Getty Images; Tim Scott/Fluid Images/Rex Features; David Rose/Rex Features; Murray Sanders/Associated Newspapers/Rex Features; Ty Milford/Getty Images; Scott Gries/Getty Images; Profile Records; Startraks Photo/Rex Features; Tristan O'Neill/PYMCA/Rex Features; Dean Chalkley/PYMCA/Rex Features; Dario Mitidieri/Hulton Archive/Getty Images; Jay Blakesberg/Getty Images; Peter J. Walsh/PYMCA/Rex Features; Roy Tees; Kevin Cummins/Getty Images; Roger Sargent/Rex Features; Marty Temme/WireImage/Getty Images; Paul Hartnett/PYMCA/Rex Features; Paulo Nozolino; Dennis Morris.

It has not always been possible to trace copyright sources and the publisher would be glad to hear from any such unacknowledged copyright holders.

Bibliography

Barnes, Richard, *Mods!*, Plexus, 1979; Blush, Steven, *American Hardcore*, Feral House, 2010; Brown, Gareth, *Scooter Boys*, Independent Music Press, 2005; Chang, Jeff, *Can't Stop Won't Stop*, St Martin's, 2005; Davenport-Hines, Richard, *The Pursuit of Oblivion*, Phoenix, 2004; Décharné, Max, *A Rocket in My Pocket*, Serpent's Tail, 2010; di Prima, Diane, *Memoirs of a Beatnik*, Marion Boyars, 2002; Doggett, Peter, *There's a Riot Going On*, Canongate, 2008; Farren, Mick, *The Black Leather Jacket*, Plexus, 2008; Garnett, Mark, *From Anger to Apathy*, Vintage, 2008; Gorman, Paul, *The Look*, Sanctuary, 2001; Greenwald, Andy, *Nothing Feels Good*, St Martin's, 2003; Gregorits, Gene, *Midnight Mavericks*, FAB Press, 2007; Harris, Maz, *Bikers*, Faber and Faber, 1985; Heatley, Michael (ed.), *Rock & Pop: The Complete Story*, Flame Tree, 2006; Hewitt, Paolo (ed.), *The Sharper Word*, Helter Skelter, 2009;

Hopkins, Harry, *The New Look*, Secker & Warburg, 1963; Hoskyns, Barney, *Glam!*, Faber and Faber, 1998; Kureishi, Hanif and Jon Savage (eds), *The Faber Book of Pop*, Faber and Faber, 1995; Lee, Martin and Bruce Shlain, *Acid Dreams*, Grove Press, 1994; Light, Alan (ed.), *The Vibe History of Hip Hop*, Plexus, 1999; Moore, Jack B., *Skinheads Shaved for Battle*, Popular Press, 1993; Neville, Richard, *Hippie Hippie Shake*, Heinemann, 1995; Nolan, David, *I Swear I Was There*, Independent Music Press, 2006; Osgerby, Bill, *Biker*, Lyons Press, 2005; Paxman, Jeremy, *The English: A Portrait of a People*, Penguin, 1999; Polhemus, Ted, *Street Style*, PYMCA, 2010;

Polhemus, Ted, and Lynn Procter, *Pop Styles*, Hutchinson, 1984; Popoff, Martin, *Top 500 Heavy Metal Albums of All Time*, ECW, 2004; Prato, Greg, *Grunge is Dead*, ECW, 2009; Rimmer, Dave, *New Romantics: The Look*, Omnibus, 2003; Savage, Jon, *England's Dreaming*, Faber and Faber, 2005; Smith, Raven (ed.), *Club Kids*, Black Dog, 2008; Sounes, Howard, *Seventies*, Simon and Schuster, 2006; Spencer, Amy, *DIY: The Rise of Lo-Fi Culture*, Marion Boyars, 2008; Spitz, Mark, *David Bowie*, Aurum, 2009; Strongman, Phil, *Pretty Vacant*, Orion, 2007; Stuart, Johnny, *Rockers!*, Plexus, 1987; Thompson, Dave, *The Dark Reign of Gothic Rock*, Helter Skelter, 2002;

Thompson, Hunter S., *Hell's Angels*, Random House, 1966; Tendler, Stewart and David May, *The Brotherhood of Eternal Love*, Cyan, 2007; Thompson, Tony, *Gangs*, Hodder, 2005; Turner, Alwyn W., *Crisis? What Crisis?*, Aurum, 2008; Turner, Alwyn W., *Rejoice! Rejoice!*, Aurum 2010; Veno, Arthur (ed.), *The Mammoth Book of Bikers*, Robinson, 2007.